A Garland Series

The
Art Experience
in
Late Nineteenth-Century
America

Twenty-six of the
most important titles from the period
reprinted in thirty-three volumes
including over 4,500 illustrations

edited with an introduction by

H. Barbara Weinberg
Queens College

Garland Publishing, Inc., New York & London

1976

Library of Congress Cataloging in Publication Data

Saint-Gaudens, Augustus, 1848-1907.
 The reminiscences of Augustus Saint-Gaudens.

 (The Art experience in late nineteenth-century
America)
 Reprint of the ed. published by the Century Co.,
New York, with new introd.
 "Chronology of the work of Augustus Saint-
Gaudens": p.
 Includes index.
 1. Saint-Gaudens, Augustus, 1848-1907. 2. Sculptors
--United States--Biography. I. Saint-Gaudens, Homer,
1880- II. Series.
NB237.S2A2 1976 730'.92'4 [B] 75-28890
ISBN 0-8240-2247-5

AUGUSTUS SAINT-GAUDENS, BY KENYON COX

THE REMINISCENCES OF
AUGUSTUS SAINT-GAUDENS

EDITED AND AMPLIFIED BY
HOMER SAINT-GAUDENS

VOLUME TWO

PUBLISHED BY THE CENTURY CO.
NEW YORK ✷ ✷ ✷ ✷ ✷ MCMXIII

CONTENTS

CONTENTS

VI

CONTENTS

LIST OF ILLUSTRATIONS

VOLUME II

LIST OF ILLUSTRATIONS

LIST OF ILLUSTRATIONS

The Reminiscences *of* Augustus Saint-Gaudens

Volume II.

I

THE TEACHER

1888-1897

Teaching in the Art Students' League—Affection of Master and Students—General Trend of Instruction—Detailed Advice—Instruction of Mature Assistants—Letters of Criticisms—Competitions—Study Abroad.

SAINT-GAUDENS' text having led him through half his stay in New York, offers me a fitting place to enlarge on his chief professional interest not definitely connected with his own work, his teaching. This interest developed as the natural result not only of his high reverence for the seriousness of the art of sculpture, but also because of a strongly reciprocated affection for youth. The French masters, such as Colin or Gérôme, often charged a round sum for a criticism, but if Saint-Gaudens felt certain that a pupil was serious in his efforts, he would go any distance to give advice to that pupil. He would go, busy or sick. He would go even when he knew that the zest of his subsequent morning's or afternoon's work would be impaired or demolished by the reaction of genuine regret over his pupil's lack of ability. Moreover, with the same spirit, toward the close of a competition in his class, to which he was supposed to come only twice a week, he would often appear every afternoon and Sundays as well; while, whenever he believed he had discovered some new idea about his work, he could not be happy until he had explained it to those he taught. For instance, after he had modeled upon the Sherman cloak about two months, he suddenly caught the composition he desired. He never rested till he had finished. But on the moment of its completion he hurried uptown to his class to tell them that "When an idea

3

comes you must work quickly and refuse to leave it until you get what you desire."

In a like manner, for their part, too, his pupils offered him unwavering affection and loyalty, though it is amusing to remember that in one another's presence both teacher and students were invariably nervous. I am told that the latter would become panic-stricken the moment they caught sight of Saint-Gaudens' rough homespun suit; in a jiffy sponges, lathes, and quick ways of working, the "concert tools," went under the table, and the special hook for his hat, his clean towel, plumbline, and fresh clay were as instantly prepared. While my father, on his side, frequently spoke of the difficulty caused him by his self-conscious desire to maintain his dignity. He used to say that whenever he criticized it always brought about an itching of his right shin which continued until the desire to stand upon his right foot and scratch his shin with his left heel was too great to be resisted. Unfortunately, he writes of all this very briefly. He says:—

An interesting side of my occupations at this time, which I have not yet touched on, lay in my teaching at the Art Students' League. It was of the greatest interest to me to watch the growth and development of talent among my pupils, the majority of whom were women. I noticed what others have discovered before me, that unquestionably women learn more rapidly than men, but that subsequently men gain in strength and proceed, whereas women remain, making less progress. Men always seem to compose better than women, and are more creative. Women can more easily copy what is before them.

It is also a proven and amazing fact to me that every pupil who is studying a model posed for the nude will

4

show a marked tendency to bias his drawings in the direction of his own physical—I might almost say mental—peculiarities. That is, assuming the model to be a well-proportioned man, the long, thin pupil will more likely make a drawing long and thin than the short and stout pupil, and *vice versa*. A pupil with stubby legs will draw his man short-legged, while the long-armed, the big-headed, the lame, in fact all personal traits, can almost invariably be detected in the work. Of course as the student acquires power this is more or less overcome, but it holds to a greater or less degree in the productions of even the highest men. It is seen also to a certain extent in the likings for other men's work. I have in mind a sculptor of great effeminacy whose men in all his drawings have an effeminate quality, he himself liking in a picture anything with that note. This characteristic obtains also in criticism. If the teacher is long-legged, he is likely to find the legs of his pupil's work too short, and insist that they be made longer, and so on in bewildering diversity.

I had taught, of course, long before I began at the League. Indeed I had started to give lessons back in the days of the German Savings Bank Building. But the first occasion where I felt my efforts well repaid was close to this later time. For about then, during the superintendence of the wood-cutting in the Vanderbilt house, which, after a while, became a terrible bore, I had noticed that one of my carvers reproduced models with an artistic felicity so markedly superior to any of the others that I had asked him to come and help me in my

studio. This was Philip Martiny, and the principal assistance he gave me, during his stay of about a year or so, was on the figure of the Puritan.

Of all my pupils, however, none has approached in importance a lad sent me by some stone-cutter as a studio boy whom he thought would answer my purpose. This was Frederick William MacMonnies. Since I was always busy and still taking myself very seriously, though by then old enough to know better, I gave scant attention to the youth. I did notice, however, that he was pale, delicate, and attractive looking, and one day I found a pronounced artistic atmosphere in some little terra-cotta sketches of animals which he brought to me. From that moment the charm of his work began to assert itself, until it became evident that I had a young man who was to make his mark.

He remained with me five years before he went to Paris. But he returned again when subsequently I asked him to come back and help me for a year or less on the fountain which I was commissioned to do at the same time as the "Lincoln." I was much behind in my work and, since I needed somebody who could aid me with skill and rapidity, I could think of no one better. He modeled the boys that are in that fountain, and, though he created them under my direction, whatever charm there may be in them is entirely due to his remarkable artistic ability, and whatever there is without charm can be laid at my door. He went to Europe immediately after that, and I did not see him again until the Chicago Exposition.

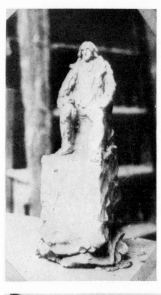
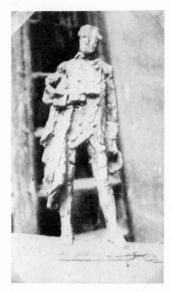

FOUR SKETCHES FOR "THE PURITAN"

Before I leave this subject of my assistants, however, I must tell of another of a different character from Martiny and MacMonnies. I was constantly being applied to by young men who wished to enter my studio and study with and under me, though I as regularly stated that I took no pupils and needed but few assistants. Nevertheless, one Germanic-looking, bespectacled, energetic-headed young man, by his persistence at last succeeded in making me employ him. This youth, who has since become an artist of talent, soon controlled the studio. I was afraid to speak to him, afraid to discharge him, and approached him in terror and trembling when I had anything to ask. I was hypnotized, and he so preyed on my nerves that one day I told the stable boy, whose work it was to bring the horse for the "Shaw" from the Riding Club, a young, red-headed, soft-hearted Irishman, wholly drunk half the time and half-drunk all the time, that I would give him twenty-five dollars if some day before I arrived in the morning, he would "smash" our mutual boss.

He agreed; but, alas, he was as weak as I, and the domination of the assistant continued until one morning, in a burst of fury, I discharged him with oaths, curses, and objurgations. To my surprise, he replied faintly and humbly, "I had not the faintest idea I was disagreeable, Mr. Saint-Gaudens."

Then I apologized, though the fury left me force enough to tell him it would be better for him if he started in fresh fields and pastures new. We are now great friends.

Of course this mention by my father of his assistants is more brief than he would have made it had he been given opportunity to complete his manuscript or to revise what he had written; since, beside those of whom he has spoken, many of the best sculptors in the land passed through his studio, men of the caliber of Mr. Herbert Adams. For example, another artist of talent who played an amusing rôle on this scene at almost the same time as MacMonnies was Mr. Charles Dana Gibson, who worked for my father when only a boy of twelve or fourteen.

The meeting of the two came about through the youngster's developing a knack for cutting out striking paper silhouettes, which caused one of his relatives to conclude that Saint-Gaudens must decide upon the boy's future career. This interview she arranged by asking the architect, Mr. George B. Post, who was then employing my father, to take her young man to the sculptor. Accordingly Gibson, not knowing what was really happening, but feeling very much in the way, was haled by Mr. Post to the Thirty-sixth Street Studio, where the architect and sculptor had a hurried and confused conversation, which left both master and pupil at the mercy of a complete misunderstanding.

As has been explained, my father already had his studio full of assistants. So now, believing that the boy had been sent to him to be given work, rather than to be artistically advised, he appeared far from good-tempered, as he drew some of the lad's clippings from an envelope to look them over.

"Did you do these?" Saint-Gaudens asked.

"Yes," breathed the uncomfortable and bewildered youngster, still gazing in terror at the elder man's unsympathetic expression and exceedingly long nose.

A big model named Van Oertzen, who had been posing for the "Puritan," stood near by. My father evidently thought that Gibson had done his work from life, which was another mistake, so he handed the boy paper and scissors and pointed to the German.

"Let's see you copy him."

That was a knotty proposition for the young man who had never reproduced a living figure before and whose eyes moreover were hypnotized by the striped stockings worn by the model. However, bravely making the attempt while my father watched him askance, he finally received for a verdict a gruff, "All right! Go to work!"

Consequently Gibson went to work. But all the time, believing himself not wanted, he continued to work only in an aimless fashion, until one day, about three weeks later, my father sent him to a photographer on Forty-second Street, whence he was to fetch some vaguely-understood object. At the photographer's, the boy received a bit of tissue paper, about four inches square, on which were drawn a few lines. Whereupon he strolled back down Broadway, staring about him at the novelty of the city and in his abstraction rolling the paper first in one direction, then in another, until finally it became a neat, perspiration-soaked ball.

My father met him at the studio door.

"Did you go to the photographer?" he asked.

"Yes, sir."

"Well, where is the drawing?"

"Oh!" Gibson remembered himself and hurriedly dropped the dirty little wad into my father's hand.

Then Gibson left.

Such young men, good, bad, and indifferent, my father kept by him through all his progress. In the case of his relief work they never became more than tools, as he felt confident of his mastery of that form of art, and desired no outside opinions on the results. But for his statues in the round they proved of unusual assistance, because, as he used to say in fun, "It is a great thing to have a lot of people developing things which you can destroy after a while if you want to." The remark contained much truth; for beneath it lay my father's

constant desire to have work carried forward while he was out of the room, in order that he might see it with a clear vision upon his return. Moreover, with these monuments and busts he was always anxious to receive criticisms from many persons, since, while frequently he would not take the suggestions, quite as frequently he would find that the personal truth expressed in a genuine reply, directly or indirectly contained a valuable idea.

On the personal side, also, these assistants, as in the case of the young men and women at the League, seemed unanimously happy with my father, their only complaint being that, quite in contrast with his attitude toward students in the schools, he was so fearful lest he hurt their feelings that they often found it difficult to learn just what he desired. No doubt this condition was emphasized by the fact that his own delicate mental balance made him supremely sensitive to the state of mind of others, especially since these assistants were much more to him than so many transitory workers. I have mentioned his desire to help with his criticism the students he encountered at the League or elsewhere. Such service he rendered with even greater sympathy when the task in question was done by some junior who had been trained under his own eye, whom he could follow with solicitude and pride through the formative period of his art. And when the young man was launched upon a career of his own, my father's delight in his successes was only equaled by an eagerness to give him all possible aid. If, for example, Saint-Gaudens' own studio was too overwhelmed with work for him to accept a new commission himself, and the monument was one which he felt could be intrusted to a former pupil, it made him happy to do what he could to help that pupil to receive the commission. Nothing in the world would persuade him to recommend a sculptor in whose abilities he did not thoroughly believe. But once that question was satisfactorily settled, he would put his heart into smoothing the young man's

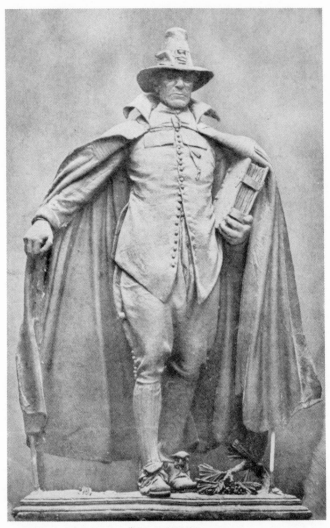

"THE PURITAN"

The Chapin Statue, Springfield, Massachusetts

path. There was something of the paternal in Saint-Gaudens'
attitude. It implied a very warm and even tender tie. How
real and how sensitive this was he showed much later, in the
course of his stay in Paris between 1897 and 1900, when he met
MacMonnies and realized, with a personal sense of sadness, that
the youth of the earlier days in the Thirty-sixth Street studio
had, quite naturally, "grown up," and was no longer the same
protégé whom he had once known and cared for. But becom-
ing philosophical as the years passed, he clear-sightedly, though
plaintively, recognized that master and disciple must some-
times draw apart. In a long letter to one of his friends at
home he breaks off to say:

This last page is for a very delicate subject, Mac-
Monnies. I will speak of our relations philosophically,
although it is difficult, after the profound intimacy and
affection I had for him at one time. It took me several
months to realize it, but finally, with deep bitterness
and sorrow, I discovered that the friend I had loved was
as dead as Bion to me; the gentle, tender bird I had
caressed out of its egg had turned to a proud eagle, with
(most naturally) a world of his own, a life of his own,
and likes and dislikes of his own. The angel boy had
grown into the virile man with a distinct personality;
my boy had gone forever. And when I realized it, the
gloom of Paris was unbearable,—that, and the absence
of Bion. I do not speak in bitterness but in sorrow
only. I find that I have met in Mac another man,
whose acquaintance I am now making,—no doubt a
fine fellow and a devoted friend when I get to know him
again. It is all quite natural, and it was unnatural in

me to expect that he was not subject to the same development as the rest of us.

Here then, at the end of my effort to establish the nature of the relations between master and pupil, I will try to explain in some measure the details of my father's professional and personal advice. First in this effort let me give the one attempt he made to define the goal towards which he felt both he and those around him were striving. I take it from a note I came upon in his scrap-book after his death:

I thought that art seemed to be the concentration of the *experience* and *sensations* of life in painting, literature, sculpture, and particularly acting, which accounts for the desire in artists to have realism. However, there is still the feeling of the lack of something in the simple representation of some indifferent action. The imagination must be able to bring up the scenes, incidents, that impress us in life, condense them, and the truer they are to nature the better. The imagination may condemn that which has impressed us beautifully as well as the strong or characteristic or ugly.

With this artistic creed, he believed a facile technique to be most needed to express these experiences and sensations, a technique which could only be gained by training and drudgery. Therefore he always remained an advocate of that long schooling which he insisted would help the mediocre and never hurt the talented.

In carrying out such a course his two chief doctrines were, "Beware of discouraging a pupil. You never can tell how that pupil will develop, consequently take as great pains to mention the good as the bad," and, "Refrain from ridicule, unless ridi-

cule is the .only way to get your remarks home." Now and then, of course, he was forced into radical steps. They tell me that once, when he failed to obtain even a gleam of intelligence from a certain student, he picked up a tool and slashed the whole work to pieces. Yet even with that he modified the bitterness of the act by saying to the victim, "This seems to be the only way to treat it. But, cheer up, it 's not your Waterloo!"

Probably this incident and others like it were largely due to his intense earnestness in his work and, by consequence, to his vigorous demands upon his classes. For though with the attentive he was all attention and rewarded the pupil by the severe task of remembering his name, he had no toleration for the badly-grounded, the frivolous or noisy, the man with the excuse, or the man skeptical of his teacher's ability to speak with authority. In the first group the fashionable girl and the old lady with the white curls, who set up her daub from her seat in a rocking-chair, were disposed of with the remark that the League was no nursery. To the frivolous he insisted, "You can make fun of anything, but a class-room is no place for that species of recreation." Accordingly, when once a tool, which had been thrown against the ceiling with a lump of clay some days before, happened to fall while he was near, he walked out without a word and refused to return until an apology was sent him. His distaste for excuses was the terror of the monitors. Frequently, after he had posed the model, the man would hold his attitude while my father was in the room, but the minute he left would relax and stay relaxed until the end of the week. Then on Saint-Gaudens' reappearance the model would resume his proper attitude and the class would receive an unfavorable criticism without the possibility of a defense. In the last division, that of the skeptics, came those like the man who was studying to be the "lightning modeler" in a vaudeville circuit, and was possessed with a gift of argumentative gab. The man's work was abominable. My father did his

best to correct it. The man talked. My father laid down the tool and waited respectfully until the man was through. Then he walked away. The man never got another criticism.

In this class-room, therefore, my father had scant patience with Rodin-like tendencies, with "cleverness," or superficial surface modeling. Rather he stood as the apostle of academic work having "construction" as the password. To his pupils seriously applying themselves he gently urged the influence of the Greeks before that of Michelangelo and his school. More specifically, such a letter as this, sent to Mr. John W. Beatty on July 10, 1905, names the men he set before his followers:—

. . . Phidias — Praxiteles — Michelangelo — Donatello—Luca della Robbia—Jean Goujon—Houdon—Rude—David d'Angers—Paul Dubois, these are the names that occur to me at once. Of course, if we knew the names of the sculptors of the portal at Chartres or "le beau Christ d'Amiens," they would replace two of the more modern Frenchmen . . .

The most satisfactory beginning of sculpture, to my father's mind, lay in the ability to draw in charcoal. So back his would-be pupils often went to the "antique" or other lower classes with the advice that, for the rest of the season, they draw very slowly and with great consideration in the manner of Holbein or Ingres, putting down but one line at a time and not changing it thereafter. Another, though less important, foundation which he insisted upon was an understanding of anatomy, since he reasoned that the knowledge of what was possible in the human figure would prove of immense aid in reproducing just what was before one. "Every man who to-day discourages anatomy, studied it with care in his youth. Now he simply does not appreciate what he learned," he would say.

18

AUGUSTUS SAINT-GAUDENS

Then when the prepared student came to my father's hands, he was told to work as naïvely and as primitively as possible, to leave no tool marks showing, to make his surfaces seem as if they had grown there, to develop technique and then to hide it. He assured them that they need never fear ruining their imagination or their sense of beauty by their attention to the fundamentals while in class. Esthetic qualities, if ever in them, would remain, though they could not be acquired at any price if not inherent. They were in the school to learn to handle their tools and to copy the model accurately and absolutely, until the ability to construct became automatic. They should be right, even if they had to be ugly, and to that end they should take all the measurements they wished of a model, almost pointing the model down to their statue if they desired. Occasionally an inspired youth would remark that he never measured his work, upon which my father would promptly rage, for he said: "You will have trouble enough in producing good art as it is without scorning such mechanical means as you can take. Beside, continuous measuring will train your eye to see accurately. Nobody can give the length of a foot off-hand as well as a carpenter."

Yet this need of infinite pains in all things that I have mentioned was my father's chief advice, which he managed to mingle successfully with a power to urge his pupils ahead. For in some strange fashion he could instil into them the feeling that work which might do credit to a pupil one month should not be accepted the next, yet at the same time arouse in them the capability of endless patience toward thoughtful effort. To him a good thing was no better for being done quickly. Change after change should be made if needed to produce what was best.

"Conceive an idea," he would say. "Then stick to it. Those who hang on are the only ones who amount to anything."

Now to speak more specifically of his detailed criticism

among his pupils let me begin with the study from the nude, the branch which was to him of chief importance. He insisted, first of all, that the figure should have its center of gravity properly placed, that his pupils should at once use the plumb-line. Here, for instance, is a specimen of his attitude towards a violation of this rule, even when broken by so strong an artist as MacMonnies in so successful a statue as the Nathan Hale. My father writes Mrs. Van Rensselaer:

. . . Bion refers to my having lifted it up a little in front when it was set on its pedestal here the other day. It fell forward. But MacMonnies in company with all the other Gauls, including the sober Bion, must have a change, and a figure that is standing simply and naturally on its legs according to the laws of gravitation is everyday and commonplace. One that does n't stand on its legs, but stands on an ear or has a foot growing out of its biceps, or behind its head, or out of its stomach, or one that has an arm which disappears mysteriously, "Oh! Oh! Mon Dieu! Quel audace! Quel génie!" Therefore Mac is crazy to get his "Hale" tumbling forward on its nose again.

Immediately after the use of the plumb-line, my father would attack the proportions with an astonishingly just eye. With a moment's inspection, he could say: "It 's too short here, or too long there." And if the pupil proved that the measurement was correct, his answer would be: "Then it 's wrong somewhere else," and invariably he was right.

From this Saint-Gaudens went on to mention his details, taking pains never to work on the studies except to add reminding balls of clay and lines, while by his words he did his utmost to make the pupils see for themselves, often saying:

AUGUSTUS SAINT-GAUDENS

"When I tell you a thing is wrong I know it is. But don't change it unless you feel the error on your own account."

As I have explained, in the class-room Saint-Gaudens refused to have these figures "treated," that is, modified from the lines of nature to suit the requirements of their surroundings. On the other hand he never expected that even the best of pupils could reproduce the model absolutely. Consequently there were certain varieties of error that brought down from him especial damnation. Studies fatter than the model, or figures that "looked like tadpoles," came first in the category, together with cross-eyes, stuck-out chins, fat rumps, short legs and shins, thin wrists and ankles, and any leaning toward turned-out toes which so frequently offended him in the attitudes of modern men. Many times he expressed his admiration of the way Indians walked with their toes seemingly turned in. And often he mentioned certain actors also who had grasped the strength of this attitude, and who had gained in apparent virility by turning in their feet.

Following work from the nude came my father's interest in compositions, upon which he constantly insisted enough importance was never laid. Therefore in this direction he often asked his classes to submit subjects. Of these, Biblical or mythological motives specially pleased him, while disassociated suggestions for titles drove him to the attitude set forth in this bit of writing: "I think the idea you wished to express a thoughtful and admirable one, but one that belongs to an order that can hardly be expressed in a group. It is too abstract."

In such compositions he insisted on the strength of concave outside lines, and on the merit of vertical lines. Simple lines running up and down he believed had much to do with the sense of tallness or beauty, while cut-up objects invariably looked short. Meeting lines should always come together with an acute angle which suggested movement rather than with a right angle which checked the idea of motion. The radiation of lines he also regarded as one of the necessities for success in

sculpture. While, contrary to the practice of many, he invariably commended the repetition of a successful accent as in a fold of cloth, using it often himself, perhaps most noticeably in the "Shaw," the "Puritan," the Rock Creek figure and the "Sherman."

After composition, my father regarded the treatment of drapery and its construction as of chief importance, the two subjects being closely allied. Here in especial he attempted to lead his pupils along the narrow path that must be trod between work that appears labored, or spectacular, or showy, and work that looks as if it were "good enough." He wished results to seem "soft," and "generous," and "easy." Texture, he always insisted, should represent the light on the thing as well as the thing itself. Furthermore, he demanded that it be "fat and juicy," though virile, with the supple lines of the folds blurred or "flued" so that they should not appear too stiff or "snappy," like tin or paper, nor too "mushy," like lead or cast iron. To this end two of his characteristic jocose comments were: "That reminds me of a box of soap," or, "All yours needs is a little perfumery and lace."

In reaching the right results in composition and the modeling of drapery, he advocated no special means. For himself, he would conceive his general scheme through countless models, set up a careful nude, drape a manikin, make serious studies with cloth, and then turning to the clay figure, quickly develop it in quite another direction from the model. He often acquired good drapery by accidental suggestions. A comparatively unconscious touch here or there would give into a more satisfactory fold or a more beautiful composition. So, in this sort of work, he was forever making impromptu and experimental moves.

The two other branches of sculpture, the modeling of busts and reliefs, naturally leads the account of my father's teaching from the class-room to the studio. For he felt that those subjects were not to be treated in such a place as the League,

saying in regard to the only bust ever shown him there, "Don't work on heads. The figure is the important thing." To those whom he took under his own roof, however, his attitude became quite different, and with them he went into these matters most carefully.

Regarding busts his chief advice was that the surface should not be given especial attention till at the last. Rather the outline should be watched and drawn from all possible points, the sculptor beginning in the rear and working towards the front. This way of modeling he thought preferable, since the first simple measurements of the mass and area make the start easy, and lay a good foundation for the details and subtleties to come.

In relief modeling, especially during his final years, he was at his greatest pains to make his criticisms distinct. It is true that he felt that he had mastered this phase of his art more than any other. Nevertheless, here he found himself unusually at a loss for words with which to describe his understanding, as the development of a medallion was to him so purely a matter of feeling. The chief maxim upon which he insisted was that the perfect relief texture, lettering, molding, background, and all, should interest by its color and light from edge to edge. For instance, to the pupil who made the background flat, he would say, "Remember that your background is your atmosphere, and part of the composition, and that the composition should extend from edge to edge of the frame." While on another occasion he wrote, "The outline of the face is much too sharp, and cut against the ground as if it were something shaved off and pasted against the back."

In these ways he produced his special treatment of light and texture. The dark spot created about the profile head, he felt could be dealt with by anybody. But the more distant bits of drapery would often look amateurish and needed, to give them strength, a fearless hand to dig into the anatomy,

and to give them color, most delicate modeling. Skill of this kind he had developed during his apprenticeship in cameo-cutting. For at that early time he had not only learned the value of producing firmness by his lines, avoiding the "drop of wax" feeling already mentioned, but had mastered also the knack of realizing instinctively which parts in the surface to raise and which to lower; because, from the way the modeled planes catch the light, their position must needs be relatively different from those of a figure in the round. Moreover, this attention to the planes, he insisted, had great effect upon the apparent drawing, a sculptor often fussing endlessly over his lines, when really only a little of the surface needed to be taken off or added on.

Other of my father's familiar remarks were that a circular bas-relief was a poor form, as it looked too lazy in conception —this despite the fact that he produced one in the original Stevenson—that a full face in a medallion was too much for the gods—this though he modeled a full face on the twenty dollar gold-piece—and that a bas-relief should never contain a landscape, or several planes in perspective. Ghiberti's doors in Florence, the classic violation of this latter theory, my father thought successful considering the circumstances, yet they never really appealed to him. When he did deal with furniture, as in the medallion of Mr. William Dean Howells and his daughter, he shifted his point of view up and down in order to represent only the edges of the table and of the chairs, all, roughly speaking, on one plane. Near the end of his life, it is true, he introduced a few trees and open-air scenes, but he hesitated greatly in these problems, and carried them out under fairly simple conditions. I fancy he himself often wondered why he so strayed from his principles. Perhaps it was because, like all artists, he absorbed and reproduced his surroundings, which then were of the country.

Let me now generalize even further concerning my father's ideas at large, which he constantly explained to his assistants.

AUGUSTUS SAINT-GAUDENS

Perhaps the most amusing of these he expressed by two lines which he invariably chalked on the studio wall:

WHAT IS ART?

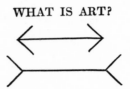

"Which horizontal line is the longer?" he would ask, and upon being told, "The lower one," he would smile and answer that they were both of the same length, so furnishing an excellent illustration that art is not what a thing actually is, but what it appears to be.

I remember also two expressions which were always at his tongue's end. Work went "Bang, bang, bang!" with virility, or was "Fragrant like a rose," which metaphor of odor referred in sculpture, as in literature, to a quality he laid great stress on, that of charm.

"Charm may lie in character, or in line, or in many things. But every man must have it to be successful," he would say. "It is hard to know what gives it, perhaps the proper choice of things to accentuate or to suppress. Anything that is final or with no more to think about is uninteresting."

Without doubt this mystic side of objects never failed to interest him. I recall the first time we visited the Broadway Theater in New York, where an old curtain bore a scene of a shepherd driving his flock up from a river. The background of dark woods and fragrant moonlight on the water had an indescribable fascination for him, one that he remarked on each and every occasion when we sat before it. Towards such an end he admitted of many accessories in sculpture provided they were more or less concealed. He considered them of great value when they bore upon the whole subject, though of none in themselves. Indeed he constantly raged against what the French call a *joli morceau*, distracting and detracting from the

whole. He desired rather details so modeled that they should add interest to a small figure, and yet upon enlargement should, by a strange law of sculpture, assume their subordinate place, giving color without confusion in the bigger masses.

Finally, in the general view, his two pet phrases were: "After all, you can model anything. It all depends on the way it is done." And: "You cannot reproduce things absolutely. So since you must err, err only on the side of beauty."

Such is a potpourri of my own knowledge of my father's efforts to teach and of the details which his pupils and assistants here and there have told me about him. Yet better than all this is what he says himself. In his deliberate reminiscences he wrote little in this vein. But luckily he expressed himself much more amply, not only in his spoken instructions but in letters sent from time to time to young artists. From these letters I have drawn the most pertinent.

The first extracts are from what he wrote to a young sculptor, Mr. Charles Keck, long in his studio and at that time studying in the Roman Academy:

The bas-relief is interesting, and has a charm of arrangement and sentiment in certain directions. The idea is excellent. The wrong thing is that the woman with the cup who, in a gentle position, all willingly tempts the man while he is struggling in action, is an impossibility that troubles the spectator. I repeat, the grouping is very good indeed. The medallion is attractive, although it has no personal distinctive attraction of your own. It is like a great many charming medallions by other fellows. . . .

. . . Your "David" is very much better in every respect than the things I have spoken of before. The modeling is very much better, freer, and firmer. My

only quarrel with it would be that it is a little "Cock-a-doodle-doo" in character, a little what I call "Frenchy," although that is not a fair term to employ when it is considered that the best modern sculpture is French—sculpture that we take our hats off to, and that "Frenchy" is the last word to apply to the masterpieces of French art.

The next two are from letters to Miss Helen Mears, another pupil whom my father held in high esteem:

. . . The kneeling boy is as yet not very successful. It seems to me something better can be found, and I've roughly indicated a possibility of improving the disposition of the legs, and thereby the general character of that figure, which is the only thing that has an element of weakness in it. It seems to me the gesture would be nobler by bringing his leg lower down. But the thing to do is to make several sketches in different positions, and select the best.

I think I should have the architectural parts put up in wood or plaster, made light so that they could be easily moved up or down or sideways as changes might suggest themselves. I do not at all agree with your friend's suggestion about the arrangement of the columns. You decide your disposition of them and let the architect arrange the rest. . . .

And later:

. . . I think French's advice excellent, except that I should make the half-size study exactly as though it

were the finished thing. Leave as little as possible to do in the large, have it enlarged mechanically, and then you can go over it with a freshness that you could not obtain otherwise. I should use models in the small exactly as though you were not going to do the large. Don't leave any serious study to struggle with in the big; of course you must do the whole ensemble together in the small. Putting them up separately can only be done in the big from what is carefully prepared in the small.

You couldn't have had a better man than Mr. Bacon, and I should follow what he says closely. The sculpture is to be the main thing, as he says, and I like his idea of the low-relief pilaster. If it looks weak when modeled it is an easy thing to increase the weight of the pilaster.

It's hard to tell what relief to make the life-size figures of your fountain. I should determine the relief in the small. I think they might look well in any relief, but I think a middling-relief would be best, say double the relief of the Parthenon cavalcade. . . .

I don't think I would put a shawl on Miss Willard unless she wore one. If she did, I should do it by all means, or something of the kind thrown over her shoulder, as a wrap would be good and justifiable. Women frequently do that to keep off the chill in a lecture room or a public hall. You know I don't despise the making of modern dress. Something can be done I'm sure.

Lastly, here are some characteristic letters which my father wrote to me during the winter of 1898. Though the matter

contains little of value, the intimate tone and the gentle spirit of banter closely approximates his spoken criticisms to those for whom he cared. They refer to some attempts of mine at drawing the pretty daughter of my boarding-house keeper in Dresden. Of my first little work, he wrote:

. . . The head is very well drawn. It is well constructed and whatever crooked things there are that show are no more than often appear in nature. If it is from somebody, or from memory, the model is evidently very handsome. The arrangement of the hair has also a great deal of character. The only thing seriously out is the nose which is too small across the nostrils—much too small. The left eye (her left eye) is a little too big in drawing (a very slight difference in reality makes a big difference in effect), and as the head is not very much turned, you should not have it so near the nose. On the side seeming nearer, the nose ought to be a little farther away from the eye, leaving the other side where it is. Also the side nearest the nose should show, by its shape, that it is a little more of a three-quarter view, as you show in her right eye.

You'll say that I make you sick, but when you have a son you can make him sick in turn by telling him what I'm telling you.

Again, upon receiving a second drawing, this time of myself:

I have your letter and the drawing. The drawing has very good qualities in it and is quite excellent considering the difuculti—duficuly—deffee . . . Thu!

31

. . . that you underwent and your inexperience in artistic production. It shows that you see very justly. It is *hard* in modeling though; for instance, where the dark red of the lips shows against the face the line is too sharp. In nature you will find that there is more blending of the outline of the lips into the face. It is softer. Then again it would be better if the face were shown against the background simply by the contrast of the dark ground against the light of the face and with no outline or line all round the edge of the face as you have it. The only thing out in the drawing is the ear. I've forgotten how your ear is constructed, but if it's made like that you have the only ear so placed in the world. You have tipped the top forward, instead of backward as it exists with everybody but freaks. If your ear is so constructed you need n't worry about studying to earn your living. You can earn that in a museum. Sometimes ears are straight up, but never forward.

Now another thing. "Punctuality is the courtesy of Princes," or something to that effect. And another swell ratatatata thing is always to answer letters and at once, no matter how briefly. So be in good form and reply (as briefly as you wish). Not to reply is very impolite.

Don't drink beer and don't call me papa. Call me daddy, governor, boss, or father, or anything. But don't call me papa or I'll cry.

Affectionately,

Your Daddy.

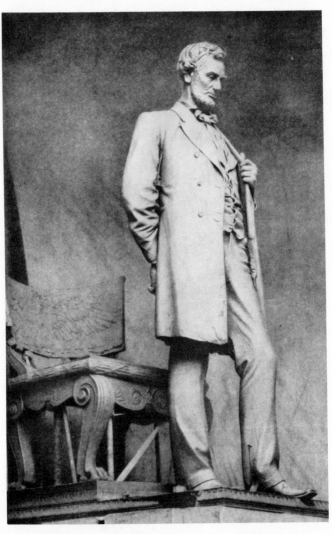

THE MODEL OF THE STATUE OF ABRAHAM LINCOLN NOW IN
LINCOLN PARK, CHICAGO

AUGUSTUS SAINT-GAUDENS

Aside from his actual criticism, in two other directions, also, Saint-Gaudens interested himself in the needs and hopes of his pupils and followers; he was constant and untiring in the advice he gave upon the conduct of competitions and upon the comparative merit of study at home and abroad.

As to the first of the two vexed questions he used to remark to his pupils, "Don't waste time on competitions. If you do a good piece of work the knowledge of it will spread through the country like oil on water. Competitions are unnecessary and many good men cannot produce satisfactory designs under such conditions, whereas bad men often make effective sketches."

Nevertheless, since competitions did exist, my father endeavored to restrict and improve them in every possible way. This letter to me written on May 2, 1906, gives a good idea of his desires:

. . . With regard to the competitions, the "pint" is this: The Von Steuben will certainly show that there are six or seven men of distinguished ability in this country who could do good monuments. It is a shame that they should not be employed, when all over the land monuments are being erected by contractors who produce deadly work, whereas, if they had competitions, based on the line of the Detroit one, they would be sure to get things that would be dignified and honorable, provided always a distinct understanding that the findings of the committee are abided by and not gone back on. That has been the cause of terrible distress and fear among the sculptors who enter competitions.

A great point could be made to show the outrageousness of this by explaining what was done with the Sherman monument in Washington. There a lot of us took

the trip down to judge the thing and gave it to Paul Bartlett. Ward, Post, Warner, French, and I went to a great deal of trouble, and, as I remember it, we were paid nothing. We did it out of patriotic motives. We were simply thrown over by the Lay Committee, by the committee of Generals and Officers, and the thing was given to the man we had ranked tenth. The result that you see there is not so bad as it would have been if X—— had not died. He was a dreadful sculptor, and the case is an object lesson, the memory of which, with two or three others of a similar character, make the decent sculptors all chary of entering competitions. . . .

. . . Of course in this I am talking of the younger sculptors who are unknown. The principal men, once they get their reputation established, obtain their work directly. But there are other artists, and they are the ones to be encouraged, and thought about, and worked for.

Another letter describes this attitude even more fully. In it he speaks of a "limited competition." This means a competition wherein a limited number of previously selected sculptors are asked to compete, with the assurance that the commission will be given to one of their number. The letter was written to Mr. Charles Moore on December 1, 1905:

. . . Thank you for the Macomb Statue competition program. I shall, as you suggest, commend it to those who may consult me. You are to be thanked for your interest in these works. I judge from what you say that you may have some authority in the matter.

If so, will you excuse me for suggesting that it would be well to have a second and third prize, say the first, three hundred dollars; second, two hundred dollars; and third, one hundred dollars. Should one be selected for execution, only the two latter prizes would be given. This encourages a better class of competitors. But the programs are out now, and it is too late, I suppose, to do anything. In any event, you will pardon this criticism, but I have, as you are aware, the good execution of public monuments very much at heart, and I know the field and conditions of the sculptors pretty well. Of course, if it could have been a limited competition, it would have been better. However, if the first fails, that could be resorted to.

As to the matter of study abroad, my father felt that for the advanced student, the man who has shown that he will undoubtedly make a thorough life work of his art, a firm understanding of what had been accomplished in Europe was invaluable. Therefore he devoted himself for many years to procuring this training for such through the Rinehart scholarship which later was merged into the Roman Academy, an institution in whose welfare my father was deeply concerned. But for the student still in the earlier stages of training in the technique of the craft, my father advised otherwise. His position in this case is summed up in three letters, to Mr. Charles Keck, to Miss Winifred Holt, and to Miss Isabel M. Kimball.

To Mr. Keck he wrote, in part, from Paris:

Dear Charlie:
. . . X. has just gone back, but his things at the Salon were not particularly good. I don't think

Y——'s work is very good either, and, on the whole, unless a fellow has stuff in him, coming over here does n't seem to do any good. Though the Salons were very interesting, there were only four or five things that were good, and not more than one or two of a really high order. But work of a high order has always been rare and always will be. There can be but few real artists. There can be lots of excellent workmen, though, and that is better than the amateurishness that results when there has been no good training. I think, as far as that goes, the academical training in New York is as good as in Paris, in some respects better. . . .

To Miss Holt he wrote on September 20, 1900:

Probably your father has written to you of my change of heart after having lived three years in Paris, and that I cannot now advise you to go there, especially without your family.

There are only two schools for sculpture in Paris, where women can study, Julien's and Colarossi's, and it will surprise you to see how weak is the work produced. The professors give scant attention to the pupils, and, if you wish to devote yourself to sculpture, I would advise you to study drawing seriously under Cox, Mowbray, or Brush at the Art Students' League in New York rather than in Paris.

This is my advice. I may be all wrong. No one can tell in advance what might be the result of studying in Paris, or New York, or elsewhere. There are so many conditions that might change one's point of view, and

what I say must be taken on general lines. I don't think any one can predict what another person could or could not do, or how another may be influenced. . . .

To Miss Kimball he wrote on December 17, 1905:

. . . The older I grow, the more and more I am convinced that as thorough and adequate training can be had here as abroad, that the work by the students here is equal to that produced by those in Europe, and that belief in this by the students will help greatly in their education. Of course Europe, with its wealth and glory of art, must be seen and imbibed sooner or later. That goes without saying. But I believe, for the American, the best time for that is after he has had a sound academical foundation here. It is time to realize that the training here is excellent, and that we are constantly adding to the list of men of high achievement whose education has been at home. . . .

II

FELLOW ARTISTS

1888-1897

Theories or the Lack of Them—The Progress of American Art—
American Art Equal to French—French and American Sculptors
—French and American Painters—Architects—Actors.

I HAVE shown Saint-Gaudens' relations with his pupils, his
attitude toward them, his lasting solicitude in their be-
half and in behalf of sculptors generally. In all this,
some notion has been had of Saint-Gaudens' feeling toward
sculpture. More is needed, but not readily supplied, because
my father was a man who spoke most aptly through his fin-
gers. Once, for example, while wishing to defend certain of
his ideas, he said to Martion Brimmer, "I'm a poor hand at
argument, but if I can get my hands in some clay, I can show
you what I mean. It is the doing of a thing so that it looks
well that is the proof of the pudding." Also, in confirmation
of the sculptor's own view of himself, I quote the following
letter to me from one of his later assistants, Mr. James Earl
Fraser:

". . . I feel as though I knew what your father meant,
but I cannot explain it. He never cared to talk art, and he
hated theory.

It seems to me that he realized what he wished without
thought, and decided whether it looked beautiful or not to him,
whereupon his sense of beauty, combined with the truth and
dignity that he put into anything he did, made it a great work
of art. I do not think for him theory amounted to anything.
A man can make theories forever, but when a man finishes
theorizing and begins to work, he forgets every theory that he

ever heard of, and it is his artistic judgment that tells. If it is the right kind, well and good. If it is not, what hope has he, theory or no theory? I believe this was your father's feeling also.

I never have heard Mr. Saint-Gaudens say much on art in general. It was more to the effect that he did not like the look of that fold, or that he would try changing this. He went absolutely by the impression a thing made on him and, to my mind, paid no attention to theory. He did not need any."

On this subject of my father's theories, therefore, or what took with him the place of theories, the subconscious actuating principles of his art, perhaps the most illuminating light is thrown by study of his attitude towards his own tastes, and by observing those about him whom he chiefly admired. His general attitude toward his work cannot, of course, be disposed of in any one place, but is continually and cumulatively indicated by this account of his actions throughout his life. Whatever inference is to be gained from his predilections in modern art, however, is more easily drawn.

In regard to modern art, and especially the art of our land, Saint-Gaudens was an enthusiast. Well he might be, for this art in America had grown with great rapidity, especially about the time of the Columbian Exposition of which my father speaks in the next chapter.

The chief reason for this speedy advance lay in the fact that from the date of the final acceptance of the Society of American Artists by the majority of the painters and sculptors, the warring groups had learned to progress with some degree of amity, since, though during all these years it is true the institution needed a home of its own, nevertheless, despite the lack of a building, the Society had promoted a feeling of good fellowship hitherto sadly lacking.

Under such auspices for the sculptors, a half-dozen men, somewhat more prominent than their fellows, had attained an eminence where at last they formed the most satisfactory com-

parison with their companion artists in other lands. J. Q. A. Ward stood their obvious head. He alone bridged with his mature work the entire period between the Philadelphia Centennial and the Chicago World's Fair, showing through such of his statues as the "Horace Greeley," unveiled in 1890, and the "Henry Ward Beecher," set before the public the following year, that he had attained an ability hitherto unreached to grasp the external and transitory details of the day, and through his art to make them both permanent and noble in bronze. Together with him stood five other strong men, Olin Warner, Daniel Chester French, Frederick William MacMonnies, Herbert Adams, and George Grey Barnard. Warner, besides his smaller commissions, created three bronze portrait statues of Governor Buckingham, General Devens, and William Lloyd Garrison, as well as his "Diana," a figure which showed a modern mastery of the nude and a charm and inspiration unequaled at that time. French, from his ascetic "John Harvard," unveiled in Cambridge, Massachusetts, in 1882, to his "Republic" at the Columbian Exposition, and his "Angel of Death and the Young Sculptor," established himself as a master in his art, escaping from the old drug of classicism on the one side and a lack of dignity in unrestrained realism on the other. MacMonnies, with the poetic refinement of his Nathan Hale, paved the way for his commission for the great fountain for the Chicago Fair, a climax of sculptural expression in this republic. Adams came to the fore in 1887, with his powerful yet delicate bust of Miss Adeline V. Pond. And finally, Barnard joined their ranks through his "Brotherly Love," and his "The Two Natures," compositions powerful and original in expression.

As in the case of the sculptors, so did the painters possess a leader, a man not only markedly their head, but able as well to bridge the past with the present. For John La Farge at last, in the midst of these years, found his especial strength when he turned his powers to painting on glass; because, of all modern

men, he there most successfully mastered the glory of actual light, and, what is more, after a firm study of it, best reproduced it on canvas. It was not until the Columbian Exposition, however, that the display of mural decoration made it clear that, aside from John La Farge, this branch of art had begun to show a recognized standing. Frank D. Millet was the director there, with C. J. Turner his assistant. Under them labored such men as J. Alden Weir, Edwin Howland Blashfield, Walter Shirlaw, Robert Reid, C. S. Reinhart, J. Carroll Beckwith, Edmund Simmons and Kenyon Cox. The remuneration was small, and the results in themselves not extraordinary, but the magazines and newspapers helped the good work to the best of their ability until, at last, mural decoration found itself upon its feet.

To demonstrate what that strength amounted to, it is necessary to step somewhat outside the allotted space of this chapter. Yet nowhere is there a better opportunity to mention the success and the significance in mural work of the erection of the Boston Public Library. In it two opportunities were given to Americans hitherto scarcely thought of in this division of art, Edwin A. Abbey and John Singer Sargent. For themselves they created masterpieces, permeated with the enchantment of glowing color and imagination; yet, more than that, they gave the impetus to mural decorative painting which afforded further opportunity to Blashfield, to Cox, with his firm understanding of Academic Tradition, to Simmons in the Criminal Courts Building, to Blum in Mendelssohn Hall, to Vedder, Thayer and La Farge in the Walker Art Building at Bowdoin College, Maine, and soon after in the Library of Congress.

Close at hand with such artists, scarcely to be divided from them in many cases, were the figure painters. More than any of the others, they labored under irritating restrictions. Salon pictures were virtually unsalable. Modern costumes presented them with no striking dress to reproduce, either with peasantry

or officialdom. Neither classics nor mythology nor religious paintings were wanted. And to cap all, a squeamishness regarding the nude still existed, as was well shown by my father's difficulty over the Columbian Exposition medal. With such limited demands, of course, the figure painters made no traditions. Yet, after all, ideals did exist, and with such ideals they put forth original compositions that instilled vitality into their work. Abbott H. Thayer profoundly touched a new feeling, an American feeling, for the purity and grace of girlhood. George deForest Brush brought out, in his paintings of Mother and Child, the sympathetic beauty of maternity, the grace and appealing charm of adolescence. H. Siddons Mowbray proved himself a sure draughtsman, with a firm understanding of beauty of form and decoration as taught by the Italian Renaissance. Thomas W. Dewing produced refined, subtle, and minute canvases, seeking grace in tone and sentiment through strange half-modern and half-classic costumes. Robert Blum filled his frames with much sparkling life, a little sentiment, a little poetry, and great charm of execution, while Frank D. Millet exhibited in America *genre* pictures of England of the sixteenth and seventeenth centuries, most skilfully planned and developed.

To step further afield, the domain of portraiture was headed by the master already spoken of, John Singer Sargent. Construction in form, mass, and tone, and calm insistence on the proper details which give character and an appearance of spontaneity, caused him, at last, to be able to substitute the true varieties of nature for the old traditional symbols of things. Under his leadership, portrait painters emerged to their national own from out the early vogue of foreign work. Such artists as Cecilia Beaux made felt a true resourcefulness of form and color and composition, a free and easy manner, and a facile power of rendering. Or again, a man like John W. Alexander turned in another direction, an artist with a sure, delicious method quite his own, opalescent in color, and, as

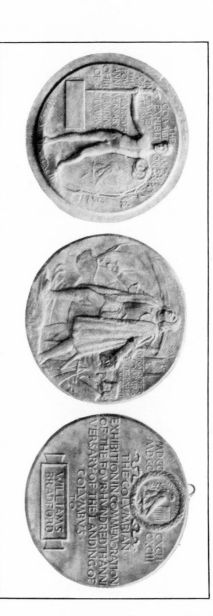

GROUP OF THREE MEDALS DESIGNED FOR THE COLUMBIAN EXPOSITION

years passed, growing in warmth and poetry. All such workers were bound together by one common condition. Their sitters desired portraits, the artists wished pictures, and only then did the result produced entail the respect of both.

Finally, close in company with these artists, though perhaps more national than any of them, our landscape painters forged to the front. Again here was a group proud to count as their leader a man who held for them the same position as was maintained by Ward and La Farge, in this case the veteran Winslow Homer. Following him were many others from whom it is hard to select; George Inness, Jr., Childe Hassam, Willard L. Metcalf, and John Twachtmann. In this division, especially, Europe seemed to have less influence upon our art than in any other. For surely nowhere in Europe exist our crisp dry snows, our blue dazzling skies, or the other details that go to make up a land where, though the inhabitants may have come from another soil, nature itself possesses nothing exotic in its charm.

In company with this advance throughout all other branches of art, then, came that in his especial domain of sculpture; so that not for one moment did my father regard the United States as in any measure behind France in the standard of her monuments. Moreover, such a condition as that which resulted upon his obtaining for Mercié and Falguière a commission to make a statue of General Robert E. Lee, was, unfortunately, far too common. The two Frenchmen evidently had thought the result was going to some out-of-the-way corner of the world, and so had bothered only with a hasty sketch of the monument, which they turned over to their assistants for completion. The result was exceedingly poor, and my father decidedly angry. Consequently, with evidence of good work at home, and with such examples of slipshod, mercenary efforts abroad, his confidence in American artistic ability and integrity steadily increased to the end of his life. Here is an excellent example, contained in a letter he wrote in 1906 to Mr. John La Farge.

The date of this letter is much later than the period now under consideration. Yet I include it, and others like it, at this point for the sake of unity, and because all the copies of his letters written during the time which is now being dealt with were burned in the studio fire. He wrote:

Far from having any adverse criticisms to make on your letter to Mr. Marburg of the Municipal Art Society of Baltimore, I am delighted to have the opportunity to say that I am in hearty accord with all that you express in it. All the more so, because I recently had a letter from Mr. Marburg asking for the names of the principal French decorators. I should be sorry to have that letter appear as an indorsement of the selection of French artists over that of men of this country. Of course, I say this with the greatest respect for the men of France whom I have named, and for whom I have the highest admiration, and also for the French school, toward which I have the deepest gratitude. But we are developing a lot of men here amply capable of executing strong and beautiful things, and I think it wrong not to entrust to them whatever work of importance there is to be done in this country. I have only recently, in the matter of sculpture, given advice in that direction, although I yield to no one in my admiration for the remarkable achievements of so many French sculptors.

It is also appropriate for me to quote here one of the very few speeches Saint-Gaudens ever made. He said:

I know that I am expressing the sentiment of the

majority of my confrères, as well as of the painters and architects, when I add that we feel for France the deepest gratitude for the generous instruction she has extended to us so lavishly in her academies and schools of art.

Her hospitality has been without bounds, and her guidance most enlightening and inspiring under the masters of our day,—Barrias, Dubois, Falguière, Fremiet, Mercié, Rodin, as well as under the masters of her past, Jean Goujon, Germain Pillon, Houdon, David d'Angers, Rude, Barye—a glorious list.

It is a great pleasure to be able to express to the representative of that great nation, what I know so many of my fellow-sculptors would wish expressed. And although we are like the strong youth who feels his strength as he breaks away from his mother's side to make his own path in the world, nevertheless, like him, we honor and cherish our alma mater, and feel for her the deepest love, respect, and gratitude.

Now to speak more specifically of sculptors, whether abroad or at home. Dubois and Gérôme stood, to Saint-Gaudens, preeminent. This letter regarding Dubois, written to Mr. Royal Cortissoz on May 27, 1905, is a characteristic expression:

Dear Cortissoz:

I agree with what you say about Dubois. I agree with both hands and all my heart. He is a swell of the highest achievement, with never an instant's weakening, and he has had more to do with keeping a high standard among those who believe, as you say, in "thor-

ough discipline" than any other man in a century at least.

Of Gérôme I will quote from a letter my father wrote to Mr. Stanford White on December 29, 1904:

I think Gérôme's "Corinthian" simply stunning. I could go on adding adjectives, but they could not express anything more than that I admire it in the highest degree. It should be purchased by the Museum. But like many other treasures, it will be allowed to pass. If I had the power, I should buy it without an instant's hesitation. You know I am a great admirer of Gérôme, and I think this a remarkable example of the singular severity and nobility of his style.

In his esteem, after these men, abroad, came Rodin and Falguière. His enthusiasm for Rodin's early work, such as the "St. John the Baptist Preaching," was revived by the production of the "Age of Brass." But Rodin's later eccentricities puzzled and bothered him. I remember my father saying to me, as we looked at the plaster of Rodin's "Balzac," on exhibition in the Paris Champs de Mars of 1898, that the statue gave him too much the effect of a guttering candle. Falguière, on the other hand, by his more mature and developed work, such as the "St. Vincent de Paul," roused my father's admiration, which is well noted in part of a letter written to me by Mr. William A. Coffin:

"Saint-Gaudens loved and understood painting, and I have heard him more than once praise a painter's work, in the Society of American Artists, for its attention to 'form,' an important thing indeed in painting but unfortunately too much neglected in what might otherwise be a remarkably good picture.

AUGUSTUS SAINT-GAUDENS

"Saint-Gaudens could call a spade a spade, and he was frank either in praise or blame of men, their methods, and their art. It did one's heart good to hear him denounce charlatan sculptors, many of whom crossed his path at one time or another, or speak with no uncertain sound of what he called 'a sissy' in any field of art. He admired strength, but he became enthusiastic over 'strength with elegance,' or 'strength with style.' In 1900, in Paris, he spoke many, many times to me of his admiration for Paul Dubois' equestrian statue of Jeanne d'Arc. One day there, at the exposition, I said I thought I had seen about all of the sculpture, and asked him what he thought the best thing, or one or two or three of the best, in the whole show. He reflected a few minutes and then named two or three works. I have forgotten what they were. Then he exclaimed, 'Henri de la Rochejacquelain—Falguière—a chef d'œuvre, a wonder!' I was glad I had seen it, noted it. It was inconspicuous, a single figure, slight and really a marvel of virile beauty."

But these first four Frenchmen were by no means isolated in my father's estimation. Close behind them came a number of other favorites, more or less contemporary, such as Fremiet, and especially his bronze of a little boy playing with bear cubs, Le Fevre and his "Adolescence," Rude and his great group, "Le Depart," on the Arc de Triomphe, Brieux, Donnay and Carpeaux, whose names I found on a slip of paper on his desk, and Meunier of whom he wrote as "one of the strong men of our times in a Millet-ish way, but minus the poetry."

The American sculptors for whom my father expressed his respect were not only J. Q. A. Ward, Frederick William Mac-Monnies, Herbert Adams, Daniel Chester French, George Grey Barnard, but, as well, a number of other men who followed in a different group because of their lesser years. I will give two extracts from letters written to some of them, both because of his praise of the men addressed and for his incidental or accidental opinions of the qualities of modern

art. I realize that such letters, and others like them to follow, presented as I give them here and in other chapters, may leave a false impression of distributing degrees of award. But rather than paraphrase or try to balance my father's direct words, I prefer to use his letters as being far more typical of him than anything I could write.

Regarding a proposed tribute to the dean of the American School, J. Q. A. Ward, here is a letter which my father wrote to Mr. John J. Murphy on April 27, 1907:

I regret that illness prevents my assisting in the homage being done to Mr. Ward this evening. His work and career, his virility and sincerity, have been a great incentive to me, from the day when he exhibited his "Indian Hunter" in an art store on the east side of Broadway. It was a revelation, and I know of nothing that had so powerful an influence on those early years. I am very happy to be able to join in this testimonial to him.

My second extract, from a letter to Mr. McKim regarding the art of William MacMonnies, is a paragraph which insists even further upon my father's admiration of MacMonnies' talent:

. . . MacMonnies is a man who has the touch of genius and everything he does is valuable, no matter whether one quite likes the subject or manner of treatment. I think that the City of Brooklyn should possess replicas of everything he has done.

Such was the general trend of Saint-Gaudens' appreciation of the sculpture around him. Close by it, of course, in his

heart, came his regard for painting, where, just as in the case of sculpture, he felt most enthusiastic over its advance in this country, though never abating his interest in the work across the water.

First, taking up the European painters, I give one of his letters, which has been referred to earlier in this chapter, written to Mr. Theodore Marburg, on May 7, 1906. Puvis de Chavannes, having died, is not mentioned, but if he had come under the head of living French decorators, he would have stood before the rest. My father writes:

. . . It is difficult to give a list, in the order of their importance, of the principal living mural painters, but I set them down here roughly: Besnard, Raphael Collin, Luc-Oliver Merson, Maignan, Chartri, and Blanc. The last man on the list you will know from the other Blanc by his having made the decoration in the Pantheon and also the remarkable colored terra-cotta frieze on the back of what they call the Grand Palais, erected in 1900. . . .

Turning now to the more pertinent subject of American painters, I quote from a letter to Mr. Charles F. McKim, regarding the decorations of the Boston Public Library, which shows whom my father regarded as most fitted for the task, at the time when they were planning the decoration of that building. He writes:

I've just seen Abbey again. He is all wound up, as I am, about the Library business, and if anything should turn up, he would come back from Europe next year for it. We have made up a list of names, all strong men, and he suggests having them meet at your office

next week to powwow some evening, Wednesday, if possible. He suggests that White be there, and that all the photographs of decorative work be got out— Masaccio, Carpaccio, Benozzo Gozzoli, Botticelli, &c., to show and talk over. If you think well of this, let me know, and I'll get the fellows together. Aside from La Farge, "qui va sans dire," and to whom undoubtedly the big room should be given, the following are the names that you should consider in this matter: Abbey, Bridgman, Cox, Millet, Winslow Homer, who, Abbey tells me, has done some bully decorative things in Harper's office that we can go see together, and Howard Pyle. These are all strong men—every one of them.

Besides these mural decorators, my father held in highest esteem such artists as John S. Sargent, George deForest Brush, T. W. Dewing, Abbott H. Thayer, Edwin Howland Blashfield, Henry Siddons Mowbray, Elihu Vedder, Cecilia Beaux, John W. Alexander, and others. As in the case of sculptors, I am sorry that I am able to include only one or two of the many letters he wrote, expressing so vividly wherein lay his admiration for the men and tendencies of his time.

First let me give a letter about Mr. George deForest Brush. The letter was written to Miss Rose Nichols:

Yesterday I went with Homer to Fontainebleau to see Brush and Proctor, who live there at "Marlotte Montigny." How remarkable Brush is! He has commenced another picture of his wife, this time with all the children and himself, and it is already a stimulating thing; the composition is so fine, and what there is of it that is drawn, is so splendidly drawn.

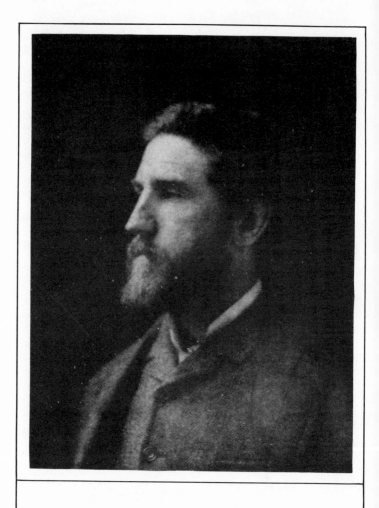

AUGUSTUS SAINT-GAUDENS IN NEW YORK, ABOUT 1887

AUGUSTUS SAINT-GAUDENS

Here is one to Mr. Abbott Thayer about the "Angel on the tomb of Stevenson at Vailima," now in the Albright Gallery in Buffalo:

I wish I could tell you how I feel about your Vailima figure. It is a glorious inspiration, and when I came upon it unexpectedly at Albright's Gallery it took my breath away. It was inspiring when I saw it before, but your changes had sent it flying heavenward.

And again, about Mr. Thayer's decoration for the Portico of Bowdoin College:

. . . Thank you for that photograph of your very, very beautiful tympanum, which I have on my desk before me. I suppose you sent it. Its directness and depths appeal to me singularly like some strangely beautiful dream.

On June 13, 1906, he wrote to Mr. E. A. Abbey:

I think you are the sweetest ducky in the world to have written me, when I know what an infernal bore it is for you to write. If you had one of these machines it might be otherwise, for I am talking to you exactly as if you were standing here in front of me with your back to Ascutney mountain and your face in the flicker of the vine-leaves, which I have so poetically described to Paton. Don't be surprised if I am poetic a number of times again before I am through.

I see about your big success in the papers. I would give a good deal, I would give a peck of those sweet

potatoes I used to hook and cook and eat in the streets when I was a boy, to have a look at your things to-day. Osler must think strange things of his theory when he sees what you've done, and what I have been told Sargent has been doing of him. We are not dead yet, "By Jingo!" are we! If you were to see the establishment I have here, you would not think I was, although I am stretched out on a couch at this moment in the flickering sunlight. I will stick at it until I am finally stretched out. That's the only thing, after all. Work, I mean, not being stretched out! . . .

Of Mr. Edwin Howland Blashfield's decorations in the Senate Chamber of the State Capitol at St. Paul, Minnesota, he sent on October 22, 1905, this letter which fairly exemplified his enduring respect for this painter:

. . . I think the whole swing *very* fine, the figures over the oxen, with the straight-lined drapery, being a particularly noble overcoming of a big difficulty. . . . The group on the wagon seat is beautiful, and the gorgeous creature in the center a swell idea, giving the impression one gets of such a goddess as one sometimes finds in unexpected places. The sick child alongside is lovely in line and sentiment. Don't change it. . . .

He wrote to Mr. Henry Siddons Mowbray, of his painting, "Le Destin," now owned by Mr. John D. Archbold of New York:

I want to dictate a word to you to tell you how much

AUGUSTUS SAINT-GAUDENS

I admire that splendid painting of the Fates. It is a
big thing, and inspiring for me to see it. You know
how much I admire all your other work. The portrait
of your wife is a gem, and your drawings are high in
style.

Hand in hand with this interest in the development of sculp-
ture and painting, came, naturally, Saint-Gaudens' regard for
that of architecture. And though it has not so strict a bear-
ing on the subject of this chapter, his attitude toward the first
two arts should not be mentioned without including his regard
for the third. McKim, White, Thomas Hastings, Daniel H.
Burnham, Cass Gilbert, and George Fletcher Babb, all these
men he felt were leading in the noble achievements of a profes-
sion in which others also were erecting proud monuments in the
land.

Now finally, to turn even more distantly afield, let me say a
word concerning my father's interest in the drama, an art which
appealed to him as being not at all unlike his own, a pictorial
representation of life, since, for this reason, what he consid-
ered worthy in stage craft illustrates in a measure the
æsthetics which he applied to sculpture. The French theater,
to his mind, undoubtedly led by an enormous distance. Not
fond only of the older French classics, he constantly referred
to Coquelin, the elder, in "Cyrano," Bernhardt in "Tosca,"
Réjane in "Madame Sans-Gêne," and Jane Hading in "Ther-
midor." The Italians followed next with Duse and Salvini.
But the English drama, aside from Shakespeare and the work
of Booth, Irving, and Forbes-Robertson, appeared a steady
disappointment to him. Nevertheless, he would look with fresh
interest and hope upon each new play, and listen with attention
to whatever his dramatist friends had to say, evidently anxious
to admire even where his deep critical interest held back his
approbation. I will place here, therefore, the following half-

jocose note which he wrote, intending some day to add it to the reminiscences, a note which he never would have taken the pains to set down if the subject had not been close to his heart:

I was really born to be either an actor or a house-keeper. I am convinced that, if I would overcome the sense of consciousness, I should be a wonderful actor; and as to housekeeping, I *know*. What I should like to have been is another question; a dramatic author, per-haps. I think it is one of the greatest experiences a man can have, to see his creations and his puppets on the stage, working before him as in life.

III

ENERGETIC YEARS

1888-1897

William Dean Howells—The Chicago Exposition—The Columbian
Medal—Many Studios—The Sherman—The Shaw Unveiling—The
Logan Unveiling—Dissatisfaction with America—Honors.

IN the last two chapters I have made a lengthy digression,
opened by my father's mention of his interest in his pupils,
which reached its height at this time. Now let me turn
again to the products of the Thirty-sixth Street studio in the
course of the last nine years of his stay there. During this
time he made the bas-relief of William Dean Howells and his
daughter, Miss Mildred Howells, a task done "for fun," in
happy relaxation from the series of important commissions.
Mr. Howells, with his delightful power of observation and
memory, has been able to describe to me both that occasion and
Saint-Gaudens' general appearance during those years. It is
especially interesting to notice how justly Mr. Howells accuses
my father of falling victim to the very fault he so often de-
claimed against, that of the sculptor's biasing his representa-
tion of his model in the direction of his own personal likeness.
Mr. Howells writes:

10 West Thirtieth St., November 15, 1908.

Dear Mr. St.-Gaudens:

My first meeting with your father I do not remember, but I
recall with great and distinct pleasure a dinner with him and
two painters at Miss Lazarus' in 1890. Though he could
talk so wisely and charmingly, he was willing to let the painters
talk, for they talked mighty well, but he interceded with them
for my share of the say, which I also could have been so willing

61

to leave altogether to them. "Now you be still. I want to hear Mr. Howells." What more was needed to make me love him?

But long afterward he came to see me, with much autobiography on his lips. He told me about his boyish life in New York, and especially about the old cameo-cutter to whom he was apprenticed, dramatizing him at his polishing wheel, and in his moments of rage. He told me also how, as a 'prentice, he used to let the water-tap run, surreptitiously, for the pleasure of the sound.

Another time he came to consult me about an inscription, and he did not mind my being no good. But of course I saw him most when he was modeling my daughter and me for the low relief he made, when he was perpetually entertaining with stories and reminiscences.

Your father was then slowly and desultorily completing the equestrian Sherman, and showed me with particular interest the figure of the Victory, which he said was studied from a young Southern girl. I owned that I did not like the introduction of the ideal in that group and the Shaw monument, but he defended it strongly, and, I have no doubt, effectually.

Apropos of my realism, he told me a dream he had had about me. We were on shipboard together, and a dispute rose between the passengers as to the distance of a certain brilliant planet in the sky. Some said it was millions of miles away, but I held that it was very near; and he related that I went down to my stateroom and came up with a shotgun, which I fired at the star. It came fluttering down, and I said: "There! You see!"

It was most interesting to watch the working of his mind as well as his hand. He changed the position of one of my arms, but changed it back, thoughtfully, almost ruefully. Like all artists he had a difficulty in keeping his own portrait out. He especially kept giving my daughter's profile his noble leonine nose. He could not see that he did this, but

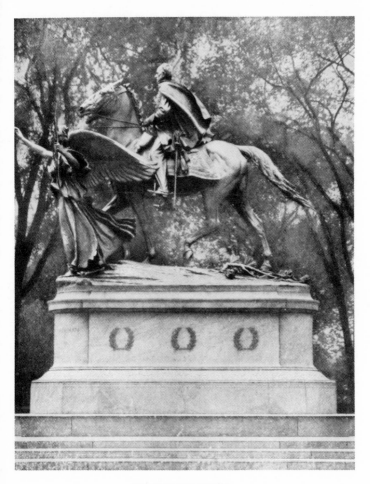

THE SHERMAN STATUE
At the entrance to Central Park, Fifty-ninth Street and Fifth Avenue, New York City

when he was convinced of it, he forced himself to the absolute fact, and the likeness remained perfect. He was suffering at this time from sciatica, and at intervals he stopped work and limped around behind a curtain to take medicine from a bottle he kept there; then he came back and worked away for hours. He was greatly interested in an Italian scholar of his who believed he had seen and talked with the devil. He made me question the man in his own tongue, and was richly satisfied when it appeared that the Devil had taken the form of a bear on this occasion.

The last time I saw your father was when he came to dine with me, to meet Mr. Henry James, at the Century Club. He had a great notion of the honor done him, and with his beautiful, beautiful modesty quite ignored the honor done his fellow-guest and host. I had ordered a feast to the measure of my means, but it turned out that both the novelist and he were Fletcherites, and they each confined themselves to a bit of fish and a boiled potato, with ice-water. He was enthusiastic for that cure, and he conjured me to practise it, though I had nothing to be cured of.

His face was to me full of a most pathetic charm, like that of a weary lion, and, after our seeing him so constantly, my daughter and I were finding sculptured lions all over Europe that looked like St. Gaudens.

You see how very little I have to tell, and the little seems to be mostly about me.

Yours sincerely,

W. D. HOWELLS.

For the most part the reminiscences which follow deal with the Chicago "World's Fair" of 1892, and with the unveiling of the "Shaw" and of the "Logan." The first of these subjects, in especial, I may well preface at some length since, despite his brief mention of the Exposition, few persons had more at heart than my father the question of the architectural beauty of the

Exposition Grounds, and were made more happy over the result. This letter, sent me not long since by Mr. Burnham, indicates the nature of my father's enthusiasm:

"An occasion of your father's accurate judgment, made almost at a glance, happened at the World's Fair in Chicago, just before the Fair opened. The Art Building had just been finished. Your father came to my rooms late in the afternoon. He took me by the shoulders and said, 'Old fellow, do you realize the rank of Atwood's building? In my judgment, it is the best thing done since the Parthenon.' This conclusion has been justified by the statements of many eminent critics. Your father's perception of the value of an architectural design seemed to be instinctive and his great generosity in praising others was a very marked characteristic."

Saint-Gaudens, however, significantly fails to mention in his reminiscences the one bit of sculpture which he did personally attempt for the World's Fair, a commission which ultimately brought him great distress of mind. It was the design for the medal to be presented to the various prize winners. At first, despite the fact that the authorities offered five thousand dollars for the reliefs, a large sum for my father in those years, he refused to accept the task, saying that neither he nor any one else in the country could model a decent medal, and that it was necessary to go to Europe for it. After a time, however, he agreed to make the effort. Upon the obverse he created a design representing Columbus at his first landing on this hemisphere. On the reverse he placed a nude boy holding a shield which should bear the name of the recipient of the prize.

Then came the catastrophe. Previous to the striking of this medal, the Page Belting Company, of Concord, New Hampshire, improperly obtained a copy and printed a caricature of it so villainous that the boy, who on the original stood as a bit of artistic idealism, appeared in all the vulgar indecency that

can be conveyed by the worst connotation of the word naked-
ness. At once the morality for which our nation is notorious
took fire, with the result that after an interminable hue and
cry the medal emerged bearing my father's relief upon the
obverse, and upon the reverse an invention from the hands of
Mr. Charles E. Barber, the "commercial medallist" of the
mint. I add a letter which my father wrote to the New York
Tribune, showing his state of mind over the result. Of course
nothing came of it as far as the medal was concerned, though
it won for Saint-Gaudens the sympathy of all his fellow ar-
tists.

To the Editor of the New York *Tribune:*

Sir:

It occurs to me that the following résumé of my re-
lations with the Washington authorities in charge of
the commission for the Columbian Exposition medal,
may not be without a pleasant moral to others moved
to entertain government proposals. I therefore send
it, for insertion, to your influential journal.

On the twenty-seventh of June, I received official
notification of the rejection of my third design for the
Reverse of the Columbian medal. At the same time it
was publicly announced that a design by Mr. Barber,
of the United States Mint, had been adopted in its
stead.

I had myself undertaken the execution of this medal
only after earnest solicitation by those then in authority,
to the detriment of other and important interests.

My first design, although it had been formally ac-
cepted by the Hon. J. G. Carlisle, was immediately af-
terwards rejected because its composition included a

nude figure, to which impertinent attention was drawn by an incorrect and offensive copy, made and published by private parties.

I regret to admit that, subsequently, at the urgent request of Mr. Carlisle, and upon his representations, I foolishly altered my design, to flatter the sensitiveness of the rampant "pure."

This second design, in which neither my feelings nor my draperies were spared, was again refused, and I was formally requested, through Mr. Preston, Director of the Mint, to furnish an entirely new model "at an early date." Unpardonable as it now appears, I complied, producing once more the required model, which was again in due course of time to be set aside.

The rejection of this third and last model is the more curious to explain, in that, with excessive care for the sensitive acuteness of the Hon. Secretary of the Treasury, I had this time in my composition—scrupulously turning from classic thought of humanity, draped or undraped—surely avoided all erotic insinuation by the substitution, for the offending figure, of "The Bird," whose fair fame is beyond suggestive possibilities.

I have reserved, in this mortifying confession of criminal *naïveté,* the final letter of vast persuasion that undid me. Let me print it, that others may judge of the frank tone and incredible *bonhomie* that may be dangerously imported into government communications, and also that I may find in their opinion "extenuating circumstances."

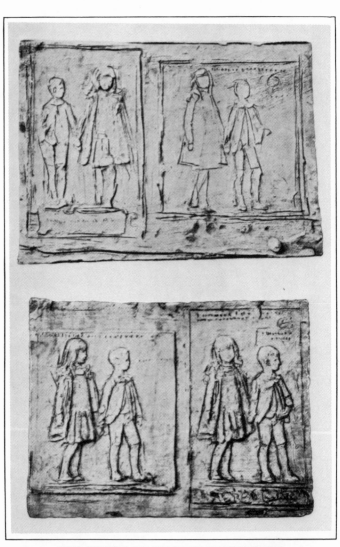

FOUR SKETCHES FOR THE SCHIFF CHILDREN RELIEF

AUGUSTUS SAINT-GAUDENS

"From Mr. Preston, Director of the Mint, to Augustus St. Gaudens, New York.

"Philadelphia, May 18th, 1894.

"Dear Sir:

"I am very much gratified by the receipt of your letter of yesterday, stating that you would prepare and submit another design for the Reverse of the World's Columbian Exposition Medal. As soon as the Reverse is received, preparation will be made to have it engraved immediately, and to make a faithful reproduction of the same. I feel sure that the Mint has made a success in the engraving of the Obverse, and will be equally successful in the engraving of the Reverse.

Very truly, etc., etc."

On the receipt of this guarantee to accept my further work, accompanied as it was by expressions of interest in its completeness and an assurance that every care should be bestowed upon its reproduction, it was, for me, impossible to hesitate.

Never was commission clearer or more kindly thoughtful in detail. In the face of this promise, that "as soon as the Reverse is received, preparations will be made to have it engraved immediately, and to make a faithful reproduction of the same," to harbor further uncertainty would have implied unmannerly doubt of the word of the gentleman who had written it. I may be excused if, in my simplicity, the idea even of such possibility never occurred to me.

And I am now willing to confess that the condition

71

of good faith common among gentlemen, which could contemplate an engagement with another man to produce this same Reverse at the very moment of holding out to me as an encouragement in my work that the "Mint has made a success in the engraving of the Obverse and will be equally successful in the engraving of the Reverse," does suggest a complication of Bureaucratic Conscience and Machiavellian Subtlety with which I have shown myself utterly unable to cope.

I shall, in all humility, await from these official gentlemen their own explanation.

And I have, sir, the honor to be,

Very truly yours,

Augustus Saint-Gaudens.

P. S. Mr. Carlisle's may be the legal right to combine my work with that of another on the same medal, but the rare shamelessness of such offense will be appreciated by all my confrères at home and abroad, and it is as much in their interest as in my own unbridled astonishment that I make this protest public.

To turn now to the reminiscences, which begin their tale with an account of the Exposition which raised all this coil, my father writes:

In the midst of this period came the Chicago Exposition, before which, at the invitation of Mr. D. H. Burnham, I made a famous visit to Chicago, together with Mr. R. M. Hunt, Mr. C. F. McKim, and others, and conferred with regard to the laying out and carrying forward of the plan.

Mr. Burnham was extremely anxious that I should undertake the entire development of the sculpture of the Exposition. But this was entirely out of the question. I have deeply to regret that my direct relation with the sculpture I was forced to confine to the figure of Columbus in front of the entrance to the Administration Building, even there acting only in a purely advisory and critical capacity. My pupil, Miss Mary Lawrence, now Mrs. François M. L. Tonetti, modeled and executed it, and to her goes all the credit of the virility and breadth of treatment which it revealed.

Mr. Burnham arranged, however, that I should become a general adviser regarding the whole scheme. Under those conditions I suggested the making of the colossal statue of Liberty in the lagoon, by Mr. Daniel Chester French. The scheme for the peristyle opening out on the lake is also an enlargement, on a far nobler scale, of a line of columns, each representing a state, which I suggested for that place, and which pleased Mr. Burnham greatly.

The monumental fountain at the other end we also decided on at that time, and Mr. Burnham desired that I should execute it. For this fountain I had in mind one or two schemes. But, in consideration of calls on me, I agreed to undertake it only on condition that I could be helped by MacMonnies. MacMonnies decided he would rather not. I then urged that the execution be placed in his hands, and there is no other piece of work with which I have been associated as adviser that has approached this in the satisfaction it has given me.

It seemed to fit in absolutely with his temperament, with his appreciation of the joy of life, beauty, and happiness, and I consider his composition as a whole, and particularly the central motive of the boat, the rowing maidens, the young figure of America on top, the most beautiful conception of a fountain of modern times west of the Caspian Mountains. It was the glorification of youth, cheerfulness, and the American spirit, and I think it is a calamity greatly to be deplored that it should have gone to ruin. It would have made a remarkable monument to that extraordinary exhibition.

The days that I passed there linger in the memory like a glorious dream, and it seems impossible that such a vision can ever be recalled in its poetic grandeur and elevation. Certainly it has stood far beyond any of the expositions great as they have been, that have succeeded it.

Meanwhile, I was fast moving through my fifteen years in the Thirty-sixth Street studio, progressing with the ups and downs, misgivings and enthusiasms, which follow all work or production of that kind, be they masterpieces or be they inanities. By now the statue of Peter Cooper had followed the Rock Creek Cemetery figure upon the memorable scaffolding, and consequently, as with this and the "Shaw" and the other commissions, the studio became crowded, I hired a loft in Twentieth Street, wherein I could model the equestrian statue of General Logan for Chicago and the Memorial monument to President Garfield in Fairmount Park, Philadelphia.

TWO OF THE MANY SKETCHES FOR THE PETER COOPER

AUGUSTUS SAINT-GAUDENS

Then, my condition in New York growing no better, since the Twentieth Street workshop was quickly filled and the Thirty-sixth Street studio remained impossible because of incessant interruption, I took yet another small studio on Twenty-seventh Street, where, immediately after the completion of the "Shaw," and while that was being cast in bronze, I began the equestrian monument to Sherman.

The horse of the "Sherman" was developed under my supervision in yet another Fifty-ninth Street studio, the famous high jumper, Ontario, posing as the model, while the figure of Sherman I created from an Italian model very much of the General's build. This man had great pride in his profession. He had "le côeur au métier" to such an extent that one day Mr. George Parsons Lathrop, who was visiting me, after half an hour or so of chatting, leisurely walked up to the model, who was seated high astride a barrel, and pinched his leg to see of what stuff the wonderful manikin was made. I am not romancing.

At this time, too, Mr. William Dean Howells had been kind enough to speak in pleasant terms of the bust of Sherman which I had adapted to the statue. So in appreciation of that, as well as the deep admiration which I have for his achievement, his principles, and his delightful personality, I begged that he allow me to make his portrait and that of his daughter, Miss Mildred Howells. He kindly consented, and the medallion was modeled in that small studio, in the stifling heat of the tropical summer, which vastly increased my

admiration for him and his patience. To show how uncertain we are, or I am, about our judgment of the work that is in hand, I will explain that when I made this medallion I felt very happy about his portrait and unhappy about that of Miss Mildred. Now, ten years later, I see that the reverse would be the proper state of mind.

Through all this turmoil the Shaw monument had come to bear more and more upon my mind, and finally reached the long-looked-for day of its unveiling. There had been much good-natured abuse of me for the time expended on the bas-relief. But it was impossible to carry out my idea otherwise, in a great degree because of the absence of sufficient remuneration. This I mention without the slightest trace of regret or reproach, as the sum I consented to execute the monument for was ample to provide an adequate and dignified work. It was the extraordinary opportunity, the interest of the task, and my enthusiasm, that led to a development far beyond what was expected of me. And I held it a great joy to be able to carry out my idea as I wished. Whatever regret I have is that I could not achieve many things which I felt might have been done with the general scheme, though much of it was to my taste, especially the enclosing of the monument between the two trees which frame the relief so admirably, and the felicity of the location as well as the architecture which supports the monument, the thought and work of Mr. Charles F. McKim.

My own delay I excuse on the ground that a sculp-

tor's work endures for so long that it is next to a crime for him to neglect to do everything that lies in his power to execute a result that will not be a disgrace. There is something extraordinarily irritating, when it is not ludicrous, in a bad statue. It is plastered up before the world to stick and stick for centuries, while man and nations pass away. A poor picture goes into the garret, books are forgotten, but the bronze remains, to amuse or shame the populace and perpetuate one of our various idiocies. It is an impertinence and an offense, and that it does not create riots proves the wonderful patience of the human animal. Who knows but what an insane asylum in this fair land contains some helpless drooling lunatic, brought to such a pass by contemplation of one of my own results?

The day, to me all-important, dawned with a fine mist. It was a strange feeling, arranging the last details for the unveiling, with a few men on the deserted sidewalks, the monument itself still uncovered. Little by little the streets awoke. The relief was hidden by flags, and finally, at the appointed hour, I followed out what I was told to do, and made the beginning of a day of extraordinary excitement.

I was assigned to a carriage in company with Mr. William James, the orator of the occasion, and we followed slowly at the tail-end of a long line of regiments and societies. It soon dawned over me that to this great crowd, this monster that lined the streets, I was nothing more than the usual fellow or public official that one finds in carriages in processions. They generally

appear very insignificant. Yet to see this line of faces on each side of the streets continuing for miles and miles, and all the windows filled with persons gazing at you, is really a profound experience to have. And such it was as we drove to the State House, directly in front of the monument. There those of us in carriages were ushered to the lowest platform of the steps that led down from the State House, immediately surrounding the Governor.

The regiment that came nearest to us, virtually at the head of the procession, comprised the remaining officers and colored men of the Fifty-fourth Massachusetts, whom Shaw had led; the bas-relief itself being within thirty or forty feet of where the colors were presented to them by Governor Andrew, before Colonel Shaw started on the march to his death. At the unveiling there stood before the relief sixty-five of these veterans. Some of the officers were clad in the uniforms they had worn during the Civil War, and rode on horseback. But the negro troops, like those in the subsequent review at the time of the unveiling of the monument to General Logan, came in their time-worn frock-coats,— coats used only on great occasions. Many of them were bent and crippled, many with white heads, some with bouquets, and, the inevitable humorous touch, one with a carpet-bag.

After a few words from Governor Wolcott, a signal was given, and a grand-nephew of Colonel Shaw's pulled the string which caused the flags on the monument to drop. The salute boomed from the cannon on

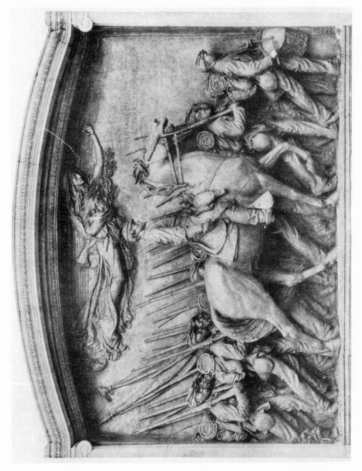

THE SHAW MEMORIAL, BOSTON, MASSACHUSETTS

the Common, and was answered by others in the harbor, and the head of the procession began to march by. The impression of those old soldiers, passing the very spot where they left for the war so many years before, thrills me even as I write these words. They faced and saluted the relief, with the music playing "John Brown's Body," a recall of what I had heard and seen thirty years before from my cameo-cutter's window. They seemed as if returning from the war, the troops of bronze marching in the opposite direction, the direction in which they had left for the front, and the young men there represented now showing these veterans the vigor and hope of youth. It was a consecration.

After the troops had all passed between the monument and the Governor and his staff, we were driven to the old Music Hall, where the commemorative ceremonies took place. Here I so dreaded being seated in a conspicuous chair on the platform that I stole away, and went in after I knew the others would all be placed, when I hoped to find a corner with the crowd at the back. But this was not to be. I was recognized, and brought forward to occupy the one chair in the front row conspicuous by its vacancy. As the others were already sitting, I naturally attracted much more attention than if I had gone in with the rest.

At these ceremonies I heard Mr. Booker T. Washington, who created a great sensation. Of course, being a negro, his appearance was particularly appropriate. Mr. William James delivered the address, noble and poetic, and with such a depth of feeling that I would

wish to embody it here and leave it absolutely with my impression. Otherwise I cannot describe what went on because of the fright that took possession of me, as I knew that sooner or later I should be called upon to say something or other, and, if there is one thing I am helpless about, it is any utterance in public. The dreaded instant came. I was announced by one of the orators, and stood up. It was an awful moment, but it would be stupid to deny that at the same time it was thrilling to hear the great storm of applause and cheering that I faced. That also was a sensation worth having. I realized what an extraordinary feeling of triumph and power must come to a successful actor, when, night after night he evokes and faces such enthusiasm, such spontaneous and convincing approval of his efforts and achievement, with the certainty that it is real, and not the polite compliment which bears no conviction.

But the following morning, while bending over the basin in the bath-room, I was suddenly struck, as if with an ax, in the lower part of my back, so that it was with the greatest difficulty that I crawled over to the bed and lay down. This was an attack of lumbago, followed by sciatica, which knocked in the head any tendency to pride or cockiness.

Soon after the unveiling of the "Shaw" came that of the "General Logan," the last monument to which I was to own responsibility in the United States for some years to come. It was most impressive, the bright sun, the sound of cannon near the lake, the music, the tat-

tered flags, giving me a sensation which stands out viv-
idly, while touching in the last degree was the march-
ing by of the veterans of Logan's division. Of course
the great majority of them were probably farmers from
the country. To see them, dressed in their Sunday
frock-coats, browned by age, turn to salute as they
marched past the monument to the sound of the familiar
old military music of the war, was a scene to bring
tears to one's eye. The spectacle also had its hopeful
side for those with doubts as to war, since they could
not escape realizing that these men, who had gone forth
from their farms and workshops to fight, had returned
to their occupations when the big job was done with no
more thought of militarism.

After this unveiling, a reception was given to Mrs.
Logan and to me in one of the public buildings of Chi-
cago. This in another way I felt to be almost as touch-
ing and pathetic as the parade, though it possessed a
sparkle of humor, which will allow me to attempt to de-
scribe it. It took place in a long hall, I should say
about one hundred feet from end to end. The public
entered at one door, were ushered before Mrs. Logan,
about twenty-five feet away, from there walked over
to me, and then went out of another small door at the
other end of the room. I am told that the great crowd
trying to get in down-stairs was jammed in a compact
mass up to the little door, out of which they were
squeezed very much as ointment is squirted out of a
tube.

At first I was exceedingly frightened and alarmed at

it all. Soon, however, I lost sight of the fact that I was being observed, and became the principal observer. The interest of the occasion to me lay in the extraordinary diversity of types that filed by and shook hands, since the people were of all classes, sizes, shapes, dimensions, and characters. There were tall men, short men, stout men, thin men, veterans, old maids, boys, fat women, thin maidens, generals, private soldiers. There were diffident girls, who approached the Grand Panjandrum with fear and trembling. There were assertive men, just as frightened, but who showed a stiff upper lip. There were those who became very formal, those who appeared just the reverse, those who smiled, and those who remained grave. There were the heads of families, who introduced their convoy one after another, blocking the free passage of the column as it went out of the room. And finally there was the kindly old woman, so interested that she wanted to have a good chat with me, while the crowd accumulated behind her until some one told her to move on. Although I seem to speak with a touch of levity, that is far from what I have in mind. I felt profoundly honored, and certainly very unworthy of so much distinction.

I suppose through overwork I had become nervous and completely disaffected with America. Nothing, it now seemed to me, would right things but my going abroad and getting away from the infernal noise, dirt, and confusion of New York City. Of course my Thirty-sixth Street studio could not have been worse situated in that regard, as any one will realize who

knows the hell that exists on the corner of Thirty-fourth Street, Broadway, and Sixth Avenue, with the elevated road discharging oil on the persons beneath, the maddening electric cars adding their music, the ambulance-wagons tearing by, jangling their diabolic gongs in order that the moribund inside may die in the full spirit of the surroundings, and the occasional frantic fire-engine racing through it all, with bells clanging, fire, smoke, hell, and cinders. So I made up my mind to sail for Europe in October, 1897, and dragged up by the roots, so to speak, all the sculptor's paraphernalia for its transportation to Paris. I see now that what brought this about was the beginning of the illness which ever since has held me more or less in its clutches.

I have a paragraph to add to my father's reminiscences, a portion of a letter written by him from Chicago, to his niece, Miss Rose S. Nichols, immediately after the Logan unveiling, on June 23, 1897.

At one o'clock yesterday Mrs. Deering, Mrs. French, Mr. French (brother and sister-in-law of Dan French) and I were placed in one carriage. Mr. Deering, Mrs. St.-G. and the editor of the Chicago *Tribune* in another, and in the wake of a lot of other carriages and followed by a procession of them, we drove to the big stand. A great day it was, with a high wind and glorious sun! I was put in one of the seats in the Holy of Holies alongside of Mrs. Logan, if you please, and the president of the ceremonies. A lot of speeches were made, one of which was very good, and

at the right moment the complicated arrangement of flags dropped, the cannon fired, the band played, Mrs. Logan wept, and I posed for a thousand snap photographs; "a gleam of triumph passed over my face," think of that! (vide Chicago *Tribune*.)

And now, as of all the work my father completed the Shaw Memorial held the largest share of his hopes and attention, it is fitting to end this chapter by enlarging upon his account of it in a few directions from which material has come to my hand.

My father speaks of a number of things not being "achieved" in the course of the commission. Chief among them was the matter of satisfactory inscriptions, though he worried over them for fully five years. Originally they were arranged in a manner most distasteful to him. So he began devious tactics to elude the necessity of placing them in permanent form. Here are three letters written in the course of these events to Mr. Howells, Mr. Thomas Bailey Aldrich, and Mr. Gilder.

To Mr. Howells:

I've lost my copy of the draft for the Shaw inscription I sent you. If you have lost yours, Amen. I like fellers that lose and forget things. If not (and I'll like you just the same) will you send it to me? Aldrich has promised to try on it too, and so has Gilder with Woodbury. I feel as if I had more cheek than a bull pup, but I was not always so.

To Aldrich:—

I enclose the various inscriptions suggested. Bad as they are they contain the material to work from. Mr.

AUGUSTUS SAINT-GAUDENS WITHOUT HIS BEARD, 1895
He regrew his beard almost immediately after shaving

X——, who is to be assuaged, is the principal stumbling block. You can judge that by what he wished to put on the monument.

I beg that you will throw all this stuff in the waste-basket and think no more of the matter if it becomes in the least irksome. I shall be as grateful for the wish as for the deed.

And to Mr. Gilder:

148 West Thirty-sixth Street, April 17, 1897.

. . . Damn the pen.

All right; "FORWARD" it shall be; it is easily corrected on the stone. Now the blessed committee wish only two names of officers on the monument instead of five, so Atkinson telegraphed me last night from Virginia. I telegraphed Col. Lee last night to telegraph you the names of the two officers which are to remain. Ellsworth said there was still time to make that correction. If Lee does not telegraph you, I should bother no more about it or them. I suppose it is Russell and Simpkins that they wish retained; the former was missing and is supposed to have been killed, and Simpkins was killed during the assault on Wagner.

Thine,

A. ST.-GAUDENS.

Finally, as it seemed impossible for my father to settle anything to his satisfaction, he turned to Charles W. Eliot, then President of Harvard University, as the man whom above all

others he considered the most able at such work. Here is one of my father's last letters to him:

Dear Mr. Eliot:

I must ask you to come to my relief in this unending affair of the inscription. I now fear that unless I can placate some of the members of the committee, what you have so kindly composed may fall through, exasperating as that would be, and another year's struggle commence, resulting perhaps in my complete fatigue and abandonment of the matter, and the placing of such an absurdity as was originally proposed on the back of this work.

You are kind enough to say that you will try and add a line to the third section of the inscription. It is fortunate that as a matter of artistic proportion it will be of advantage from my point of view. If it is possible for you, in that added line, to put words that may in a measure set forth the ideas which Mr. X—— wishes, I believe I could see my way out of this slough. Mr. X—— insists on the use of the "Oh, fair-headed Northern hero," and, in order to placate as much as I can, I am going to tell him that I shall use that poem, either on one of the lateral sides, instead of the lines, "I know Mr. Commander," etc., or in place of Emerson's "To-day unbind the Captive, etc."

Should all this make you lose patience, and cause you to dismiss the whole subject, I should not be surprised; on the contrary, I should consider it a very natural result of what has occurred.

AUGUSTUS SAINT-GAUDENS

Mr. Eliot's final effort wholly satisfied my father in the end, and of the sculptor's ultimate regard for it Mr. Coffin has written me in a most interesting manner.

"Saint-Gaudens had a great respect for learning and for literary ability. When I was in his studio in October, 1896, at the time I was writing an article about his life and his work for *The Century Magazine* (published in the June number, 1897), he showed me the inscription for the Shaw Memorial written by President Eliot, and expressed his great admiration for it as a piece of composition. The division, so to speak, of the inscription into three parts, beginning: 'The White Officers,' 'The Black Rank and File,' and 'Together,' he said was 'a fine thought,' and I could see that his artistic sense as a designer was strongly appealed to by the material form of this inscription as it would appear cast in bronze on the back of the monument."

Yet, despite such distracting details as those which centered upon the inscription, my father's state of mind following the unveiling was exceptionally happy and optimistic, for through the "Shaw" more than through any other commission he reaped his reward. It came to him from many sources. First, shortly after the unveiling, the mother of the hero Colonel asked him to visit her and explained that although they had originally planned only a modest bas-relief he had devoted infinite labor and money upon the commission, and that therefore she hoped he would add a personal check from her to the small sum he had already been paid. It is not hard to imagine with what feelings my father took the money. Then following this sincere courtesy, came many other personal congratulations from his friends and fellow-artists, and among those which affected him most was this indirect one sent him by my mother, in her account of the attitude taken by his friend, Kenyon Cox, whose opinion in matters of art, my father held preeminent. My mother wrote:

Dear Gus:

. . . After hitching to a hammock-hook we went to the front, and found an enchanting view, and Kenyon Cox. He soon warmed up on the subject of your Shaw Monument, and finally said, "People say it's the best thing Saint-Gaudens ever did. For my part no one anywhere in any country has ever done any better. I don't say I never anywhere have seen as good, but never better. Saint-Gaudens has for a long time done everything with great charm, but in recent years he has also done them with great *force.*"

So, my dear, here is an artist's praise not given "silently" according to Mrs. X——'s idea, but all the more welcome because it is given strongly and forcibly."

The recognition which the world at large could offer Saint-Gaudens was now pouring upon him, the most important share reaching him through the degree of LL.D. given him by Harvard University. It was then that President Eliot spoke the few words concerning him that summed up his efforts in a fashion that must remain unequaled. He said:

"Augustus Saint-Gaudens—a sculptor whose art follows but ennobles nature, confers fame and lasting remembrance, and does not count the mortal years it takes to mold immortal forms."

Not long ago President Eliot was kind enough to send me an account of the way in which the proceeding affected my father. Here it is:

"At the time your father received his honorary degree at Harvard he attended the Commencement Dinner in Memorial Hall upon the express stipulation that he should not be called upon to speak. During the dinner and the speeches which followed it—two or three hours—he sat leaning forward, his arms resting on the table, and looking about him in a most intent manner. After the ceremonies I met him and inquired the reason for his strange preoccupation, which had seemed to concentrate itself successively on different parts of the room. Mr.

AUGUSTUS SAINT-GAUDENS

Saint-Gaudens' only reply was: 'Great Scott! those heads!' "

Yet while proud and grateful for such honors, the actual taking of the degrees badly tormented my father's self-consciousness, though he was relieved in a measure by his power to see the humorous side of things. His attitude, indeed, he well explained in his often-repeated account of how these affairs affected him.

His first troubles of this kind, he explained, began at the two hundred and fiftieth anniversary of the founding of Princeton University, when he was asked if he would receive a degree in company with President Cleveland. He accepted the honor with what he considered unusual calmness and dignity. He left Cornish to go to the College, and on his way stopped to spend the night at the New York Forty-fifth Street house, then occupied only by a caretaker. He was always dignified when taking a train, for, as he said he realized that though others were sometimes in a hurry, he, the almighty, could not be moved by any such insignificant object as a railroad car. Therefore he washed in a leisurely manner, and in a leisurely manner he sought his shirt in the top drawer of the bureau. The top drawer was empty. He was not quite so leisurely in opening the second drawer. The second drawer was empty. He was mildly excited when he pulled open the third drawer. The third drawer was empty. He was obviously heated on opening the fourth and bottom drawer. The fourth and bottom drawer was empty. Then his passion knew no bounds. He damned the caretaker. He damned the house. He damned the universe. He rushed out of doors and up and down Sixth Avenue. All was in vain at that early hour. So at last he departed, dressed in a superb frock coat and top hat, beneath which peered the disreputable shirt and collar that had borne the brunt of the trip from Cornish the day before. He missed his train. He waited. He arrived in Princeton, where the railroad station is only about fifty rods from the college grounds. Not knowing this, he took

a cab. The driver chose a roundabout route to avoid the festivities, and on his way my father saw crowds of people shouting.

The degrees had been given out. His turn would come next year.

The next year accordingly he appeared both prompt and immaculate. Alas! that was all he remembered of the proceedings. He was the only man in the University with a top hat.

Two years later the Harvard degree I have spoken of arrived. The clothes to be worn at such a function were branded upon his mind by the memory of the Princeton affair. To no purpose! Top hats there were a plenty in the "Yard," derbies not a few, straws to several thousands, and of soft "fedoras" just one—his own.

IV

LIGHTS AND SHADOWS

1892-1897

Distractions — Studio Confusion — Studio Annoyances — Irritating
Commissions; Logan, Garfield—Peter Cooper, a Labor of Love—
Outside Activities—Friends—The Death of Bion.

THE previous chapter concludes my father's mention of
the Thirty-sixth Street studio life. But as I prefaced
the account of his work there with a description of his
surroundings during the earlier years of the period, so now I
will add, by way of an epilogue, an attempt to picture the at-
mosphere in which he worked during the end of his stay, the
confusion of his studio to which there have been so many al-
lusions, the stress and pull of outside engagements naturally
coupled with his success.

Two letters in especial set forth the excitement in which he
was expected to evolve æsthetic ideas. The first is to Dr. Win-
chester Donald. Even at that early day the Phillips Brooks
Committee, in Boston, had offered him the commission for the
monument and had asked for his thoughts on the subject. This
was his response. The second letter he sent to the sculptor,
Mr. A. P. Proctor. In this letter the reference to his assist-
ant, Mr. Robert Treat Paine, is especially interesting, since
it marks my father's first experience with a pointing-machine.
Previous to this, all sculpture had to be enlarged from the work-
ing model to the final size by a series of "points" taken by
hand. Consequently, in order to obtain a result in any time
at all, a number of assistants were necessarily employed and
the factor of personal error crept in to a tremendous extent.
My father had an especially rough experience with the standing

"Lincoln," the "Peter Cooper," and the horse for the "Logan." After they had been laboriously enlarged by the old system, he was forced to remodel them entirely free-hand in order to bring back the effect he desired. But shortly after that time Mr. Paine solved the problem of mechanical enlargement, and before long, on such work as the "Sherman" horse, there were being made as many as four hundred correct points a day.

My father writes of all this:

148 West Thirty-sixth Street, March 21, 1893.

Dear Donald:

You are the best fellow in the world, and when I receive such letters as yours I feel smaller than I usually do, and that's saying a great deal.

In order to write as appreciatively as possible, I have taken a quiet hour in my studio to-day, Sunday. But notwithstanding the peace of the day and the place, I am alone and undisturbed, it is hard for me to express myself as I ought to. The whirl I am in, the concentration of thought necessary for the final emblematic figure in the Shaw monument, together with the indescribable confusion and haste of the completion of the "Diana" and "Columbus" by ten assistants, and a removal in the midst of it all, have put my brains in a condition where it is impossible for me to give the Brooks monument proper thought. For the present I ask you to believe that I feel greatly honored by the action of the committee. . . .

The other letter runs as follows:

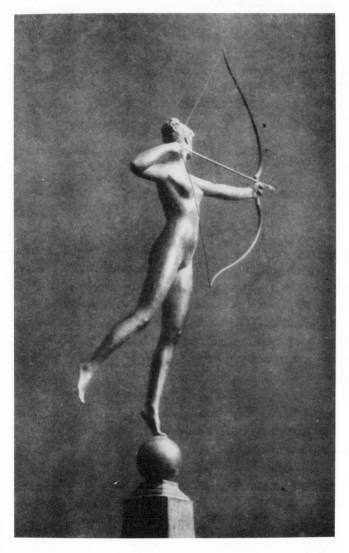

DIANA
Madison Square Garden Tower, New York City

AUGUSTUS SAINT-GAUDENS

148 West Thirty-sixth Street, March 1st, 1896.

Dear Proctor:

Your letter of February first is in front of me, and I feel a little guilty at not replying to it before this, but I am a bad correspondent and I'd put off writing to the angel Gabriel. I have had the concert in my studio to-day that I have once a year in honor of Mr. Wells. The crowd has gone, the place is quiet, and I have a few moments to spare before the dinner-hour. Paine has finished pointing the big horse and has started on the figure of Logan. He has also started enlarging the flag on the same scaffold with the same kind of machinery, and the confusion that you saw up there is placid order compared to the intricate mess of planks, ropes, pulleys, strings, &c., &c., that he is reveling in now. I have still half the studio down in Twentieth Street. . . . So you see life continues about the same in this lively corner of the earth. . . .

The chaotic state of affairs shown in these letters, like the greater part of the upsets mentioned in the past chapter, were to be expected as ever pertinent to a sculptor's studio. But my father seemed especially victimized by a series of set-backs from accidents or the clumsiness of those about him. I will describe one mishap in which I figured as a boy, since it deals with the failure of the pointing of the "Logan" horse, and in telling it I am exposing only myself. The absurd needlessness of it, the time, the money, and the brain-force wasted by it, were all unfortunately typical.

It came about through my pet goat. The "Logan" horse had been modeled for my father in Cornish; and, after its completion, stood in modeling wax in the studio barn, waiting

101

to be cast in plaster previous to enlargement. During that summer I had brought to delightful perfection a new game with my goat. First I would induce him to butt and then, stepping aside, take joy in his bewildered plunge past me. What could be more natural than that, one noon hour, while the studio was deserted, I should play this trick directly before the stand on which was mounted the Logan model. The result is obvious. When the goat made his dive and I dodged, he drove his horns with a crash against the pedestal. For a second of horror the horse rocked to and fro. But as it did not fall, I never imagined future consequences and, boy-like, soon forgot the incident. The horse was cast and the pointing up carried on by hand for over two months, until at last both my father and Mr. Proctor, who was directing the work, began to notice that the rear of the animal appeared strangely askew. Careful measurements were taken, with only too disastrous proof. The large model had to be torn down and the small model remade in clay at the loss of a summer's work. By that time of year I was away in school, and far too frightened to volunteer the incriminating information as to "how it happened." It was not until long after, when, at the dinner-table, I heard my father explaining to some friends about the inaccuracy of the old method of pointing, that I "owned up." By then I was too large to spank, so my father contented himself with a smile. Perhaps he knew at the time, anyway.

Many such studio misfortunes as this my father bore calmly. For, as he often punned, even Michelangelo found it impossible to organize a studio that was not a stew. But when there were added such outside irritations as those furnished by clients who doubted his sincerity or who questioned the artistic value of the result, as in the case of the Columbian Medal controversy, he became bitterly distressed. Of all such disagreements, the Logan commission involved perhaps the most irritating. The friction was developed in this case through the committee's only too evident distrust of the sculptor, caus-

ing them to send him letters that would have roused a far calmer soul than his. One bone of contention, very sweet to them, was dug up through the difficulty of convincing them that the small working model, the last which my father's hand actually touched, was to be regarded as the finished model. I dwell upon it particularly, for debates on this subject followed him up to the end of his life.

Here is the first letter on the question to a member of the Logan Committee:

148 West Thirty-sixth St., New York,

October 12, 1894.

Judge H. W. Blodgett,

Chicago, Ill.,

Dear Sir:

. . . A misapprehension has no doubt arisen from my not having made it sufficiently clear that the small model is the working model on which all the time, thought, energy, and expense necessary for the artistic conception and development of the monument are expended; that it is, in sum, the vital part of the work, and that when it is done the statue is essentially completed. This working model is about half the size that the bronze will be, and the enlarging from it to the colossal model necessary for the bronze-founder is a mechanical operation done by assistants, which, as well as the bronze-casting and its erection in place, could be carried on without me, were I to die or become incapacitated after the "working model" is finished. . . .

You are entirely mistaken in your inference that "the work is no further along than when the last payment was made," that I have merely "done some work cor-

recting and improving the design," and that "but little headway has been made"; inasmuch as I have been incessantly at work for more than a year (six months of which have passed since the last payment), developing and completing it, and that, in consequence, this final working model will be completed and ready for the enlargement at the end of November. . . .

Again:

<div align="center">148 West Thirty-sixth Street, N. Y.,
April 2, 1895.</div>

My dear Mr. Logan:

. . . I can fully understand how from your point of view all the delay is irritating and incomprehensible, and I highly appreciate your courtesy and forbearance. On the other hand, if a sculptor is in earnest and determined to leave nothing undone that can better his work, you can hardly realize how important an event in his life the execution of a colossal equestrian statue is, particularly when the monument is of so conspicuous a figure as your father, and is to be so prominently placed.

I have had from four to six assistants constantly at work for more than a year enlarging my model. This model was completed six months ago and my personal work ceased at that time. . . . During the execution of large works in sculpture there are long intervals when the assistants have entire control. It was during one of these periods that I made the study you refer to from Mr. Howland's horse. I beg to assure you that you are mistaken in thinking that your father's monu-

ment has been neglected in the slightest degree or set aside in any way for the prosecution of other work. As I have before said, the delay arises from my resolution to prosecute the work to the utmost limit of my ability even at the cost of misapprehension of the reasons of my delay, to say nothing of the serious pecuniary loss and inconvenience which result from prolongation of the work. In this respect I am a serious sufferer.

The monument is to last a long while, and I trust that when it is erected you may feel repaid for the tax upon your good nature that its execution has entailed. . . .

After the lapse of some little time my father received the following:

Chicago, May 21st, 1895.

Mr. Augustus St.-Gaudens,
 New York City.
As you will probably recollect, I am the treasurer of the committee appointed by the Legislature of Illinois for the erection of a monument to the late General John A. Logan. When the contract for this monument was awarded to you we felt that the committee would not be complicated by any delay on your part, but after our experience, I am compelled to express my disgust at the impossibility of getting any information as to what you are doing. We ought to know when the work is likely to be completed or else you should refund the money paid and let us deal with some other sculptor.

It has required some effort to prevent this matter being brought up in the Legislature which is still in session; should the delay be commented on in that body it would be very mortifying to all the members of the committee.

Very truly yours,

JOHN R. WALSH.

To which my father replied:—

<div align="right">May 27th, 1895.</div>

Dear Sir:

The tone of your letter of May twenty-first was a great surprise. You say it is impossible to get information of what I am doing. You are entirely mistaken. When asked for it, I have on three or four occasions given a full account of the progress of the work. The letters were written to Judge Blodgett. The horse was far advanced in life-size, when I thought another action better. The rider was finished also, but in my opinion it would be better three inches larger. Either was acceptable, but I preferred to spend a large extra amount of time and money to make it as I thought best. This causes the delay, and both models life-size can be seen at my studio which is always open to any of your committee. I regret very much that they may be put in a disagreeable position with the Legislature, but my experience shows me that where delay has occurred before, it has been more than compensated for to the committee by the better monument.

You speak of other sculptors. You may remember that I did not seek the commission and that work by other sculptors was submitted to you before I finally consented to accept it. . . .

So much for the "Logan," but while I am upon this subject of annoyances suffered at the hands of some clients, let me mention another case, regarding the monument to President Garfield. The difficulty arose here not through the Committee's having any question of my father's probity, but because of a

desire on their part to take the matter of the artistic disposition of the lettering into their own hands. This resulted in a correspondence which continued until my father, at last worn down, agreed to make the changes they suggested if they were willing that he should not sign his name to the work. Evidently this brought about some sort of compromise, for the monument was unveiled with little further comment. The alterations which my father did make in deference to their wishes, however, never pleased him. On the contrary they rankled in his mind until ten years later he wrote them this letter characteristic of his constant desire to improve what he had done. Nothing ever came of it.

After seeing the "Garfield" with you the other day, I wish to make a suggestion to the Park authorities which, if carried out, would greatly help the appearance of the monument. Through a misunderstanding the shield was made for a larger inscription and now seems bare. I would remodel part of it, so as to remedy that defect without any expense to the authorities as far as my work went, if they would bear the cost of the casting in bronze. Furthermore, to obviate the bad effect of the black bronze, I should advise gilding the bust and the figure and toning the gold down lower still than I have done with the "Sherman" in New York. This would add immensely to the effect. I would charge nothing for my time. Should this meet with the approval of the Park Commission I should be glad to proceed with it at once in order that it might be completed by Spring.

However, lest it be thought that all my father's work was accompanied with business difficulties I should explain that much of what he did was assisted by a limitless patience on the

part of his clients with his tardiness and with his endless desire to alter, a patience that brought only happiness to all. The Shaw committee, which waited fourteen years without a reproach, is noteworthy in this respect, though of course that work was in a category by itself. Rather more typical commissions were those for the Hamilton Fish monument to go in Garrison-on-the-Hudson, and for the statue of Peter Cooper to stand before the Cooper Union in New York.

At the outset my father planned the Fish monument to contain figures of two women, heavily draped and kneeling, adoring a cross. Later, in memory of the mother who had died when her little child was born, he added thereto an infant, kneeling in the folds of the cloak of one figure, a conception which had that sense of mystery always so interesting to him. When Mr. Fish was asked to see the completed result, however, he expressed himself as most pleased, except with the child. Accordingly that infant was removed. And last of all, after this rearrangement had been completed, my father discovered that the early Christians stood with upraised hands when they prayed, whereupon he became dissatisfied with the whole group and started it anew for the fourth time. It is unfortunate that some record of the earlier composition has not been kept to meet the discussion among his friends as to whether or no the first attempt with the kneeling figures was not better than the final effort with the standing ones.

The monument to Peter Cooper is not quite so good an illustration of the occasional client good-naturedly bearing with this same readiness on my father's part to reconstruct to an endless extent. For here, as with the Shaw, the Committee realized that because of his deep gratitude toward the institution which had given him his start he regarded his task as a labor of love into which he wished to put more effort than his financial returns would warrant. What caused his delay here was that before he even thought of beginning the large figure, he erected in front of a model of the façade of the Cooper

Union, which he set up in the studio, as many as twenty-seven sketches of the figure with various compositions of the hat, coat, and cane. In this work alone I think my father showed later some little dislike for the efforts of his faithful collaborator, Stanford White, because one day, a few years after, on passing the monument with me, he remarked that he was sorry the canopy had not been further studied, since with his more tranquil eye he could see that the delicately traced architecture and fine lettering were not in keeping with the subject of a heavy and bearded man.

Such instances as these, however, in which my father was allowed to pursue the natural deviations of his work unmolested, were, as I have said, the exception. Nor were the entanglements where they did exist confined to the commissions concerned. His intensely sensitive nature permitted any distraction to affect his work at large for days at a time. Therefore, I will dwell even further on this aspect, and turn from distractions within to those without the studio. I quote a leaf from my father's weekly calendar beginning Sunday, March Fourth, 1894, which hints briefly at the demands of his outside engagements.

4. Sunday
 Wells Concert 3 P. M.
 Wells dinner at Petit Véfour at night.
5. Monday
 Architectural League dinner 6:30.
 5 P. M. Ward. (Sculptor.)
 Jap Lecture. (La Farge.)
6. Tuesday
 Society of American Artists revision and prize
 awarding.
 Tom Moore. Ellen Terry. General Miles.

7. Wednesday
 Municipal Art Society meeting at 4:45 P. M.
 10 West Twenty-third Street.
 Typewriter 6 P. M.
 Miss Goeghan.
8. Thursday
 Boston with McKim and Hunt.
 Jap Lecture. (La Farge.)
9. Friday
 7 P. M. Society American Artists dinner.
 Varnishing day Society American Artists.
10. Saturday
 Dr. Wallace Wood.
 Mrs. Chapman. 4 P. M. Studio.

As this calendar indicates, my father, during the course of years, spent more and more time in the center of an active group of men who were eager, without pose or affectation, to aid in the artistic development of their land. In especial does the following letter with its annotation suggest the variety of considerations to which my father and Mr. Gilder, his chief fellow-enthusiast, gave thought, and were prepared to give more when backed by similar attention on the part of others.

New York. April 12, 1892.

Mr. Richard Watson Gilder.
Dear Sir:

I am very much pleased to see the interest you have taken in the building of the Washington Memorial Arch and other works of art in our city.

I read with much pleasure the remarks published in the New York *World* last week upon the completion of the Arch.

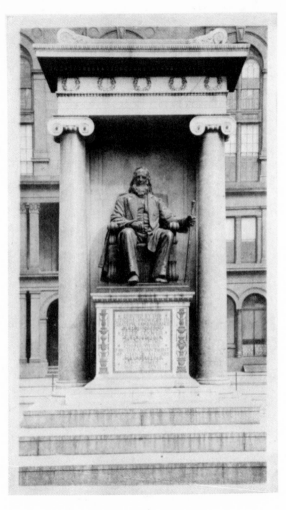

STATUE OF PETER COOPER

This statue stands in front of Cooper Union, New York City. The pedestal and architectural
background were designed by Stanford White (Messrs. McKim, Mead and White)

AUGUSTUS SAINT-GAUDENS

I would like to call your attention to one point in the city which has been neglected, and where I think a great improvement could be made.

I refer to the unfinished tops of the two towers of the Brooklyn Bridge. By adding a few courses of stone and placing a balustrade or bronze railing on the top enclosing a colossal group of statuary they could be made the most striking objects along our river front and bay of New York.

A group on the New York tower representing an Indian, a Hollander, and an American citizen would be very appropriate. Or a group composed of John Jay, Alexander Hamilton, and deWitt Clinton, all New Yorkers, would do.

Allegorical groups would also be very appropriate—Commerce, Agriculture, and Manufactures.

I hope you will use your influence to have this work carried out sometime in the near future.

Yours respectfully,

CITIZEN.

On the envelope of this letter is written, "How would it look? R. W. G." and beneath, in my father's handwriting, "It's hard to tell without seeing the Bridge. But from a rough pencil sketch I have just made it seems to me worthy of consideration. A. St.-G."

Again, in 1887, Walt Whitman was even poorer than usual. Also the photographer, Mr. George C. Cox, was producing results far ahead of his decade, to the delight of New York artists, though not to that of the public. So under the leadership of Mr. Gilder and my father, who were friends of the aged poet and the photographer, the admirers of Whitman and of Cox combined forces. Cox took a limited number of photographs of Whitman, who signed them, and the results were sold at fancy prices for the benefit of both.

From such examples of comparatively foreign considerations, I turn again to one much nearer my father's path of life, the development of the Boston Public Library building. The groups

113

to go in front of it, which my father was unable to finish before his death, he probably held more at heart than any other work he ever undertook. But beside his interest in this actual sculpture, he displayed great activity in the development of the building. For instance, though Stanford White, during the course of this work, seemed chiefly anxious to allot the decorating of the interior wholly to European painters, my father. on the other hand, strenuously insisted that there were strong men of American fiber who should be employed. So it was in a measure due to him that Sargent and Abbey were given their opportunity.

The letter which he wrote Mr. McKim regarding these American painters, I have already inserted in the chapter on his fellow-artists. But here is another he sent later to the same friend, which shows his enthusiastic state of mind towards the whole undertaking.

148 West Thirty-sixth Street, Nov. 29, 1894.
Dear Charles:

I was in Boston the other day with my brother Louis, and saw for the first time the staircase finished. I write to tell you that we were both completely bowled over by it; it is a splendid piece of work and even as it is, without the painting of Puvis, I know nothing to equal it. The oiling of Louis's lions, and the placing of the inscription under them, has entirely changed their character too. They now seem to me to have a very swell look, and a big "raison d'être." They certainly have completely changed in character from what they were; and, now that everything is "cleaned up," they fall completely in harmony with the rest. But it was not about them that I started to write. It was simply

to congratulate you on the splendid work you have produced. It has fired me all up to get at the groups and make as swell a thing as possible; although it will be hard to compete with the nobility of the staircase.

All I have said may seem wordy, which is very likely the case; it may also seem fulsome, which is not the case; for I am simply expressing what I feel.

<div align="center">Yours,</div>

<div align="center">Gus.</div>

Yet though in his efforts for the public good, it must be obvious that my father was ever ready to work and to work hard behind the scenes, any personal appearance in public was extremely distasteful to him, as the following letter to Mr. Hamilton Bell will confirm.

147 West Thirty-sixth Street, Oct. 7th, 1895.

Dear Bell:

I fear my silence with regard to the Presidency of the Municipal Art Society may have appeared discourteous. Please forgive me. It has been on my mind and I hoped to see you at "The Players" on several occasions and speak to you, but you were "non est." You will have to leave me out of that very honorable position. I am totally unfit. I should be a helpless man, and on the one or two occasions where my presence might be necessary I should not only be frightened to death, but I should demoralize everything within sight and hearing.

<div align="center">Yours faithfully,</div>

<div align="center">A. St.-Gaudens.</div>

Throughout such interests outside as well as inside the studio, my father clung tenaciously to his original body of friends.

White was still the rock to fall back on, though the personal intimacy of the two was slowly growing less, while McKim, on the other hand, came more and more close. Strangely enough, aside from Herbert Adams, my father had few sculptors close in his confidence. But among the painters there were as ever Dewing, Thayer, Brush, Cox, H. O. Walker, and many others, as well as a few whom he saw less frequently, like Edwin Abbey, John Sargent, and Andreas Zorn. I remember how Sargent entertained Saint-Gaudens by his efforts to have him undertake something ugly. "Don't be afraid," Sargent would say. "Why I've got a sitter down in my studio who looks as though he'd been fished up from the bottom of the sea." Zorn, too, who made an etching of Saint-Gaudens and was always a favorite with my father, furnished many anecdotes which the sculptor recounted in after life. The last of them was especially liked because of its illustration of the casual way Zorn took himself.

The artist appeared at the studio one morning to sit silent for some minutes, as was his custom while my father worked.

"What are you doing next?" said my father, finally breaking the pause without turning around.

"Going back to Europe in twenty minutes," breathed Zorn without looking up.

And he went.

For the most part, I think my father influenced his friends more than they did him. But one change in especial which they brought about during these years was the making of my father into a club-man, so that before he left New York, he belonged to an endless succession of organizations from "The Lambs" to "The Metropolitan." Chief of these, the one which he regarded most seriously was "The Century Club." But even closer to his affection stood "The Players," where he became early a member, and where his delight in the "round table group" never ceased. The men of this little clique, especially those who called themselves members of the "Saturday Night Club," which habitually clustered before the rarebit with oys-

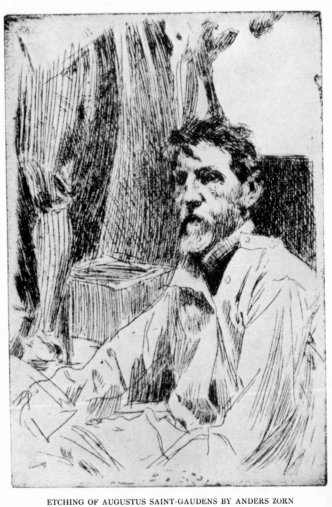

ETCHING OF AUGUSTUS SAINT-GAUDENS BY ANDERS ZORN

ters, made by Dewing or White, comprised many of those I have already mentioned. But in addition there were other such cronies as Edward Simmons, Robert Reid, Willard Metcalf, Cooper Hewitt, Charles S. Reinhart, with later William Smedley, Charles F. McKim, and James Wall Finn, and always for some mysterious reason on the night after Thanksgiving, William Gedney Bunce. Here again, as with the first body of men whom I mentioned awhile back, my father was in his prime story-telling mood. The anecdotes in themselves were not unusual, but few were immune to the charm in the manner of the telling, the Irish wit, and energy, the trick of rising from his chair to illustrate his discourse with irresistible gestures, the varying tones of voice, the magnetic enjoyment both of the humor of the anecdote and of the appreciation of his listeners. One source of pleasure alone he never really shared with his friends, tobacco. He always had a wistful longing to appreciate a smoke as he saw his friends appreciating it. But up to the last ten years of his life he could never make a success of his attempts, and even after that it was with no real relish that he handled his after-dinner cigar.

Finally on leaving this period I quote a letter which my father wrote to his niece, Miss Rose Nichols, not long after the death of his friend Bion who had remained so intimate with him through all his life. Bion had given up sculpture and was devoting himself to his friendships and his philosophy. With infinite leisure on his hands he had fallen more and more into the habit of writing my father long weekly letters in which he spoke of the actions of his acquaintances and of the events of the art world. My father's lengthy replies were unfortunately destroyed according to a request in Bion's will. On his death, my father wrote:

148 West Thirty-sixth St., Feb. 17th, 1897.
Of course the one thing on my mind, the terrible specter that looms up, is poor Bion's death; night and

day, at all moments, it comes over me like a wave that overwhelms me, and it takes away all heart that I may have in anything. To-day, however, I have had a kind of sad feeling of companionship with him that seems to bring him to me, in working over the head of the flying figure of the "Shaw." The bronze-founders are not ready for it yet. I have had a stamp made of the figure, and I am sure you will think I have helped it a great deal. You know that Thayer told me he thought an idea I once had of turning the head more in profile, was a better one than that I had evolved, and I 've always wished to do it. It is done, and it 's the feeling of death and mystery and love, in the making of it, that brought my friend back to me so much to-day. . . . The young, thank Heaven, do not feel these blows so profoundly as do older people. In one of my blue fits the other day I felt the end of all things, and, reasoning from one thing to the other and about the hopelessness of trying to fathom what it all means, I reached this; we know nothing (of course), but a deep conviction came over me like a flash that at the bottom of it all, whatever it is, the mystery must be beneficent; it does not seem as if the bottom of all were something malevolent. And the thought was a great comfort.

I shall be all the week at the figure. I 've made an olive-branch instead of the palm,—it looks less "Christian martyr-like,"—and I have lightened and simplified the drapery a great deal. I had not seen it for two or three months and I had a fresh impression.

At Twenty-seventh Street I 've finished the nude of

the "Sherman," and next week I begin to put his clothes on him. I had another day with the model for the "Victory" last Sunday, and that, too, is progressing rapidly. Zorn, the Swedish artist, was with me all day Sunday, making an etching of me while the model rested; it is an admirable thing and I will send you a copy of it.

The studio is once more in a fearful condition with the casting of the "Logan," and the getting of the "Puritan" ready to photograph and cast for the Boston Museum and to send abroad to have the reductions made. . . .

This letter is no good, but it must go; the clatter of seven molders and sculptors does not help to the expression or the development of thought, confusion only. . . .

V

THE LAST TRIP ABROAD

1897-1900

A Sick Man—To Paris—Paris Work, Sherman, Library Figures, Brimmer, Lowell, Dana, Stevenson—Scotland—"Amor Caritas"—Sherman—Depression—To the Midi with Garnier—Aspect—Saint-Gaudens—Garnier's Narrative.

THE previous chapter ended the account of my father's life in New York. He never returned there again as a resident. He had paid the city its price. From the "Farragut" to the "Shaw" he had given it his prime, his health. He left it a sick man, crippled for the remainder of his life by the ardor of his work. He had but ten years to live, ten years which he contrived through an extraordinary strength of will and body to spend wholly upon his art. When he returned to this land in 1900 he returned to the surgical ward of the Massachusetts General Hospital. Twice in the succeeding seven years he visited such places, and in the interims he lived for the most part in Cornish, New Hampshire, where the outdoor existence he had learned to appreciate helped, above all else, to keep him at his work until the month of his death. Let it not be thought, however, either from what I have said or from his own reminiscences that Saint-Gaudens' sickness had taken him abroad. Quite on the contrary, it was his knowledge that his art had reached its strength that, for the last few years, had given him his desire to visit France. For in Paris alone he could measure himself with his contemporaries, place his work before the world's most critical audience, and learn, once for all, wherein it was good and wherein bad.

With this foreword I turn to the laconic four paragraphs

which my father gives to his arrival in France and his work there, before I attempt to substitute for his omissions the letters and notes which I have gathered. He writes:

As I have said, as a result of all this turmoil, and sickness, and discontent, I resolved finally to face the problem of uprooting my American studio paraphernalia and of betaking myself and it to Paris for a stay of unknown length.

From the dock at Liverpool we went straight to London. From London we went on the following day to Paris. The country between Calais and Paris seemed very grand; great rolling lands with immense fields being plowed in the waning day. The peace, simplicity, and calm of it all was profoundly impressive; just a plowman and a boy, alone in the country on a hillside following the horses and the plow along the deep, straight furrows; no fences, a clear sky with the half-moon, and only a small clump or two of trees—all so orderly and grand.

On arriving in Paris, after the usual inevitable agony of a dreary, maddening, and hopeless search for a studio, racing from one side of the city to the other, and back and forth, I found a place in a charming little garden-like passage in the Rue de Bagneux, of which there are so many in out-of-the-way corners of Paris, the mere existence of which makes life worth living. There I began by remodeling the figure of the Sherman Victory and some studies of the groups I have still to do for the Boston Public Library. When I reflect on the number of years that has elapsed since the latter com-

mission was given me I feel as if I should hide my face. The reason of the delay is that I am determined that I shall do everything that lies in my power to make them as good as anything I have ever executed, and they are somewhat in a category, considering the number of figures, as far as compensation goes, with the Shaw monument. The bust of Martin Brimmer I also did in Paris at that time for the Boston Museum of Fine Arts, and the medallion of Mrs. Josephine Shaw Lowell, who was then visiting Paris.

First of all, however, stood my work upon the "Sherman," and while I was at it the days came and went rapidly because of my steady and enthusiastic toil. The head of the General on the statue was virtually a copy of the bust I had already made from him, without any modification other than the change of a detail or so. But the rest was far from being so simple a matter.

That is all my father has to say. Yet in addition to the orders he has mentioned, while in Paris he modeled a medallion of Charles A. Dana for the *New York Sun*, altered the Stevenson relief, once more created a new variation of his "Angel with the Tablet" from the Smith tomb figure, and made reductions of a large number of his medallions, as well as the "Puritan" and the "Diana."

The Dana relief was completed first for Mr. Lafan, though later the Dana family desired and obtained it. Otherwise it was sent home without involving Saint-Gaudens in any further complications during the course of its construction. But the other work, the "Stevenson," the "Angel with the Tablet," and the medallion reductions, were produced under circumstances so close to his intimate life that they should be dwelt upon.

AUGUSTUS SAINT-GAUDENS

The second commission I mentioned, the large variation of his Stevenson relief, was remodeled for the church of St. Giles, Edinburgh, Scotland. Beside increasing the size, my father changed many details, in addition to those already mentioned of replacing Stevenson's bed with a lounge, and his cigarette with a pen. Among them it is a matter of amusing record in the studio that the one thousand and fifty-two letters of the inscription, which contain quotations from Stevenson's poetry, were modeled—not stamped—twelve consecutive times. For my father was worried as to whether he should insist that Stevenson's poem, "Lines to Will H. Low" be inserted, or should yield to the Committee's desire that a Stevenson prayer be placed upon the plaque. Furthermore, the emblematical heather and hibiscus garland seemed to cause him much trouble in procuring proper models.

On the other hand the commission gave him occasion to make two trips to England, where he felt most happy over the cordiality with which he was received by the English artists and sculptors, who ultimately made him a member of the Royal Academy. For example, a dinner was given him at Earl's Court, a sort of London Coney Island, whereat that serious body of men, Sargent, Abbey, Sir Alma-Tadema and the rest, with their serious group of women-folk, behaved as all serious people should upon such an occasion. From that dinner, not so very serious, they went to see the Javanese dancers, in whom Sargent had become so interested that as a relief it was needful to cap the evening by indulging in such Scenic Railway excitement as the land and the law allowed. These portions of two letters to Miss Rose S. Nichols show his interest in the matter and the pleasure brought him especially by his last visit while negotiations were in progress.

He writes:

AINSLEE PLACE, Edinburgh, January 7, 1899.
I left Paris Wednesday morning and found, when I

125

got to London, that a meeting with the Stevenson memorial committee was absolutely necessary and that they could not be got together till to-morrow, Monday, morning. All this after much telegraphing, and conferences with Sidney Colvin, the "Keeper of Prints" of the British Museum and the intimate friend of Stevenson. I therefore had two days of it in London, two of the most miserable days of my life. Sargent I saw for a few hours; he was very busy with a crucifixion for the Boston Library, a remarkable thing. I had lunch with Colvin, and then I roamed around the streets under the gloomy sky.

The one thing that made a great impression on me was an exhibition of almost the entire life-work of Burne-Jones. He certainly was a very big man, but his work contributed to the intense melancholy that seemed to seize me. I have felt it somewhat in Paris with the gloomy weather we have had of late there, but here it has been unbearable; moments of feeling that which I have never felt before, indifference to achievement of any kind, and an utter absence of ambition in myself. However, I am away from London now and the two nights of ballet spectacles there were a relief. Then also, after great hunting around, I succeeded in finding a great friend of Joe Evans, Robert Tabor, an actor who had been with Irving and has had great success here in "Macbeth." He played with Forbes Robertson.

Yesterday, Saturday, I journeyed all day in the mist to this place, and all to-day I have been tramping round

Edinburgh, first with Mr. Bell, then this afternoon with General Chapman, commander-in-chief of the British forces in Scotland, and Mr. Blaikie, the printer of the great Edinburgh edition of Stevenson. I lunched at the General's; and he took me to the castle, and the entire day has been spent in the mist. It is certainly a remarkable city, and I did not have much time to indulge in melancholy, but I should have enjoyed it more keenly had I been in another mood, or if there had been sunshine. That may be the reason of it all. Not a ray of sun for ten days now.

We had Professor Masson, Professor of Rhetoric and Languages at the University here, and Mr. Blaikie at dinner last night. They cracked ecclesiastical jokes which were absolutely mysterious to me, but provoked great hilarity in them. They talked with that rich Scotch brogue I like so much, and were altogether very kindly disposed.

To-night they have the President of the Royal Academy, besides some great literary swell, whose name you know, but for the life of me I can't remember; and then there's an artist of the Glasgow School, a man of talent.

It seems as if all the élite and nobility of England are associated with the Stevenson monument; beginning with Lord Rosebery, who was the originator of the idea and is the president of the committee. I shall probably make the "Stevenson" full length, in gilded bronze with a pen in his hand instead of the cigarette, with perhaps the name of his works or some selections

from his writings that they may choose, all very simple, on some red marble, with perhaps a Greek lyre in the middle, under him. Or I may make it in some yellowish stone on a gilded slab.

Again:

> 3 Rue de Bagneux, Paris, Jan. 15th, 1899.

. . . Edinburgh is a great place, and I 'm sorry I did n't see it in fine weather. Coming back I became very chummy with Gerald Balfour, General Secretary of Ireland, brother of the noted Balfour of Parliament, and nephew of Salisbury; a nice fellow, who told me of some black draught that prevented his being sick on his frequent trips to Ireland during gales. The result was that, although in crossing the Channel the steamer turned somersaults, I remained god-like and superior while the other mortals were in the usual throes. As Louis wrote, "Life is full of surprises, mostly beneficent." . . .

<div align="right">A. ST.-G.</div>

Allied with work on the Stevenson came work on the other medallions, the "Angel with the Tablet," and the reduced bas-reliefs, which, together with the larger work in two exhibitions, had much to do with the French Government's creating my father an Officer of The Legion of Honor, with their making him a Corresponding Member of the Société des Beaux Arts, and with their offering to purchase certain of his bronzes for the Luxembourg Museum.

What led my father to consider altering once more the ideal figure which he had developed from the Morgan tomb angel into the Smith tomb form, was that John S. Sargent had become interested in the composition of the Smith tomb figure and

SKETCH FOR ALTERATIONS OF STEVENSON RELIEF FOR EDINBURGH

SKETCH OF ORIGINAL IDEA FOR BAS-RELIEF OF WAYNE MACVEAGH
AND HIS WIFE

had desired to make a painting of it. Therefore, since my father had the greatest admiration for Sargent, he began to believe in a piece of his own work that could be paid so high a compliment. Also, beside this consideration, the Smith tomb figure had originally been modeled in the studio with the knowledge that it was to go to the stone-cutters, and consequently the technique was not over carefully rendered; so that now, realizing that the most skilful sculptors in the world would see it in bronze, my father felt it needful to give his attention to each and every detail. As a result, though he made only the fewest changes in the general composition, he modeled the wings in a more formal fashion and simplified the drapery with the greatest care. Indeed this process of conventionalization went even to the inscription, where the pains he took to substitute the present result shows anew his anxiety over even the smallest trifles. It is pleasant to remember that the composition achieved such a success in the large that my father decided to reduce it to the small size now so frequently seen. He often announced his intention of producing this reduced figure in marble inlaid with gold and ivory and precious stones. Unfortunately he never found the time or the proper occasion.

Here are two letters he wrote to Miss Rose S. Nichols concerning the figure:

<p style="text-align:right">September 14th.</p>

. . . I have had a good reduction made of the "Angel with the Tablet" that came out very well, some changes that I could accomplish in the shape helping it a great deal. This also I am going to put on the market, and the question is what inscription I shall put on the tablet. Can you think of any? The figure means so much that a wide range of device is possible. "To know is to forgive," "Peace on Earth," "God is Love," "Good will towards men," "Amor Caritas," are

those that have occurred to me. Of course I would only use one on the tablet. You can imagine the figure with her hands upholding the tablet with the inscription. Either of the four are appropriate, but a longer one would be better. If any occurs to you let me know.

December 16th.

Since my last letter I have seen the Director of the Luxembourg. He called to see me and I went to see him. It is now settled that the Government is to purchase the "Angel with the Tablet," for which I will ask them a nominal sum, as I wished it clearly understood that it was *solicited* and *bought,* not offered by me to them. They said that Burne-Jones had given them a painting when they asked to purchase one for a small sum, as he felt the honor of being solicited. I said, "That's the way I feel, too, and I would do likewise, but I do not wish to have it thought in France that I offered my work to museums." * Yesterday the gentleman, a government official, who was the intermediary between the Director and me in the affair at first, came to tell me that my name had been inscribed for the Legion of Honor and that, if it were not officially put through in January, it would be in the spring certainly. He also took me to see two of the most distinguished of the new men here, and I have been loaded down with praise and attention by him and them; all of which is very pleasant, "n'est-ce pas?" . . .

* Ultimately my father acted as did Burne-Jones, and refunded the purchase money.

AUGUSTUS SAINT-GAUDENS

But if the "Amor Caritas" did much towards establishing my father's reputation abroad, the "Sherman" did more. Let me turn now to his mention of the equestrian monument, which I have held until the last in this account because, as he himself says, "it was far from a simple matter."

To bring the statue to a point where it could be properly exhibited in the French Champ-de-Mars of 1899, my father had knocked into one studio three of the ateliers in his little alley-way, and had gone at his work with his usual energy. Throughout its progress, the state of turmoil reminiscent of New York days remained only too like and too constant. I recall one typical incident of the time. An accident happened to the cast of one of the hind legs of the "Sherman" horse. As my father was in urgent need of a duplicate he sent a man to the United States especially to pack it and to bring it back. Three weeks later the man returned—with the wrong hind leg.

That hind leg had a vindictive manner of agitating my father anyway. Later, when the horse was enlarged, the leg constantly sagged, and the assistants as constantly plugged up the cracks in it without his realizing what they were doing. Then, just before the monument was to go to the exhibition of 1899, in taking his final examination my father noticed that the limb seemed out of proportion, though every one assured him it was correct. He persisted, nevertheless, and at the last moment requested Mr. Henry Hering, his assistant, to measure it, only to find it three inches too long. So again useless work was entailed.

Results, however, justified the pains spent on the monument, and, best of all, my father realized it. His state of mind as to the Sherman is further told in these letters, one to his old assistant Mr. A. P. Proctor, two to Miss Rose S. Nichols, one to Mr. Louis Saint-Gaudens, and one to me.

To Mr. Proctor:

3 Bis Rue de Bagneux, Saturday, 6:30 P. M.

Dear Proctor:

. . . I should like very much to pass to-morrow with you, but I have a job in front of me that I have devoted the day to, i. e., looking for the measurements of General Sherman. It seems impossible to get at them. I want them *"right now"* and I suppose, after I have looked at every scrap of paper, rag, wood, clay, photograph or drawing I possess, and there are millions of 'em, I'll find the durn thing under my nose. . . .

To Miss Nichols:

. . . I have been arranging drapery on four copies I have made of the nude of the "Victory," and one of the four has come out remarkably well, so all I have to do is to copy it, and I am consequently much elated. In a day or two I shall have the "Sherman" cast, and the enlargement to the full size begun. While that is being done, I shall model the small "Victory," which will be ready for the Salon in the spring. My idea is to exhibit the full-size "Sherman" on the horse, and alongside of it the small model of the entire group. . . .

The reason I have felt so elated over this drapery business, is that it makes the drapery on the Library figures, and the Angel with the Brooks,* child's play, as far as the always complicated and terrible question of how to arrange flowing draperies goes. It's a ques-

* Compare page 327.

tion that each fellow has to dig out for himself. I
have been two weeks arranging these four models with
the greatest care, and now I am ready to pro-
ceed. . . .

Later:

I think I told you that my "Victory" is getting on
well. It's the grandest "Victory" anybody ever made.
Hooraah! and I shall have the model done in a month
or so. On the other hand, I do not know whether I
have told you that the cloak has been the sticking-point
on the "Sherman." Well, I pointed and cast it with re-
luctance; and now, after a good rest, I went at it again
to-day with a rush and with a new and simpler ar-
rangement which I was able to make on the manikin.
I worked like the devil until Antonio, my handsome
Italian boy, brought in the lighted lamp because it was
so dark, and to-night I feel I have *that* cloak now, just
as I have the "Victory."

To Louis Saint-Gaudens he wrote a year after, this time on
the occasion of the statue being exhibited in the French Ex-
hibition of 1900:

I'm very cocky about the "Sherman," which has
turned out well, particularly the "Victory." It has cost
me about two thousand dollars, though, getting all these
things together and in the Salon, and many, many gray
hairs; and I have often wished that I could be the
Egyptian-like philosopher that you are, instead of the
red-headed monkey that I am, jumping from branch

to branch apropos of nothing, hanging on by my tail, and throwing cocoanuts at the other apes, also "à propos de rien." . . .

Lastly, perhaps after all this letter to me expresses best his state of mind:

3 Bis Rue de Bagneux, May 2nd, 1899.

Dear Homer:

At last I have a free moment to send you a line. Talk of insane weather in Cornish, that's nothing to the insane asylum at the above address for the last eleven days. Eleven molders, some of them working all night with the boss lunatic, your illustrious father, at their head! Whew!!! Sometimes I'd cry, then I'd laugh, then I'd do both together, then I'd rush out into the street and howl, and so on. Now it's as peaceful as the ocean in a dead calm. Only I have got a swelled head for the first time in my life, for the "Sherman" really looks bully and is smashingly fine. It's in the place of honor at the Champ-de-Mars, and from a screeching maniac I have become a harmless, drooling, gibbering idiot, sitting all day long looking at the statue. Occasionally I fall on my knees and adore it. And there you are!

With the account of the "Sherman" complete, I may shift from my father's work to consideration of his state of mind while he produced it. The gloom of which he speaks in the letters to come, together with the note of introspection that accompanied it, was a phase of life brought about by his illness, and very different from his usual condition in his healthy and

active years. Of this unhappy neurasthenic state Mr. William A. Coffin has spoken in a letter written to me sometime since. He says:

"Paris nauseated him. He explained that in the streets the men and women he met seemed to him 'to be thinking about sex all the time,' and he found Paris changed. I remember that in that talk we were inclined to lay the blame for certain changes in life and manners on the back of the Republic, though neither of us had monarchical sympathies. We noted changes, that was all."

But perhaps my father himself best describes his own mood in a letter to my mother:

. . . I have been so depressed and blue that I have felt, as I have only felt once before, a complete absence of ambition, a carelessness about all that I have cared so much about before, and desire to be ended with life. The feeling has been uncontrollably strong and I can sympathize with you when you have that terrible depression that makes you wish to cry. That is what I have wanted to do frequently since I've been gone. There is too much misery and unhappiness in the world, and all this struggle for beauty seems so vain and hopeless.

This letter, then, explains my father's true state of mind, which he so lightly touches on in the reminiscences. a state of mind that caused him to seek anxiously for distraction and so to take to Italy the trip he so vividly describes. He writes:

Since it was October, I at once found that I was to experience one of those dark French winters, so terrible in comparison with the bright skies in America, and

this knowledge did not contribute to alter the deplorable mental condition I was in when I left America. Therefore, shortly after my arrival in Paris, I started off for a trip to the old beloved haunts in Italy, planning to make on the way a visit to my father's village and to do that for which dear old LeBrethon had put one hundred francs under my plate at the dinner to me thirty years before. I had invited to accompany me Alfred Garnier; be it remembered that he was one of the friends with me on that trip to Switzerland, which I began by tumbling down stairs. So one fine day we met by appointment in the Gare d'Orléans, very much as we had met in the days of our youth and hopefulness. It was a shock, as I entered the station and recalled that first departure, to see there in the distance the little man with white hair and beard, for his had been black at the previous appointment and mine reddish. Nevertheless our hearts were just as light as we got in and the train moved off.

It is impossible for me to describe my emotions upon arriving at the village I had heard my father speak of so frequently and at seeing my name over a door at the head of a little narrow street, where a cousin of mine conducted a shoe-trade and also dealt in wines. It is that singular sense of being at home where one has never been before which I am sure is the result of inherited memory. We inherit all kinds of strange things—why should we not inherit memory? This is no uncommon feeling I have had, but one I hear constantly spoken of; for instance the love of England,

... ADAMS WITH HIS COUSIN HECTOR SAINT-GAUDENS AT SALIES DU SALAT

that so many of my friends of Anglo-Saxon origin have when they go there for the first time. I have not a trace of it for England, though a great lover of its dignity and beauty, but I have it in a singular way in France, and what was much more extraordinary, I possessed it in Spain, during a visit I am going to tell about later on. I suppose the vicinity of my father's birth-place to the Spanish frontier, which is only about twenty miles away, must account for that.

From this little village of Salies du Salat, which I spoke of in the beginning of my narrative, a cousin of mine drove us over to Aspet, my father's birth-place. On that drive the gorgeous scenery of the Pyrenees, the orderly look of the country, well-cultivated, well attended to, the thrifty look, so common in France, and the jangling of the bells on the horses, gave a first hint of Spain that can only be appreciated by those who have had experiences of a similar nature. The village of Aspet is about three hundred feet above the plain and you come into it suddenly. You enter the principal street and, directly at the head of it, which is as picturesque as the winding streets are in all those towns, is the snow-capped Pic du Cahire of which I had heard my father speak so often.

"It is a beautiful country I come from, my boy," he had frequently explained, and I had just as frequently taken his remarks with a grain of salt. But I have found now, so many years after he has gone, that what he said was literally true.

From Aspet my friend and I resumed our old habit

of long before, and decided to walk to the town of Saint-Gaudens. We left in the early morning to the cheerful clink of the village blacksmith's anvil, as no doubt Father had heard it in his youth. We walked down into the valley of the Garonne, across that river; and beyond, rising on a gentle slope, we entered the town. We rested at a little café on an open plaza so placed that from it, as you looked south, you saw the range of the Pyrenees; and a noble one it is too, not enough realized by us in America, snow-capped, extending from the horizon on the extreme right. The location of this public square at this spot shows the unconscious love of beauty that pervades the people of the country even in so small a village. I wish I could say as much for their love of cleanliness. In this town also there is a Roman Church, small but very beautiful, which an archæologist friend tells me is quite remarkable, for some reason too deep for me to fathom. We roamed around for two or three hours and finally took train for Toulouse and our beloved Italy.

On the way from Saint-Gaudens to Italy we stopped at Nice over night and were assigned a room in a hotel that recalled the stately days of the periwig and minuet, an enormously tall place with high windows and everything on a scale which made us feel lost in space. I had had a little experience with my friend on the two or three previous nights of our journey, but what follows was the first thorough revelation of a characteristic of his which lent singular diversity to our journey.

First, I became dimly aware, in the middle of the night, that something strange was occurring. This took place two or three times. On each occasion, when I half awoke, the strangeness grew on me, until with a final effort I sat up in the dark to listen. I shall not be believed, but for a moment it seemed to me as if some one was moving furniture in the next room, the moving of heavy furniture up and down the floor by wild men and lunatics is the only way of giving the impression of this terrific sound. Presently, however, the rhythmic character of the noise revealed the extraordinary snore of my friend.

I shouted "Garnier!"

The sounds kept on.

Again I called and louder, "Garnier!"

Still the furniture moved.

My third shout followed, but the impassive Garnier kept at his work. At that moment I saw it was early dawn, while from a belfry that ran up on the other end of the court, chimes began to ring, and I understood the reason we were given so beautiful a room for so small a price. There was a sounding-board character to the four-sided court that made the bells seem at that hour as if they were swung by fiends instead of angels. Moreover it was Christmas morning, which we had not realized.

I went over and pulled up the curtain. The bells mounted in their peal. "Ding-Dong! Ding-Dong!" Then Garnier's snore out-topped that. Then the bells reasserted themselves, some high-keyed, others low,

but no less strenuous. "Dong, Dong, Dong!" they continued, broken only by my shoutings and Garnier's trumpeting. It was incredible. It seemed as if the bells would wake the dead in their knelling paroxysm, but Garnier kept at it until I seized him by the feet and shook the sleep out of him.

"Snore," said he, "I never snore. I have been married thirty years and my wife has never said anything about it."

"I replied: 'Your wife is either a saint and bears all this, and in order not to hurt your feelings, does not tell what is true, or she must sleep in a way that is beyond my belief.'"

Then I remembered my father and Dr. McCosh!

From Nice we walked along the Italian coast to Ventimiglia where we took the train for Rome. It was one o'clock in the morning when we reached there. But on our arrival, I was so excited, for it is the city of all cities I would prefer to live in, that I insisted on our sallying out from the hotel in order that I could go to the Café Greco and climb up the Spanish steps, and Garnier followed me with patient toleration. Why should one go out at the hour of the night when one might be in bed? In the old Café it was strange to see the same waiter who had helped me to my coffee, now a comparatively aged man. This return to the places of earlier days invariably brings to me a touch of alluring sadness, a singularly sweet melancholy. This meeting of the waiter, grown old in the years of my absence, recalled again to me the almost daily im-

pressions I had received during my stay in France; it was the shock, so to speak, of seeing my hilarious, shouting comrades of '67 become old men, bald, white-bearded, and grave.

After Rome we visited Naples and Pæstum, and, coming back from the latter place, we walked from Salerno to Amalfi on a day and a moonlit evening which were beautiful and poetic beyond belief. Then we returned to Rome and I was for going to Florence and Venice. But by this time, although it was only ten days since our departure from Paris, Garnier had grown homesick for his sacred city habits, and despite the fact that here was the opportunity of his life, the first time he had visited Italy and certainly the last time he would have the chance, he preferred sacrificing those wonderful places to prolonging for another day his absence from his beloved Rue de Couesnon. He was of the type of essentially reasonable Frenchman of whom I have spoken, cultivating their little gardens in MacMonnies' Court. I was a wild American who had come in one fine day and dragged him on journeys afar off, dragging him away from his studio, his beloved wife, and all the habits of the wise Frenchman who has settled down to a peaceful life with his "déjeuner" under his little vine, amid the peaceful and orderly making of his little errands.

Thus my father ends his account of his trip. As I filled out his description of his first walking trip with Garnier by a letter from that old friend, so now I add to my father's story of their

later voyage, a translation of what his comrade wrote of it in French to my uncle, Louis Saint-Gaudens.

My dear Fellow:

What I told you yesterday is nothing alongside of what I think and know about Augustus. They are trifling things, if you will, but I remember so many. It would take days and days to write it all. It would be like recommencing "A Thousand and One Nights."

Our trip in Switzerland years before was like a merry dance. In it we were like escaped colts; we came upon such beautiful things, buildings, sculpture, paintings, but the greatest of all was continually to look, look, look. We swallowed road after road. We saw valleys and mountains, one after another, and constantly said to ourselves, "What is still behind them? I wonder what is above and what is below?" Never satisfied, never satiated, we were like children emptying a sack, stopping only when we had got to the bottom of it. We were intoxicated with the air and with the sky. The far-away horizons attracted us. We absorbed all nature. It was a marvelous life which we imagined would last forever, for at our age we thought of nothing except of living.

But when we went to Italy we looked at things through other eyes. I was very happy to have Gus come at the time of the Exposition of 1900, as I had not seen him since 1889. What a surprise it was when he said to me, "I am going to Italy, and you must accompany me."

"But, my dear friend," I said, "I can't do it. I have neither time nor money."

"Don't let that trouble you," he replied. "You will give me pleasure by coming with me and you will help me to save money. For on the railroad we will go second class. Traveling alone, I would go first class, and in the hotels you will know how to keep the people from cheating me."

Well, at any rate, he said a lot of things to prove to me that

I was doing him a service instead of the other way, that he would really be very much obliged to me. There again he showed his good heart, saying, to himself of course, "If I do not get Garnier to go with me to Italy, he will never have the means to go himself, so I will try and make him believe that he is obliging me, and that will decide him." Of course you understand I saw through it all, but it was so tempting that I said, "All right."

We began our trip by going to the Pyrenees. He wanted to see the country and the village where your father was born. We arrived at night at Aspet by a carryall, passing through an interminable road which zig-zagged up the side of the mountains. It was a beautiful country, and the town had the air of a prosperous village. Everybody seemed polite and well-bred. We went to an old hotel which was well known in the place, kept by two old-maid sisters who had an extraordinary sweet-sugared air, middle-class, important, and polite, yet almost humble. While they were preparing supper we were out hunting what we could find about the Saint-Gaudens family.

"Oh, yes," some one said to us, "Mr. Saint-Gaudens, we know him well. He is the mail-carrier. You will find him there in that street living with his mother and his brother who is a shoemaker." We noticed by the way that he spoke of Mr. Saint-Gaudens that the mail-carrier had a reputation, that he amounted to something in this country. And in fact we found a man with an intelligent aspect, very frank and putting on no airs, but conscious of his own worth. We were surprised in this mountainous region to discover people with such open countenances. They are a hundred times more intelligent than the natives of the suburbs of Paris. Augustus asked a great many questions about the family, and it was arranged that the next morning they would take us around to find the houses of their grandparents.

So we went back to dinner and then upstairs to bed in a great room with two beds, damp and cold in spite of a little fire in the chimneyplace. When we had slept at Toulouse Augustus

had accused me of snoring to such an extent that he could not close an eye. But here at Aspet I seem to have been even worse. so in the morning he gave me an awful scolding; in fact, in Nice, he decided never to have me sleep in the same room with him again. Of course I could not appreciate this, never having heard myself snore.

The next morning we had a better chance to see the inhabitants of this country and were very much charmed. Then we found the old house and the room where probably your father was born. I am sure that Augustus said to himself, "What a happiness it would be to have father living now, to be with us here." We had a charming time in this place.

From Aspet we went through all the South on a railroad as far as Marseilles, where we spent a fine day. Augustus reminded me that he had passed through this city on his way to Rome thirty years before, in 1870. How beautiful it was from Marseilles to Pisa! What marvelous art, sculpture, and painting, not real but better than the reality! It was the most delicate sensation an artist could have, and I often think of all that work. I do not know why I speak about all this, because he himself, our dear friend, must have told you of it when he returned. He was happy and jubilant to witness my pleasure in admiring all that he saw.

From Pisa we went to Rome, where we arrived very late at night. It was eleven o'clock and we carried our bags to the hotel intending to go to bed. But instead Gus said to me, "Let's take a walk first. Then you will see Rome at night." So we walked as far as the Place d'Espagne, through streets where there was no one, but where there were magnificent fountains splashing in the night air. The next day we found Defelice, and Augustus took me all around the city. Those were great days. Defelice went with us through the Roman Campagna where we remained a whole night, it was so beautiful. What surprises me is that neither Augustus nor I ever thought of going to visit his old studio or his lodging.

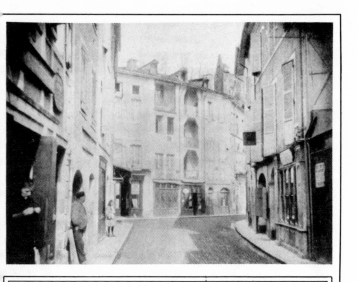

**HOUSE WHERE AUGUSTUS SAINT-GAUDENS LIVED
AT SALIES DU SALAT**

When speaking of continuing on to Naples, Augustus tried to persuade Defelice to accompany us. Defelice did not wish to go, but said that if he could he would come to see us at Pompeii. So we started, the two of us, and the day that we were to take the train from Naples to Pompeii, while it was still so early that the dawn had not broken, Defelice arrived from Rome. What pleasure it was to find the three of us together after thirty years. It is impossible to describe the sensation, at least mine, on seeing Pompeii. Augustus was happy in showing me everything there. The next morning we three went to Paestum. I do not know what adjectives to employ to describe all we saw, so I stop, stupefied. Defelice left us, or at least he returned to Naples and Rome while we went to Salerno. Thence we followed the road along the sea in a carriage, from Salerno to Castellamare. What a marvelous country! We slept at Amalfi, but did not stay there long enough, which I have ever since regretted. Very often since that time, when writing to Augustus, I have finished my letters to him by saying, "Great goodness! Why did we not remain at Amalfi forever!"

At Sorrento, on our arrival, we had a dispute with a stupid coachman who wished to take us to Naples against our will. We had just missed a train through the fault of another coachman and Augustus was furious, and the coachman pursued us and blocked the way across the street with his carriage. Our scolding was of no use, so Augustus was going to throw himself on the man to strike him with his cane. But I, on seeing this, said to myself, "If he gets into a fight it will be most unpleasant for him as we shall be arrested. What a misfortune to be arrested for fighting with a coachman! If it was only I it would be all right." So I jumped in front of him, and I do not know exactly what happened, but soon the coachman decamped. We were both of us so much worked up over this that we had to go and lounge on the seashore for a little while to get over it, after which we looked around for some place for luncheon.

AUGUSTUS SAINT-GAUDENS

We soon discovered a kind of café or restaurant where we entered and found a beautiful young girl there who was surrounded by three or four young men. They seemed to be annoying her, but on our arrival they disappeared. After we were served, a big cat jumped on to the bench and the girl came and sat alongside, showing us the cat. "What do you call it?" Augustus asked in Italian. I told Augustus to ask her to take luncheon with us, to which she answered "Si Signor." And now we were in society. She told us she was a contralto singer and evidently had a very beautiful voice. She also certainly had a big appetite. She was very much surprised to be invited to luncheon, and after a while we shook hands like old friends and left her to return to Rome.

Later we saw marvelous Florence. Then Augustus wished still further to surprise me by pushing on to Venice. But as he did not seem to be very well I decided we had best return to Paris immediately. This journey was for me a great joy, especially for us two to be alone together. For it gave us time to talk together of many things, as we saw each other so rarely.

From the point of view of art, of intellectual art, it filled up a void in my understanding, and you do not know how much I have been able to repair my knowledge as a result of this trip. But in all this I give you only a sketch of what I might possibly tell you. For I remember everything, and I see it all again as though I were there. Now I have to say to myself that my dear old companion is no more. It is very sad for me. Finally all this may be of some interest to Homer, this scribbling of mine. But yes or no, it is all the same to me. For as I have said to you, I have had the sad pleasure of going back to the pleasant past with my dear friend.

VI

SPAIN

1899

The Cirque de Gavarnie—Across the Pyrenees on Mule-back—Cata-
lonia the Magnificent—The Spanish Male—Saragossa—Madrid—
Toledo—The Alhambra—The Bull-Fight.

UNDOUBTEDLY my father's health and spirits prof-
ited greatly by the vacation with Garnier. More-
over he learned through this experience that he
had reached a time in his life when a certain amount of re-
laxation had become vital for the success of his work. Con-
sequently, it was not long before he prepared to leave Paris
again, this time on a trip to Spain. At first glance, he seems
to devote unusual detail to this journey and to an ensuing
one like it, quite in contrast to his former brevity. Spain,
however, was a place to which he had ever constantly referred
and desired to visit, just as he always longed to go to Greece,
though the opportunity never came to him. Of course there is
nothing new in what he describes of Spain. But the reflection
of his character, so inherent in his sculpture, is much more
distinct in all he relates here than when he devotes himself spe-
cifically to words about his work.

For a time after this trip with Garnier all went well
and I felt more cheerful than I had for many months.
But at the end of that period my depression returned
again. In my attempt to shake it off I pulled myself
away, and in company with my wife started once more
for a place in the Pyrenees called the Cirque de

Gavarnie, not far from my father's village; for I had taken up golf, and was told that an English colonel had established golf links at that region.

I found Gavarnie lying at the foot of an enormous amphitheater in the mountains, about three miles across, an ideal situation for a golf links. But golf links there was none. My English colonel, who had gone there in distress at the loss of his wife, had married again within a year and Gavarnie had seen him no more. We approached the town after a long and toilsome journey upward through a narrow gorge, until from a sudden turn in the road we emerged on this almost semicircular plain, and the great sight burst upon us. The stream we had been following up the gorge, came toward us over the plain from the tremendous cliffs which faced us. They resembled the Palisades on the Hudson, only on a far greater scale, forming a colossal semicircle, capped with snow and ice. It was too much for me. By looking up at any moment I was face to face with eternity and infinity.

What interested me profoundly, however, was that Spain lay immediately on the other side of the snowy ridge that topped the cliffs before me, and that from the ridge Spain could be viewed. We therefore determined to get away from the overpowering character of this barrier by passing across it. We hired a guide and pack-mule, tied what we would need for a short trip in bags on each side of the mule, mounted our horses, and started up the narrow path along precipitous sides of the mountain until we reached the top,

and the snow, and Spain was at last under our feet.

As we had been told, we found no difficulty in knowing the boundary line, for the path, bad as it was in France—though in France all those things are cared for even in the smallest places—became an almost impossible one on the descent into Spain. Down we went, however, on the other side, and were soon out of the snow. What struck us forcibly was the transition from the comparatively bleak northern French side to the warmth of the southern slope, fragrant with enormous wild boxwood bushes that surrounded us continually and through which we wound our way in and out.

The descent of this path in the great heat was exhausting to the last degree. It seemed as if we never would arrive at the bottom. But, finally, we were delighted to reach signs of life, though our joy was far beyond what that life justified; a miserable hovel adjoining, of all things in this deserted spot, a kind of diminutive campanile, around which were loitering a few Spanish soldiers, dressed in miserable rags but handling the most advanced and deadly Mauser rifle, or whatever the crack gun of the period was that they used with such effect on the American troops in Cuba. Along with these, who turned out to be Custom-house guards, was a Spanish mother with a horde of children groveling in the dirt; while, moving around, lord of the manor, strode a magnificent Catalonian, in the full costume of his country, strutting for all the world like a magnificent winged king of the barnyard.

We remained in this dirty place only long enough to eat a pretended omelette, in a room over the cows. Yet notwithstanding its distance from anything approaching civilization, sophistication had penetrated the vicinity far enough to make the noble bandit charge us outrageously for what cost him but a penny or two. Then we started on from there with one of the Spanish carbineers added to the procession. He was to accompany us to the first village to fulfil some formality about sending our horses into Spain, registering them and taking them out again. We soon left the little open valley where the hamlet lay and entered a winding gorge that led downward through wonderful scenery. There was not a trace of civilization of any kind, man or beast, no cultivation or sign of it, past or present, only bare hills and formidable granite peaks in the distance, the sensation being entirely different here from what it is in Switzerland, with all the surrounding life and humanity. Here was nothing but desolation.

The journey we took is one that has been written about frequently and remarkably, and on it we were promptly infected with what Sargent had told me we would be taken by, namely the fever of Spain,—"La Fièvre Espagnole." The main impression of the trip, as I write five years afterward on a pleasant day in the New England country, is that of the masculinity of Spain. It seemed to me to be decidedly a man's country, distinctly more so than Italy. This male quality really embodies Spain as we have read about it,

a romantic figure, tragic, ruthless, courageous, with a grand pride dominating it all. The pride of the North American Indian is the only thing that resembles it, the Indian who sits unmoved in Barnum's, with his blanket wrapped around him, and shows not the slightest surprise at the man walking with his feet on the ceiling. I suppose the village we finally arrived at has not been visited by ten Americans in a hundred years, and there was no question about its being unspoiled by the modern tourist and his civilized accompaniments. Yet though children followed us about the streets of the village as we roamed here and there for an hour before nightfall, and though the women, seated in the dirt at their door-sills, with babies at their breasts, turned their heads lazily to see us, never a man would give a sign that he was conscious of our existence. Even at the blacksmith shop, where we remained several minutes looking at the extraordinarily picturesque scene of these men in costume hammering at the anvil, not for a moment did any one show the slightest interest in us.

We lodged that night in what was evidently the domain of the lord of the village and the surrounding country. The architecture was most picturesque, the large room having a baronial character, and the little room in which we slept being an insignificant one with a gorgeously embroidered bedspread on the baronial bed. A wash-basin, about the size of a large tea-cup for the two of us, gives the key as to the comforts of the place.

To this village there was no wagon road, the only

means of approach being on horse- or mule-back. Yet the church in this out-of-the-way corner of the world was crammed with gilded rococo ornaments that made one feel how in every corner of the earth, no matter what the civilization, the same conditions, heartburnings, and passions move the poor human.

We started from here in the early dawn, long before the sun rose, on our journey to the first town where a vehicle could be hired. We descended into an open valley and kept on for hours, the grand scenery still continuing, for we found that, far from being down on the plains of Spain as we had imagined the night before, we were still high up in the Pyrenees. After another tedious trudge we reached a village where there were evidences of civilization. We lunched, rested, and in the afternoon took the regular diligence to the railroad station some fifteen or twenty miles away. This ride was Spanish to the last degree. In the mixture of the few passengers were the usual priest, a woman, a nurse and some children, a mysterious esthetic man, and ourselves. We tore right off as if shot out of a cannon from the hotel yard, and galloped for miles without a break or change of steeds. The jangling bells, the hot sun, and the cracking of the whip of the muleteer, all intermingled with the wild Spanish songs he and his friends sang during most of the drive, continued the impression of picturesque and vigorous Spain.

We arrived at the railroad station, and there, after an interminable wait while the ticket-man endeavored

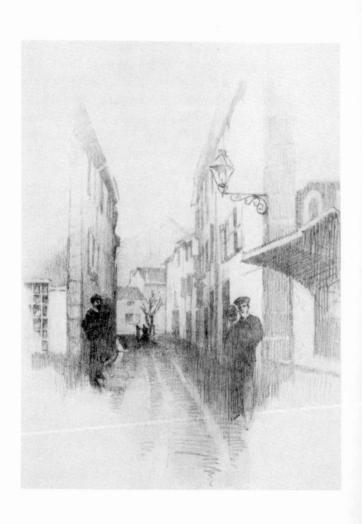

STREET IN ASPET, FRANCE
Drawn by Mrs. Homer Saint-Gaudens

to swindle us by charging us twice the fare, we started on our way to Saragossa. They all seemed to be robbers thereabout, but they were robbers with such a grand and noble air that one felt mean in protesting. The trip to Saragossa occupied many, many hours. At the stations the trains stopped in the most familiar way as if to relieve the monotony of life of the engineer by providing him with entertainment, for the whole train crew got out, shook hands with the employees at the station, smoked cigarettes, and then, with great dignity and quiet, started off again. And all this time, from the moment we left the hovel at the foot of the mountains to Saragossa, we traveled through a wild country, austere, and with virtually no vegetation, that resembled in a striking way Southern New Mexico. No wonder the Spaniard felt at home in Mexico!

It was at Saragossa that I saw the first of their cathedrals which impressed me so deeply. This one in especial gave me the feeling that it was the place of worship of royalty, of the great ones of the earth; distinctly above the herd, it seemed to say. It was a new association with a place of worship. Human grandeur seemed the dominating note, not the reverence of God. There does not appear to be that embracing of all humanity which is the feeling that I have had of the cathedrals of France, England, and Italy, and which came over me more in St. Paul's in New York than ever elsewhere in my life.

From Saragossa we went to Madrid, near which an-

other extraordinarily vivid impression was made on me by my visit to the monastery of the Escurial, a colossal, appalling, and terrible monument, I call it, to neurasthenia, built by a neurasthenic, Philip II. To me, in my condition, it was overpowering, so we left by the first train. We were there long enough, however, to hear the mass sung, as it has been sung at the same hour every day for three hundred years, for the repose of the souls of Charles V and Philip II. There was no one there but those who sang and ourselves, the priest and acolytes officiating at the mass to absolutely nothing but the gray stone walls of the church; nothing that seemed to tell of humanity and its gentler, or let us say weaker, aspect. It is strange that in this place, on each wall of the choir, should be two of perhaps the most remarkable groups of the sculpture of the Renaissance. I speak of those by Pompe Leoni, in niches. They represent Charles V with his two or three wives and other feminine members of his family on one side, and on the other side Philip II with a wife or two and other figures of the same sex. Again I received the same feeling as at Saragossa, as of a place of worship for royalty and the grandees.

Then at last, as the finishing touch, I found that under the choir of the church in this awful place is the sexagonal chamber where, piled on top of one another, are the sarcophagi which hold the bones of Charles V, and the Philips, and so on down in grim succession. Good-by, Escurial!

From Madrid we went to Toledo. None of these

places I shall try to describe. "There are others" who have done this in a way to check my attempt. But I cannot help speaking of the almost incredible appearance of the town as we entered Toledo. Passing under the Roman, Moorish, Lombard, and what-not-else walls, we emerged into a Seventeenth Century, delightful, triangular, court-like piazza, with its low houses, awnings, comfortable little cafés, where, lolling around for all the world like the drone in Maeterlinck's "Bee," were the usual proud "male" Spaniards that I have described as my first vision on descending from the Pyrenees.

The cathedral at Saragossa brought me one of the profound moments of my life. But in addition to the regal character of the Saragossa church, the one in Toledo possessed what the former seemed to have to a very small extent, the embodiments, so to speak, of Spain, its history, its traditions, its character, its climate, in fact everything. There were the tragic signs about it all, intense love and hatred, the passions of blood and jealousy, all virile and powerful, no half measures, no hesitancy, no introspection. The architecture, which I had regarded with indifference from the photographs, shows this virility and its independence of the traditions of the Gothic architecture of Italy, England, and France. In fact, it seemed to me so full of the seed of life that it made the sister churches of the other countries seem pale and almost emasculated in comparison.

One feels in looking at the architecture in Spain that

all the wonderful Gothic creations in the North and East are the result of an advanced civilization, where certain traditions and rules had to be observed and followed, where there was a community with other artists whose opinions had to be taken into consideration, which led to the well-governed, inspiring, and noble productions we know of, but that Spain retained sturdy and virile indifference as to what the other men thought. Of course their great cathedrals, as this one at Toledo, are barbaric, yet they are vital beyond measure. The picturesque quality I will not dwell upon. It goes without saying. The great flood of light that threw itself across the wonderful nave, the tragic corners in contrast, all this was Spain, the Spain one reads of and knows about, the Spain of the Inquisition, of the Armada, of Columbus. It was all there, throbbing within us, as it had been within the thousands and thousands who had prayed in the past where now we stood as spectators.

From Toledo we journeyed to Biarritz and from there back to my "Sherman" and the accompanying figure. My trip had filled me with such enthusiasm, however, that the following summer, with my friend Colin, I started on another journey to the same land. For I have become insatiable about that fascinating country and my interest in it never flags.

It is useless for me to attempt any description of the ecstasy I felt the first morning I awakened to a vision of Granada. As we looked down on it from the parapet of the Alhambra its peacefulness, as well as

its beauty and an indefinable something which we could not describe, took a profound hold on us. I have not as yet seen the Parthenon, but there is no doubt that at the Alhambra you feel as you do at the Parthenon, that you are in the presence of one of the highest of human achievements, one of the two or three great pearls of beauty on this globe. It was to me all the more extraordinary in that I had shrunk from it because of the photographs which gave not the faintest idea of the fascination of the place, and also because of the abominable little plaster and stearine imitations of the ornaments and what not that one finds "ad nauseam" in the big cities. Those who have not seen that divine spot must divest themselves of any idea that these replicas reveal its beauty in the slightest degree.

What this grace is I cannot define, except that it shows a refinement of mentality that is very different in its way from that which created the Parthenon. Greek things strike me, always, as masculine. The beauty of the Alhambra seems in comparison, extraordinarily feminine. Yet one feels it is not the creation of a feminine mind, but is the result of infinite delicacy and restraint in a strong masculine mind. There is a lingering charm about it that holds the visitor in a wonderful way. The delicacy and love of beauty of the past seem to hang about it as they do about no other form of achievement with which I have been brought in contact.

The following day we went to a bull-fight. What struck me forcibly here was the festal character of the

occasion. The winding street leading to the arena was crowded with the Spanish women; every one of these daughters of Eve, with their mantillas, and carnations in their hair, making eternal love with the Spanish male, in the midst of the pell-mell of all kinds of vehicles and of animals of high and low degree surrounding them in the rising dust and blazing sun. It was a picture which made me realize Spain and the South, the real Spain of the novelist, a tincture of life and living with no retrospection; just as when, in the evening in Toledo, as we sauntered around, it seemed incredible to find the lovers in the narrow streets, under balconies, whispering to the señoritas above on the balconies with the fluttering curtains, for all the world like the romantic Spanish songs.

Eventually we reached the arena. Although the walk had been interminable, it was intensely interesting, for all the city was there. The people not only filled the sidewalks, but crowded among the carriages in the roadway, and about a gorgeous cavalry troop on splendid black horses. They were magnificent, and on great occasions are always very much in evidence, I am told. By us also some in carriages, some on horseback, rode the matadors, the picadors, the toreadors and so on, in all the gorgeousness of their costumes. Virility, and pride, and the very essence of life swelled out of them, as well as out of everybody else, in extraordinary fullness. The arena is at the edge of the city, and beyond it I could see the bald fields that reminded me of the Roman Campagna,

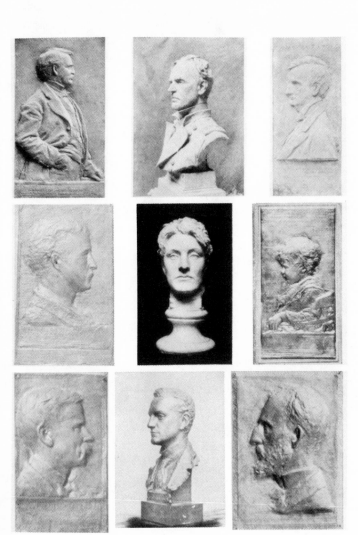

NINE PORTRAIT RELIEFS AND BUSTS

Charles C. Beaman	General Sherman	William M. Evarts
Francis D. Millet	Miss Page	Homer Saint-Gaudens
D. Maitland Armstrong	William A. Chanler	George W. Maynard

while the same sense came over me that I often felt in
Rome, that the reason of its uninhabitableness was be-
cause one might be murdered there at any moment. I
do not say that one would be, but it has that look; the
look I imagine the country must have had when the
marauders of the Middle Ages were at large. It
seemed as if the people lived in towns for protection
as much as anything else. The dribbling, sordid
suburbs that disfigure Paris, New York, and London
were not present. The arena reminded me in a meas-
ure of the Coliseum of Rome, being built of brick with
a recall of Moorish architecture. I suppose it is com-
paratively recent, however; probably erected within the
last fifty years.

After the usual trouble a stranger has in buying his
ticket in foreign lands at places of amusement, we en-
tered, and as we were quite early we saw the spectacle
from the beginning. The arena was first compara-
tively empty, the stone seats bare, and whatever peo-
ple there were, were standing in the ring itself. We
loitered through this, and, crossing, entered a little
yard where the inevitable guide led us into a chapel
with the usual picture of the Madonna, the Mother,
the Woman, the Eve, whom we all of the other sex
adore! To her the bull-fighters pray before the fight.
Adjoining this little chapel is the hospital, which we
had to pay an extra fee to see. It was a room about
thirty feet long by fifteen feet wide, with half a dozen
beds or so prepared to receive those that might be
wounded in encountering the bulls. It was really

strange for us from Paris and New York to think that all this was going on in a city with its locomotives, electricity, telephone, and what not. As we came out we found the yard well crowded with spectators, and in among them some of the picadors in full costume on their horses, which did not seem, by the way, like the miserable Rosinantes generally described. There was a post in the corner of the yard, and every now and then one of the gorgeous cavaliers would go right through the crowd at a rapid gait and strike the post with his heavy lance, as practice for what was to come later in the morning.

All this in the brilliant sunshine was extraordinarily strange. It seemed as if it should be in a dream, a dream of the seventeenth century, not in the days of base-ball, football, and automobiles. We reëntered the arena, that by this time was black with the crowd which made a great contrast with the empty sunlit seats above. Presently a bugle sounded and the crowd began to crawl up to the seats like so many ants, gradually darkening what was bright, the black arena gradually turning light. Then this open, spotless space became singularly impressive to us, because of the suffering and death that was presently to be rampant there.

There were some moments of quiet. Again the bugle sounded. The doors at the end by which we had entered, were thrown open, and out in stately line came all of those who were to take part in the fight. They were preceded by a man in black on horseback, look-

ing like the sad tenor in Lucia di Lammermoor. He was followed by a staff of four or five other tenors in similar costumes. Then came the cocky little toreador, the picadors, the matador and the espadors, lithe of body and energetic of manner. They went directly across the space to the royal box, where, after having saluted and hailed the grandees occupying it, they marched in procession around the ring, finally distributing themselves in the places they were to occupy during the fight: in one direction the picadors with their horses, in another the matadors, in still another the toreadors, and so on, spotting the clean white sand with the brilliance of their color and personality. The gaily caparisoned mules that were to drag out the dead animals later, and the sadly beplumed and becaped tenors, disappearing through the door before mentioned.

During all this gorgeousness, I noticed an insignificant assistant, ostentatiously modest, in a corner. But he had his part to play. In another moment the bugle sounded again. The first door was opened and our black Roland dashed out once more on his beautiful horse, seeming even more noble than before. He galloped over to the royal box, where, after a sweep of his plumed hat, a great key was dropped in it by the most honored person in the box. He then whirled to the other side of the arena, where stood my tramp in front of a large closed door, and disappeared again. The tramp put this key into the great door after much fussing and in evident appreciation that this was his

moment, the extraordinary moment of expectancy before things are going to happen. But at last he opened it and vanished between it and the wall. There was an instant of tragic expectation. A low hum pervaded the audience. Then out rushed a magnificent bull, head erect. He stood for a moment within a few feet from the door, evidently taking in the spectacle, facing all these men in their brilliant colors with the antagonistic red at every turn. Then suddenly, with a succession of short steps, as if to obtain good headway, he rushed at one of the fighters, head down. The man had a purple cloak which he held directly in front of him. At the moment the bull lunged, he stepped lightly aside, and the animal helplessly thrust his head into the cloth, and then turned about at another cloak, and so on. Then the espador came up with a queer little running approach and with his dart extended straight at the dazed animal. The bull hesitated a moment, pawed the ground in the noblest manner, lowered his great head and shoulders, and rushed at his tormentor, who, stepping forward and planting the banderillos in each side of the animal's neck, skipped lightly aside. Again the bull rushed as before, wasting more of his tremendous power. This was repeated a number of times until he tore about distracted, with bleeding flanks.

I can tell but little of the massacre of the horses by the infuriated beast. This was so sickening that I turned my head aside. They would lead the horse, one eye covered with a cloth, toward the bull. The picador.

having a great lance, moved clumsily as if he were cased in armor, although covered with his gorgeous colored clothes. I am told that underneath there was a cork suit to protect him from the horns of the bull and the fall of the horse. The horse would go forward, and then suddenly the bull would rush at him. As the bull lowered his head to lunge, the picador would lower his lance and thrust it into the bull's shoulders. Sometimes the force of the bull would lift the horse, picador, and everything into the air, all rolling over in the dust together. The other fighters would then rush over and distract the bull from his victim. But even by the time they reached him, he would have gored the horse in a most appalling way, and the picador was frequently in great danger, unable to rise from the entanglement.

I remember that after this had occurred a dozen times there was evidently somewhat more confusion than usual. Either the picador had not directed his lance just in the right manner at the bull or had not acted in proper form at the proper moment, I know not which; for the entire crowd shouted in derision at the man as he was pulled out of the dust, the bull goring and hacking at the horse. They finally got the maddened animal away, and as the picador walked awkwardly from the scene, they hissed and howled and threw objects at him in derision, shouting to him to "Go to Paris!" This was said in scorn, because a month or two before there had been bull-fights in Paris which were performed with padded spikes,

padded swords, and everything that was merciful and uncharacteristic.

It was evident then, as always, that where we saw nothing more refined or complicated than the rushes of the bull and the dextrous stepping-aside of the matadors, this crowd who hissed the fighters and the bull indiscriminately—the bull as if he were human and the man as if he were an animal—possessed a knowledge of the various intricacies of the fight, just as the player detects the slightest move in a game of chess, or as the boy on the bleachers at home detects the slightest error when to the unaccustomed observer nothing of import seems to have happened.

But at last, after all these efforts, when the power of the bull was visibly weakened, when he was dazed, mad with pain and worry, the great act came, that of the espador, the hero of the day, the man with the sword and the handkerchief.

There were dead and disemboweled horses lying around the arena, which had been so orderly and clean but was now spotted with blood. There were men moving cautiously in various directions. Then, with the audience hushed, the espador approached the bull. He stepped forward, with a bright red cloth held over the sword, until he had come quite close to the animal, whom he irritated by waving the cloth to and fro. The bull hesitated, suddenly lunged forward, his head down as usual. Then, very much as the picadors thrust their aggravating darts in his shoulders, the man drew his sword slowly from the cloth to the accompaniment of

the expectant hum of the audience and plunged it into the neck of the bull at the head of the spine.

Sometimes it penetrates to the hilt, which brings uproarious applause from the audience at the espador's success and valor. If he fails, and the sword does not go in at all, there are shouts of derision, as at the failure of the picador. Sometimes it goes half way in and breaks, and then it has to be pulled out again and thrust in once more, the poor animal running about from one tormentor to the other until he receives his death stroke.

There it is. This is what I saw of the bull-fight. And this was repeated again and again until the day was over. It was as Colin described it, "superbe et immonde," superb and ignoble.

A strange sense of fatigue and boredom came over me at the end; but I fully understand how, like drink, notwithstanding the disgust, a man goes to it again and again. We came out, our hearts still beating violently, and walked along to a peaceful part of the town where we entered into conversation with a Spaniard, telling him of our experience. He explained to us the feeling of shame with which a large number of the Spaniards look on the savagery and ignominy of it all. But none the less there is some deep, underlying, elemental principle about it that attracts the human animal, let shame say what it will. Subjection to it reveals a nearer relation to our primitive ancestors. This, I think, is the secret of its continued existence.

At Granada, too, I came upon something else which

interested me profoundly. Whether it will interest the reader or not is another affair, but I do not care, I am going to set it down and he can toss it out of the window or back of the bureau, as the impulse leads. We had visited the cathedral, naturally, but after those of Saragossa and Toledo we were not particularly impressed. The only part that struck us as beautiful as we approached it from the side, and before passing around to the front to enter, was the exquisite Gothic architecture of a part of a chapel which seemed of much more ancient and infinitely greater charm than the rest of the church. We were about to leave when the snuffy and dusty old sacristan, who looked as if he had cobwebs on him, asked if we would like to go into this chapel. Of course we accepted the opportunity eagerly, and entering we found, instead of the ecclesiastical character of the usual chapel with its columns, etc., that we were in a tall, four-walled, uncared-for, unkempt room, dusty and cobwebby, and as snuffy-looking as our guide. I may be all wrong in this description, but I am recording my impressions and memories, not "what things is."

On the left as we entered from the body of the cathedral, on a little elevation that crossed the entire chapel, barred off as I recall it by some excellent iron work and apparently covered with dust, were the tombs of Ferdinand and Isabella. The entire absence of dignity of surroundings and the evident inattention to these historical tombs, was a surprise and a shock.

The sacristan then asked if we wished to see some

of the paraphernalia belonging to the royal couple, and we assenting, he shuffled to the other side of the room, which really seemed to be the only name to give it, and turning a large key which creaked in a rusty lock, opened a tall cupboard. The door groaning and moving awkwardly on its hinges, made it appear as if we were disturbing the spiders who had woven their webs inside. On swinging back the doors, the sword and scepter of Ferdinand and Isabella, their robes, and other things of their regal paraphernalia were revealed to us, hung up, so to speak, any old way, with a look of battered theatrical properties sadly in need of a thrifty housekeeper. Perhaps they were not what I believed, but the guide said so, and that made an impressive moment. To think that from those who bore these things, the development of this great continent resulted! I am not given to sentimentalizing in matters of this kind, but, as in the case of my friend X——'s wedding, the absence of dignity gave me an ugly impression.

From Granada we went to Seville and paid our reverence to the Campanile and to the Alcazar, and then to Cordova where we visited the bewildering mosque. But we were tired. We were traveling too rapidly, and, like my friend Garnier, we were glad to get back to Paris, which, in comparison to Spain, as we entered it on the gray, dismal day of our return, resembled a cemetery.

PARIS LIFE

1897-1900

ONCE more in his autobiography Saint-Gaudens is abrupt and cursory. He had planned here as elsewhere an amplification which he was never to accomplish. But again I am fortunate in being able to fill out his text with pertinent and illuminating letters which show how, aided by the excursions south, his virile mind had drawn him out of his depression, so that since he now entered with energy into the life about him, the remaining account of his stay in Paris proves a comparatively happy one. He writes in his reminiscences:

There does not seem to be much to mention concerning this period other than these journeys, except that slowly I had come to appreciate Paris in a way I never dreamed of in the heyday of my youth. Paris in the spring is wonderful. There are two or three weeks when the pride and joy of life is at its full there as it is nowhere else. The people appreciate life more than we do. In fact, as has been said a thousand times before, they enjoy living in a million ways that we do not. I do not mean that they are actually happier at all times. On the contrary, I think the tug of life there is so terrific that they are more inclined to skepticism than we are in this heaven-blest country. But I

am digging too deep for a narrative of this kind and I shall go back to my experiences before my last return to America.

Not long after my arrival in Paris, MacMonnies, who was quite intimate with Whistler, brought us together. So from that day, more and more frequently as time went on, Whistler would come to my studio at dusk on his way home from work. And in my studio he would sit and chat in his extraordinary, witty fashion. He was certainly a remarkable man. If he liked you at all, he would take you at once into his confidence in a most attractive manner, telling his adventures and stories with a verve and wit that are indescribable. At times, he, MacMonnies, and I, and occasionally an old French friend of Whistler's student days, dined at Foyot's, opposite the Luxembourg; and a dull moment was impossible with his extraordinary character descriptions of people and his biting irony. We formed a strange, lantern-jawed trio, he, MacMonnies, and I; he dark, MacMonnies blonde and curly, and I red, where time had left the original color. He was small, but lithe and thin and active. His studio, at the top of a long flight of stairs, was very high; and his paintings, which were numberless and which he was chary of showing, were piled in stacks against the wall. I was there several times, and I regret, as was the case with General Sherman, that I made no note of his talk. But I was sick, and very busy, and saw much less of him than I should have otherwise.

The following incident, however, describes what I think an interesting side of Whistler's character. I was crossing the Pont des Saints Pères in a cab and he was walking in the same direction. As I overtook him I called, and he jumped in and sat alongside of me. On that day I was experiencing a sense of elation which comes to every artist, be he of high or low degree; and when, the moment after he sat down, he asked, "Well, Saint-Gaudens, how are you, how are you?" I replied that I had just stuck up one of my things in the exhibition and that I was feeling somewhat cocky about it.

"That's the way to feel!" he suddenly jerked out. "That's the way!" and, seizing me by the thigh with a firm grip, he shook it, and continued with great energy, "If you ever feel otherwise, never admit it! Never admit it!"

It seems to me that this reveals something of the quality of the man, the bravery of his attitude toward life. One had but to see his portrait of his mother, his "Carlyle," "Piano," and one or two other canvases, to realize that, though covered by his extraordinary wit, there was in his nature a deep substratum of true feeling.

In a letter written November 16, 1897, Saint-Gaudens said:

Mac and I made a short call on Whistler, whom I found much more human than I imagined him to be, and to-day I went to the Court of Appeals where

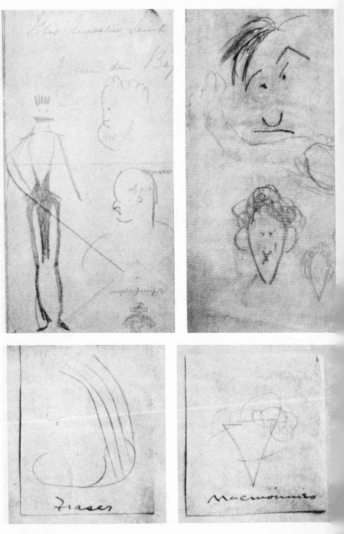

CARICATURES, BY AUGUSTUS SAINT-GAUDENS, OF STANFORD WHITE, WILLIAM
GEDNEY BUNCE, CHARLES F. McKIM, HENRY HERING, AUGUSTUS SAINT-
GAUDENS, JAMES EARLE FRASER, AND WILLIAM MACMONNIES

trial of his was to come off. It did n't, but I had a delightful chat with him. He is a very attractive man with very queer clothes, a kind of 1830 coat with an enormous collar greater even than those of that period, a monocle, a strong jaw, very frizzly hair with a white mesh in it, and an extraordinary hat.

Two years later he wrote again:

Sunday Whistler called, because I " never called on him," he said. He wanted me to lunch with him, but I wanted to work.

The reminiscences continue:

Afterwards our relations were cut short by my illness and departure for America. I regretted not having seen more of him.

Among the other men of my acquaintance at that time there stand out most vividly Paul Dubois and Auguste Rodin. Paul Dubois held a higher place in my esteem than any of the others, for his "Joan of Arc" is, to my thinking, one of the greatest statues in the world. I know of but one or two that I would rank higher. For elevation, distinction, and nervousness of style it is extraordinary. It is one of the works that makes a man wish to strive higher and higher, and to criticize his own results to a degree which would not be possible if Dubois and his productions did not exist. The first of his sculpture I remember was the little " St. John the Baptist," which at the long-past time it

was exhibited seemed extraordinary to me, though of course at this writing it falls far below his final achievement. Then came his " Chanteur Florentin," which still remains a lovely masterpiece.

Though a man of rather austere countenance, Dubois had a kindliness underneath, and the " young eye " which a French friend of mine said was the distinctive quality of an artist's face. I came in personal contact with him only between 1898 and 1900, when I saw him at his studio, and he was good enough to invite me to dine at his house. He was amiability and kindness itself, and that is saying a great deal when one considers the continued and constant calls that were made on him by young men, his admirers. At that time he had begun his sketch for a great monument to the Franco-Prussian War. His work meant the modeling of many figures, and, although seventy-two years old, he said to me "You see I expect to live forever." He had the groups set up in his studio, and I was particularly taken by the kindness with which he asked me if I would really tell him what I thought of his sculpture. He has made as profound an impression on me as any living artist. Especially I remember the time when he told me with amused irony of his experiences with the Committee concerning the statue of Joan of Arc. This had cost him, outside of what he had received, thirty thousand, or fifty thousand francs, I forget which, probably the latter, yet the Committee acted with him as if he had been trying to deceive them. This is a common experience, but to think that it oc-

curred with him, and that, despite all his labor and toil and the extraordinary beauty of his creation, he should submit to experiences of that kind, shows us how we are all, big and little, in the same box.

At the end of this time came the Paris Exposition of 1900, when I was on the jury. Such a collection of sculpture, rammed together ignominiously, has never been seen nor ever can occur again. The space was so limited that in the foreign collection all the statues were crowded pell-mell, helter-skelter on top of one another, in a bewildering and phenomenal maze of extended and distorted arms, legs, faces, and torsos in every conceivable posture. It took very great patience and calmness of spirit to discern the many very remarkable things that were there shown.

So much for the autobiography. Here I take up the letters concerning this period, beginning with Saint-Gaudens' brief and vivid comment on the comparative merits of the French Salons two years before the Exposition just mentioned.

I think if the Champs-Élysées were sifted there would be more good work found in it, or as much as at the Champ-de-Mars. It is remarkable how much good work is done in Paris. The first impression is bad, as the good is concealed in such a mountain of trash; but it's like gold in a mountain.

On May 14, 1898, he wrote to Miss Helen Mears, the sculptor, his pupil, assistant, and close friend:

 . . . My things are all well placed at the Champ-

de-Mars, and seem to be liked. I have had a very interesting and amusing experience there which I will tell you of if you return here. It is too bad that you should have missed the Salon, for, although there are very few good things, there is much food for thought in the failures and semi-failures, as well as in the successes and semi-successes. There are two things that rise about the rest, however, in my opinion. Puvis de Chavannes' painting, and an adorable statue by Gustave Michel called "Dans le Rêve." Otherwise it seems as if there were millions of statues each more violent and more uninteresting than the next. But it all forms the rich soil from which the rare flower springs. . . .

The next letters are to Miss Rose S. Nichols:

3 Rue de Bagneux, Paris, May 10th, 1898.

This Paris experience, as far as my art goes, has been a great thing for me. I never felt sure of myself before, I groped ahead. All blindness seems to have been washed away. I see my place clearly now; I know, or think I know, just where I stand. A great self-confidence has come over me, and a tremendous desire and will to achieve high things, with a confidence that I shall, has taken possession of me. I exhibited at the Champ-de-Mars and the papers have spoken well, and it seems as if I were having what they call a "success" here. I send you some of the extracts from several of the principal artistic papers here, the *Gazette des Beaux Arts, Art et Décoration,* and from the *Dic-*

AUGUSTUS SAINT-GAUDENS

tionnaire Encyclopédique Larousse; four of these have asked permission to reproduce my work. . . .

My father makes reference to Paul Leprieur's article in "Art et Décoration." Here is a translation of the criticism, beginning at a point where the author turns to Saint-Gaudens after an attack on the "Balzac" of Rodin.

"The more completely to forget this sinister vision, one may well linger before the work of a great sculptor, almost unknown among us, who reveals himself to us, so to speak, for the first time, with an altogether remarkable collection of monumental sculpture and photographs of monuments previously executed. We refer to M. Saint-Gaudens, an Irishman by birth, who has worked mainly for America, and who was, if I mistake not, the teacher of Mr. MacMonnies, a teacher far superior to his pupil. His exhibit is one of the surprises and delights of the Champ-de-Mars.

"Had we only the photographs which he shows us, whether of his 'Peter Cooper,' his 'President Lincoln,' the noble and serious allegorical figure for a tomb, called 'The Peace of God,' or the charming caryatid for the Vanderbilt house, we could already perceive the grasp of composition, the decision of the contours, the depth of the sentiment expressed without any splurge or noise. This sculpture, in its acceptance, or ingenious reshaping, of traditions from ancient sources, as well as in its modern inventiveness, imparts a savor of intimate charm, of dignity without parade, which are rare indeed in our day.

"The actual work exhibited simply confirms the impression of the photographs. To say nothing of the plaques and medallions, models of a fine bas-relief, and the highly entertaining and picturesque statue of the 'Puritan,' the large high-relief dedicated to the memory of Colonel Robert Gould Shaw may well be esteemed as a model of intelligent decoration. The idea

of representing, not the death scene itself, but the moment preceding it, and of showing the army of blacks, led by the white officer, filing by as if in a march to death, grave of mien, solemn, and heroic, is as novel as it is boldly treated. While presenting prodigies of skill (absolutely without triviality or pettiness in matters of detail), and modeled with a great freedom and understanding of how to arrange the various groups of lines in perspective, which all men of his profession will admire, everything is kept subordinate to the ensemble and to the predetermined unity of motion. Upon each of the faces one feels more or less the reflection of the motto of self-sacrifice and enthusiastic faith inscribed on a flat surface in the background (Omnia relinquit servare rem publicam), and the superb figure of a woman with flying drapery, symbolical of glory or of death, comparable to the loveliest creations in this style by Watts or Gustave Moreau, succeeds in giving to this very sculpturesque composition a distinguished moral significance."

The general reception, of which this review gives an example, had an effect on Saint-Gaudens which, related in the foregoing note to Miss Nichols, receives farther and rather more interesting comment in the following letter to Mr. Will H. Low.

3 Bis Rue de Bagneux, Sept. 2, 1898.

Dear Old Fellow (or Young Buck, as you now probably prefer to be called):

I received your letter yesterday to my great and joyous surprise, surprise as great as you will experience on receiving this prompt response, but absence from home makes frequent correspondence with home a "sine qua non," and Fridays are the days I devote to that (to me) laborious task. To-day is Friday, and what is more it's a wonderful American autumn day, one of

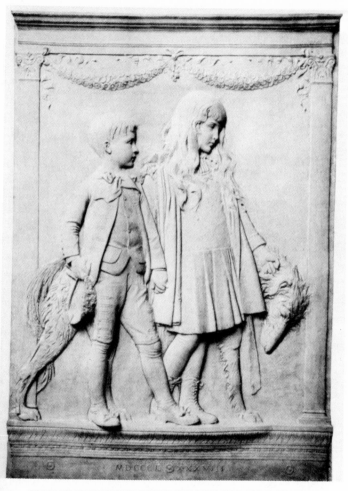

PORTRAIT IN BAS-RELIEF OF THE CHILDREN OF JACOB H. SCHIFF

those languorous, sumptuous, golden days we have at home, and it recalls the other side so much that this business of writing has for once turned into an orgy of correspondence with old friends.

With the exception of a week of real New York heat, the weather here this summer has been glorious and I have revelled in it after a winter dark and miserable beyond description. It rained steadily for eight months, and I have come to the conclusion that I am made of stiffer and better stuff than I thought, to have held out here through it all. I was miserably blue and homesick in the beginning of my stay, beyond reason in fact. Finding so much that I disliked intensely, which I had expected to like immensely, I plunged into work moodily, and with set teeth, the only relief coming at the end of the day when I emerged from the street to the river; for the quays, the bridges, and the big open sky with the great effects of clouds, are always fine, rain or shine, and a contradiction to the dark thoughts.

But coming here has been a wonderful experience, surprising in many respects, one of them being to find how much of an American I am. I always thought I was a kind of a cosmopolitan gelatinous fish that belonged here, there, and anywhere. "Pas du tout," I belong in America, that is my home, that is where I want to be and to remain, with the Elevated Road dropping oil and ashes on the idiot below, the cable cars, the telegraph poles, the skyline, and all that have become dear to me; to say nothing of attractive friends, the scenery, the smell of the earth—the peculiar smell

of America, just as peculiar as the smell of Italy or France—and the days like to-day.

Another thing (I'm rattling on about myself, but I know it will interest you) is the view I now have of my productions. Up to my visit here I felt as if I was working in a fog. I knew not "where I was at." That is dispelled, and now I see my ground clearly. I feel well-planted and know where to strike. I have acquired a strange feeling of confidence that I never have felt before (and which, oh, irony, may mean that I'm losing ground), together with a respect for what we are doing at home. In fact, I shall return a burning, hot-headed patriot.

What a place this is over here, though, seductive as a beautiful woman with her smile. I suppose when I get back I shall want to return here again! "on est jamais content," as I have previously remarked. . .

On the following letters I need make no comment. To Miss Nichols:

Sept. 12th, 1898.

My work for the last three or four days has been progressing well, and I suppose in a month I shall have the figure of the "Sherman" entirely finished "for better or for worse." I'm somewhat blue to-day and have a feeling of weariness at this life of work between four walls that I have led. Of course a life of work is the happiest one, but a fellow gets tired sometimes. I have been having a desire lately to do a nude, suggested

by a man in the street; a working-man coming home from work carrying his child (who had rushed out to meet him) astride his shoulders. I want to make a Venus carrying a winged figure of Love on her shoulders in some such fashion, and the little God of Felicity and Misery shooting his bow.

<div align="right">Sept. 23rd, 1898.</div>

I have worked quite late in the gloom; I often do that, as the half-light suggests things in one's work that cannot occur in the blaze of day. . . .

Now I shall go out, it's too sad in this big studio with the lamp flinging great shadows on the walls. . . . I suppose my despondency is helped by the first autumn chill to-day, the falling leaves, and what X—— writes me of the death of Capitaine Nicolas, my fencing master; he fell _unconscious while fencing. The masks we used together, and the foils and gloves, are hanging on the wall beside me, and it is gruesome to look at them and remember the ghostlike look of his face behind the wire mask; ghostlike as my face appeared no doubt to him. . . .

<div align="right">Jan. 3, 1899.</div>

. . . The reason that I'm pleased at the angel going to the Luxembourg, and the possibility of the cross of honor, is, I assure you (I see you smiling, but what I say is the gospel truth just the same) not from vanity (I see you smile again); I don't think I have much of that in me (the smile continues); but on ac-

count of some of the good friends I have at home to whom it is said, "Oh, he's all right over here; but let him go abroad, and then we'll see." *

April 12th, 1899.

Sargent has been here recently, and I saw a good deal of him during his visit as he came to see me about the enlargement of his crucifixion for the Boston Library. It is in sculpture and is to go directly opposite the Moses. He has done a masterpiece. He is a big fellow and what is, I'm inclined to think, a great deal more, a *good* fellow. . . .

Then the other day I called on Rodin, who it seems felt hurt that I had not been to see him. There is no doubt the doors he is doing are very fine, very fine, and I am deeply impressed.

Yesterday afternoon I had a visit from Messrs. Simon and Mesnard, both men of very great talent whom I have known through Saglio. They were most complimentary.

I had passed a charming evening with one of them, a "pétite soirée en famille" that was delightful in its simplicity and unaffectedness, in the simple homelike character so unlike the general idea of French life and manners. Saglio says that represents the real French, and not what the general novel shows. . . .

Last night I went to see Coquelin represent Napoleon admirably in a stupid play that I enjoyed a great

* Doubtless Saint-Gaudens was thinking of a proverb his father, Bernard, was fond of repeating—" Dans le pays des aveugles les borgnes sont rois "—which is translated: " In the country of the blind the one-eyed man is king."

deal. I dine every night with Shiff. We have our constant talk about morals. Grandibert, a young French friend of Shiff, a student who is studying to enter the financial bureau, says there is no such thing as morals! And there you are!

To Miss Mears:

. . . Frequently I go to that cheap circus at Montmartre where I laugh at the same jokes and the idiotic farces I have laughed at twenty times before. It's an old-fashioned circus with one ring where I can sit close to the ring and see the beauty in tights and spangles on the white horse, just as in my youth when I wondered if I loved such a goddess would she ever love me!

. . . Also the other day I saw a fine new play, based on the relation of religion and modern life and science to one another, which is very profound and touches on all that we think of so much, "La Nouvelle Idole." I'll send it to you and your dear sister.

. . . Shiff is constantly taking me to just the kind of places that would have delighted your heart. Do you remember the restaurant on the right-hand side of the Boul. St. Michel, a little below the café? You and I looked in at it one night, but were frightened at the lot of men and did not go in. Well, it's the most characteristic students' dining-salon there is in the quarter. Shiff took me there. It was simply packed with medical, legal, and School of Mines students. They had an unusually good lot of faces and I thought

of you a thousand times. Then again he took me to a "brasserie" at Montmartre where he is in the habit of meeting a charming woman, a young and ardent socialist who earns her living by doing massage. Again we went to a workman's ball near the College de France, and again to a purely workman's café, a charming place, in the quarter St. Antoine. Also he has shown me houses and places of interest galore, for he knows Paris like a book. Oh, you must come right back and trot around with him. He has very anarchistic views of things, although, dear old selfish Jew that he is, he takes the greatest care to get everything in his power that will contribute to his comfort. He is optimistic, however, and his company is cheerful and encouraging, unlike that of the author of the following little scene produced at one of the "cafés chantants." The action runs thus.

A room is shown with a door leading into another room where there is evidently a sufferer, nurses going in and out anxiously. Finally one of the nurses brings out a new-born babe who has a belt around his waist in which is thrust a dagger. The nurse very formally, rigidly, and slowly, brings the child down to the footlights, holds him up to face the audience, turning him slowly first in one direction and then in the other. The child opens its eyes widely, solemnly, evidently taking its first look at the world as it gazes at the audience. After a moment, with a terrible disgust he exclaims, "Oh, quelles têtes. Oh, quel sale monde." Then he draws the dagger, and plunges it into his heart say-

ing, "Je rentre dans le *Néant!*" That's pessimism with a vengeance.

To my mother:

3 Bis Rue de Bagneux, August 3, 1899.

. . . It's been hotter than forty hells here for the last two or three days, and if you should miss this letter, it would be hotter still in the studio. For instead of finding letters easier to write as I progress in years, I find them more and more of a burden, and I'm jealous beside of every minute that I give to them. If I could write at night, well and good, but I can't do that as you know. It's so hot in the middle of the day that I only commence work at four in the afternoon after a hearty noon meal. I stay at the studio very late. I eat a light supper and go to bed and to sleep early, and get up at six o'clock.

The Luxembourg matter is officially settled. Since then Bénédite has shown me the splendid place he has set apart for my work, and he has assured me that the red ribbon would be determined certainly before 1900. For I told him that if it did not come till then it would be valueless to me, as I did not wish to be mixed up in the crowd of perfunctory honors that will be distributed at that time.

I'm working away hard, although I think I will go to Boulogne as I did last summer for a couple of weeks. Thierry is going to be there then. Just a year ago I was on the field of Waterloo with Homer, and I have a suspicion that I enjoyed that more and felt less

blasé about the whole business than Homer. However, when I was his age I don't suppose I should have enjoyed those things as I do now.

By all means get him a horse, for I suspect he may have a malarial tendency from us. Damn heredity! What angels we should be if it were n't for the vices, mental and physical, which, given us by our parents, we pass on to those we beget and love most.

I 've been tearing up a lot of copies of my old letters lately and they all seem inane. Those I thought the best at the time were the most inane, so you can understand why I don't want ever to write another letter. The only parts of them that were readable were in *your* handwriting. Evidently I must content myself with expression in bronze. That makes me mad for we always wish for what is around the corner out of reach.

To Mr. Low:

8 September, 1899.

. . . It was a great treat, old boy, to get your letter. Somehow or other it seemed like a real whiff from home, a real talk with a living friend, unlike the character of telephonic messages from behind a blank wall that most letters one gets from America have, no matter how kindly or affectionate they may be.

One day not long ago I lunched with Harrison and with de Monvel, whose acquaintance I made only a month past. Then de Monvel asked me to lunch at his house. What a delightful man he is! He has a great

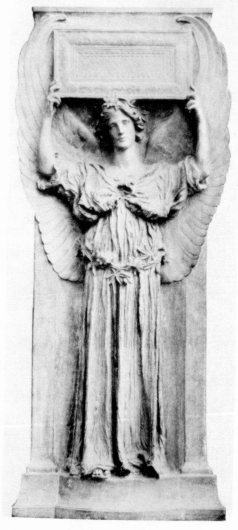

AMOR : CARITAS
In the Museum of the Luxembourg, Paris

English-looking son, and he has all the charming side of the French with apparently none of that which is unpleasant; the clearness of vision, the thoroughness and conscientiousness of work, and, withal, the power of enjoying life, "la joie de vivre," a quality of the French which custom has not staled for me in the two years I have been here.

Indeed, many of the nation's unpleasant traits I see no more of, whereas many attractive ones have appeared in their stead. I have grown to like it very much here. "Reste à voir" how I will enjoy the coming winter, as the last eighteen months have been a long period of sunshine which made me forget the six months of rain and gloom that prevailed during the first winter here. I propose staying until after the exhibition opens, and then I shall go home with a glad heart. For, after all, we are creatures of habit, and my twenty-year habit of New York and New Yorkers cannot be broken by two years of alluring Paris. The Esquimau hies back to his ice-hut in the Arctic Circle with a glad heart, why should n't I go to the place where I have such bully friends who are such bully men?

They have done well by me here, as you know. I was elected by an almost unanimous vote, member of the Société des Beaux Arts. The "Sherman" was stuck up bang in the center of the garden at the last Salon, and I was so cocky I made myself sick of myself for three days. For the first time in my life I had the swelled head. Finally, Bénédite, the Director of the

Luxembourg, asked me if I would sell him a bronze copy of the "Angel with the Tablet" to go in the Luxembourg, and a series of the medallions, which I agreed to do "con amore" as you can imagine.

"Voilà, mon ami"—alongside of all the rose-color view of life that I've given you, there has been the reverse. I have been very sick. I'm all right after it all, thank God, but I know now what nervous prostration is. It's fearful, and I pity from the bottom of my heart many whom I had looked upon before as possessing a "maladie imaginaire."

You have no doubt been in good health, at least so I suppose from what I know of you and from your silence on the subject. And your good wife, how is she and how has she been? I think of her so often when I see the charming side of the French women, who are such absolute mates to the man, such companions, such real wives.

In reading your letter, you speak of the weak overrating of the importance of Paris as regards art, which prevails so much with us at home. Well, my visit here has made me feel that we can stand on our own legs and that that other time has gone by forever. I could give a great many reasons for this which you can think out better than I can set them down in writing, but we have much to be proud of and nothing to fear. . . .

There have been hints of my father's fondness for intellectual and philosophical discussions with Shiff and others. Accordingly, to further emphasize this marked characteristic of his, I will conclude the chapter with the following paragraphs

from some letters to Miss Nichols which will reflect, somewhat, his frame of mind in these more abstract matters.

You have often wondered what I think about things. I wonder myself. I think anything and everything. This seeing a subject so that I can take either side with equal sympathy and equal conviction I sometimes think a weakness. Then again I'm thinking it a strength.

. . . Five thousand different points of view are possible. After all, we are like lots of microscopical microbes on this infinitesimal ball in space, and all these discussions seem humorous at times. I suppose that every earnest effort toward great sincerity, or honesty, or beauty, in one's production is a drop added to the ocean of evolution, to the something higher that I suppose we are rising slowly (damned slowly) to, and all other discussions upon the subject seem simply one way of helping the seriousness of it all. . . .

. . . I once told Shiff that at times I thought "beauty must mean at least some goodness."

You speak of Browning—I shall read the "Ring and the Book," but unless a man's style is clear I am too lazy and I have too little time to devote to digging gold out of the rocks, fine as it may be. On the other hand I got the Schopenhauer that Shiff spoke about, with the intention of sending it to you, but it is so deadly in its pessimism, judging from the ten or eleven lines that I read, that I flung it away. It was terribly true from his point of view, but what's the use of taking that point of view? We can't remedy matters by weeping

and gnashing our teeth over the misery of things. "That's the way things is" and although I have been told all my life it's best to put on a brave face and bear all cheerfully, it's only lately that it is really coming into my philosophy.

It seems as if we are all in one open boat on the ocean, abandoned and drifting, no one knows where; and while doing all we can to get somewhere, it is better to be cheerful than to be melancholy; the latter does not help the situation, and the former cheers up one's comrades. . . .

A Russian professor at one of the universities here has sent me his translation of Tolstoi's last work, "What is Art?" and has asked me (with highly eulogistic terms about what I have done, in an inscription on the fly leaf), to give my opinion, which he wishes to publish with those of other men of note. So I am in for reading it.

Lately I have been finishing Tolstoi's Art book to see if I should reply. I will not. He goes a great deal too far. It would take too much time and I would say some damnphool thing. It has given me, however, a great admiration for Tolstoi's character, his sincerity and kindness of heart. But there are things in heaven and earth not dreamed of in his or anybody's philosophy, and the meaning of art is one of them.

The prevailing thought in my life is that we are on a planet going no one knows where—probably to something higher (Darwin, evolution). But whatever i

is, the passage is terribly sad and tragic, and to bear up against what seems at times the great doom that is over us, love and courage are the great things. I try to express it without entering into any philosophy or definition of art. I care nothing for the thousand philosophies about art, the intricacies of which seem too complex for me to delve into. The thing to do is to try and do good, and any serious and earnest effort seems to me to be, to our limited vision, a drop in the ocean of evolution to something better.

VIII

THE RETURN TO CORNISH

1900-1907

American Art as Saint-Gaudens Left It—The End of the Remin-
iscences—America with Fresh Eyes—The Hospital—A Railroad
Accident—Cornish Winters—Cornish Friends—Letters Here
and There—Illness.

DURING the last fifteen years of my father's life, that
is on from 1892, it became increasingly evident that
he had attained an uncontested position as leader of
American sculpture. In the midst of this period he made his
three-years' sojourn in Europe, chiefly that he might compare
his work with what was being created on the other side of the
Atlantic. The trip, however, was valuable to him not only for
this, but as well because, on his return, he found himself able
to look upon American art with a fresh eye and to see therein
qualities which would compare honorably with those of any
other art then being created in any land.

Indeed, during the span of Saint-Gaudens' days the art of
this nation had taken swift steps forward. At the time of his
birth artistic movement was irresponsible and unshaped; the
foreign dying, the archaic recognized as such, but the new
not yet ready. Through his boyhood continued a growing,
but still unsatisfied, desire for new departures. During his
student days abroad these instincts began to assume vague
form in the minds of such leaders as J. Q. A. Ward. Yet,
upon his return, life still presented scant attractions to the
struggling artist. A young man's sympathetic friends of the
Latin Quarter with their easy manner of existence were re-

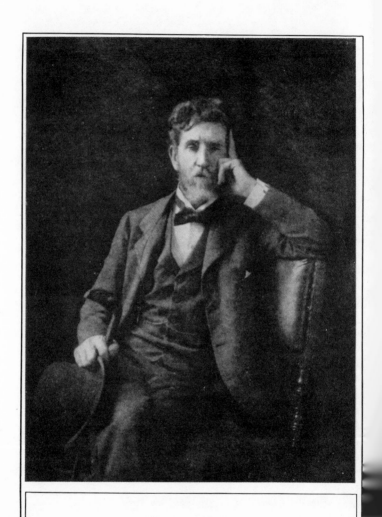

AUGUSTUS SAINT-GAUDENS ABOUT 1901

placed by the nervous exactions of American surroundings. His pet work was either often idiotically blamed or quite as idiotically praised. His expenses for studios and models proved outrageously high. And, to cap the climax, just at that instant it was the habit of father and uncle to draw in their purse-strings.

Soon after Saint Gaudens entered upon his struggle for mature recognition, however, better things began to shape themselves, chiefly through the formation of the Society of American Artists. The result was that within the next ten years, or up to the time of the Columbian Exposition, came a wholesome development of sincerity and characteristic progressiveness which, at last, succeeded in establishing itself sanely enough to curb any rash impulses towards eccentricities, to look only for the joy and beauty in life, and to admire that sentiment which, when expressed by the unskilful, might become mawkish, but beneath hands of growing dexterity attained rather to beauty. Then, at last, through the strongest period of Saint-Gaudens' life there rose in this land a final understanding of the presence of a recognized national art. Of course even now the average American can hardly be said to have developed into a satisfactory critic, but from the time of the Chicago Fair he became anxious to learn, and moreover succeeded in learning both to take greater enjoyment in beauty and to give greater time to that enjoyment. Municipal Art Societies, the result of a sense of care in the design and elaboration of public buildings and places, sprang up in city after city. Great corporations began to put real art into their edifices, not through altruistic notions about the need for them to join in educational movements, but because they appreciated that civic enthusiasm was shifting from pride in the size of its street signs to a pride in true municipal decoration. So it was that my father came finally to see throughout this land an art dealing with the life of the day after the manner of the

day, a glory to its own age and a firm foundation for the generations to come.

In this movement sculpture has progressed more distinctly in channels determined by American surroundings than has painting. The technique of both arts came equally from abroad. But the sculptor's commissions, on his return, grew chiefly from incidents or persons conspicuous in the life of this land. He did not feel hampered as much as the painter by the beck and call of individual taste and fashion in his efforts to set forth the nobility of the national spirit. He had no opportunity to wander away from actual life. From Saint-Gaudens' point of view this was lucky, for he felt that the greatest ideals lay in life itself, and that the greatest art was to show to the world the truth of this condition by a representation of life filled with these ideals.

Throughout this onward advance of sculpture Saint-Gaudens continued to regard J. Q. A. Ward as the dean of the school. Up to the year of his death, Ward, as President of the National Sculpture Society, maintained his independence and intellectual preëminence, strong in the understanding of the technique of his art, free from the clap-trap of over-cleverness or appeal to sentimentality, truly a sculptor both in conceptions and training. Among those about him another pioneer, Olin Waner, remained prominent in his sober strength up to the time of his sudden death in 1896. Daniel Chester French, with such figures as those from the John Boyle O'Reilly work to the "Alma Mater" for Columbia College, continued to show so well the reticence of the New Englander, intellectual comprehension, distinctive training, faithfulness to little things, and respect for the whole. Frederick William MacMonnies steadily exhibited his dexterity, his lightness of touch, and his instant ability to bring character to the fore in the "Winged Victory" for West Point and the "Sir Harry Vane" for the Boston Public Library; though, as time

went by, he made evident in his "Bacchante" and "Shakespeare" that the versatile joy of youth was giving place to greater technical proficiency. Herbert Adams carried out his early promise of creating distinctive busts and figures such as those of William Ellery Channing, and the Pratt Memorial Angels. George Gray Barnard continued to bring forth such fresh and creative nudes as that lazy, healthy animal, "The Great God Pan," or "The Hewer," an example of the sculptor's understanding of masculine strength, or the "Maidenhood," which demonstrated his power to reproduce the grace of woman.

Close on the heels of these sculptors also, came a number of other young men who made themselves known in the last five years with which this book deals, men such as A. P. Proctor, James E. Fraser, H. A. MacNeill, Adolph Weinman and Albert Jaegers. At the date of my father's death his interest in them was probably as vital as in any other members of his craft, because in them, he believed, lay the immediate future of American sculpture. Here are four letters he wrote concerning them which show so well his regard in this direction. The first he sent to his brother, Louis Saint-Gaudens concerning the latter's figures for the Pennsylvania Railroad Station in Washington.

I wrote a line or two on your ensemble drawing the other day, but as I was feeling miserably I said as little as possible and failed to tell you how well the thing looked as a whole, how the figures carried together harmoniously and yet were diversified. They made a bully impression on me, sick as I was, and those you had modified since you sent me the larger drawings were a distinct improvement and left no thought in the back of my head that I wished they were different.

As I remember, the "Fire" was changed and a great deal better. The "Electricity" struck me as a fine idea, with the electricity at his feet and behind his head; all over, as it were. I liked your last "Fire" better than the "Prometheus." Perhaps I would make the flame a still bigger one, that's all. . . . There is no doubt that the work cannot be too direct, that large simple lines and planes with strong dark shadows are the essentials.

The next letter is to Mr. A. P. Proctor, for a long time my father's assistant, especially on the "Sherman" and "Logan" horses.

May 27, 1906.

Dear Proctor:

I return to you to-day the sketch of the lion which I received in good condition and which, if you receive it in bad condition, will be the result of bad packing by my men, or a smash-up on the railroad. I think it is excellent as all your work is. I only feel that for architectural work it should be more in planes, more formal. I do not know why I say that to you, as you say the same thing yourself in your letter.

You will forgive me for speaking just as frankly as I always have about your work, and as I wish people to do with me. I think you have not insisted enough on the nobility and force and power of the manes of the lion and have perhaps insisted a little too much on the ape-like character (that is putting it rather strong) of the face. Some of the photographs of those British lions in that famous book on animals that I have, show they can have a nobility which is extraordinary. This

212

A CARICATURE LETTER FROM AUGUSTUS SAINT-GAUDENS
TO JAMES WALL FINN

one looks a little too much like the lions in the menagerie and distinctly the head does not bear the importance to the rest of the body—the overpowering importance —that one generally feels with a lion. . . .

In the following letter my father speaks of Mr. Albert Jaegers, a younger sculptor in whom he took an unusually deep interest, though Mr. Jaegers was never his assistant. The competition referred to in this letter was one for the Von Steuben monument for Washington.

. . . I may have been prejudiced in the character of Jaeger's work but it appealed to me in a singular way and it really taught me a lesson in my own work. I certainly wish that I could have done that figure in its dignity, directness, and simplicity. I think also that the poetry of the groups on the side is very fine. The pedestal is weak, of course, but they will fix that. Cass Gilbert will get at it personally and will arrange it. I think that later on you will agree with me that my choice was wise. When I look back at the only competition I have been in, and in which I was defeated, I thank God that I was not fired out of the window. Of course what you have done in this competition is a million times ahead of what I did in that.

Last of all, this letter to Mr. White on May 27, 1904, contains his enthusiastic praise of a relief modeled by his old friend and pupil, Mr. John Flanagan. The relief is now set into the wall of one of the dining-rooms of the Knickerbocker Hotel.

. . . Flanagan has made a beautiful Venus in bas-relief that I thought you would like to see. I think

it really very fine and I volunteered to write to you to go and see it. You might find a chance to place it in some of your houses. In marble or gilded bronze I think it would be swell.

In painting, as in sculpture, the art of this land established itself and progressed. Beginning with mural decoration, that craft especially like sculpture became American in its execution. For though in a general way the painters learned their trade in France, they readapted it, after their return, to meet our national requirements in such problems as those offered by the rotunda of the new addition to the Boston State House, for Sargent in the completion of the Boston Public Library, for Edwin H. Blashfield, Henry Siddons, Mowbray and Kenyon Cox, in such buildings as the Appellate Courts Building in New York, the Baltimore Court House, and the State Capitols in Harrisburg, Pennsylvania, for La Farge at St. Paul, Minnesota, and Des Moines, Iowa, and for John W. Alexander in the Carnegie Institute in Pittsburgh. It is hard to speak of these men as a body. No fundamental rules were laid down for their craft. Each continued to progress according to his own conception of what was needed. La Farge in one direction, Sargent in another, Blashfield in a third, Mowbray in a fourth, and Cox in a fifth.

Closely allied to these mural decorators, especially in the sense that they have furthered their own development irrespective of what has been happening abroad, appeared a group of figure painters. They sought beauty in beautiful persons and things. They knew their drawings. They knew their colors. They respected both their own individuality and that of their fellow workers. Abbott Thayer developed into the painter of the essential spirit of womankind by means of his power to infuse concrete human beauty with a most elusive quality of divine significance. George de Forest Brush, gently,

thoughtfully, and with ever increasing force, continued to express to the world the most fundamental of human emotions, the love of mother for child. Thomas Dewing mastered the external fascination of delicate forms. His results seemed the product of peaceful but untiring effort, without a hint of undue struggle on the one hand, or difficulties avoided on the other.

Nor may this domain of figure-painting be left without including one other school which reached a respected rank in their company, the school of Illustrators. In a speech before the Society of American Artists I once heard Howard Pyle say in part approximately as follows: "You can never succeed in any attempt to uplift or educate the public of this country to any standard above them which you may fancy that you have attained by offering them that for which they have not asked. To create great art it is necessary to take what the people want and then, by infusing into this desire the strength of your genius, make it a masterpiece. In the time of Raphael, let us say, Madonnas were in vogue. It is possible that certain esthetes considered Madonnas as not being fit subjects for art. But Raphael was a painter who could meet the world squarely and satisfy its demands. Therefore, as his neighbors desired Madonnas, he set himself both to paint Madonnas and to permeate these figures so thoroughly with his power of sentiment and imagination, that their reputation would be beyond criticism for all time. To-day I often find that the word 'illustrator' is regarded with contempt by a few who claim a higher position as being 'painters.' Such an attitude I cannot see, cannot respect. The world to-day for one thing wants illustration, and I, as an illustrator, believe that by nobly satisfying their wants there can be created from them another and vital art."

The words of Pyle's speech, so filled with nobility and sincerity and honesty, have proved true of him, the first of

American illustrators, and of others such as Maxfield Parrish and Frederick Remington. Moreover he has led the painters in this land into a new and vital field which, as time progresses, has come to be more and more respected. And though these words were spoken some time after my father's death, yet I am certain that nothing ever said on the subject could have more fitted in with Saint-Gaudens' understanding of the situation, which was that no masterpiece of art could be produced except when a great artist was in full accord with all intense popular demand. Here, for example, is the way my father expressed his admiration for such illustrations in a letter to Maxfield Parrish:

. . . The three drawings for Milton's "Allegro" you have done for *The Century* are superb, and I want to tell you how they impressed me. They are big, and on looking at them I felt that choking sensation that one has only in the presence of the really swell thing. The shepherds on the hill, the poet in the valley, are great in composition, and with the blithesome maid are among the most beautiful things I have ever seen.

It is always an astonishment to me how, after all the fine things seem to have been done and after all the possibilities of beauty seem to have been exhausted, some man like you will come along and strike another note just as distinctive and just as fine. It is encouraging and stimulating.

To turn now to the landscape painters, who again were making an independent American name, with them craftsmanship was not so much at a premium as was genuineness, while a desire for strength seemed more to the fore than any sensitiveness to subtlety. That the crisp clean air and colors of

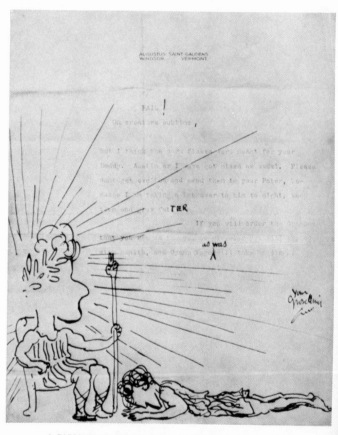

A CARICATURE LETTER FROM AUGUSTUS SAINT-GAUDENS
TO MAXFIELD PARRISH

this land formed other problems than those of Europe became appreciated at about the time of the World's Fair, and at last essentially the same list of men as that which has been mentioned before, such men as Twachtmann, Hassam, Metcalf, Bunce, Coffin and Harrison, mastered the situation. Their school increased in strength with their confidence in their technique rather than in their imagination or varying points of view. It became no longer the school of the daring innovator. It was the school of assured craftsmen with, as their leader, Winslow Homer, who personified the cleanest type of fresh American virility. Sober, earnest, and full of movement, his pictures went direct to the point with originality of vision and with that strange power of the big man who does subconsciously the thing so often felt though never expressed.

Finally portraiture, making no especial change from its condition as last spoken of, continued its normal progress with Sargent ever the head, and following close in his company, Cecilia Beaux, Alexander Chase, and others.

This, then, may present some slight idea of the atmosphere which my father found about him when in 1900 he came back to work once more in this country, an atmosphere of health and vigor and vitality. No wonder he returned with the conviction more than ever firmly established that he was an American with his home in America, his work in America. No wonder he felt pride in the projects of this land and at last remained firm in his conviction that whoever could stand preeminent in art on this side of the Atlantic need fear no competition from the art on the other.

The closing pages of my father's reminiscences are sadly incomplete, and even my best efforts can give only a ragged presentation of the final busy period of his life, a description of which would have come so vividly from his pen if only a few more months of health had permitted him to finish this account with his own hand. His text

ends, as will be seen, with light-hearted references to his last play-days here in the country around him. Such an ending is characteristic. For, whatever caused him anger or worry or pain, he invariably attempted to make over into a jest; and these few years were full of pain. His remarks show also the unwonted turn of his mind toward open-air pleasures. It was strange to us about him to see the man of the city alter at his age to one of the country. But that is what occurred. He showed a marked concern one spring because a heavy snow, falling after the robins appeared, killed many of these. He took the habit of throwing bits of apple on the studio stoves in order that he might smell them burning while he worked. He built and graded. He entered with zest into landscape gardening and the construction of a golf course. And finally he explained to us one day that, next to opening the mail-bag, looking out of the window in the morning was the first enjoyment of life.

His own words explain what brought him back:

In the midst of this Paris Exposition I was suddenly told that I was a sick man and that I could not get to a surgeon any too quickly. So I dropped everything and took the first steamer home.

Though in a misery of mind beyond description, the impression of New York, of America and Americans, after a three-years' absence, was memorable. I was but a day in New York and a day in Boston before entering the hospital. The note which struck me in the people, and a distinctive note at that, one about which I had no doubt, was that the general look of the faces was one of keenness and kindness.

There is enough misery in the world without adding to it by a tale of my experiences in the hospital. Grati-

tude for the great kindness I experienced there and to the men of medicine I was under, only added to my admiration for the generosity of that profession.

I found also my usual comedy, this time in a male nurse who took charge of me nights. I needed the most constant care and upbuilding and, in the course of it, this chap discovered a bottle of rare wine which he thought no doubt too good to waste on an unappreciative and ill-tempered invalid. In short, he emptied it, and, as a result, handled me in a Louis Fourteenth style hardly in keeping with the gentle treatment I required. He was discharged, but without my knowledge. Later I met him going out of the corridor and, in answer to my inquiry as to what he was about, he said, "I 'm leaving the place. I don't like it here at all."

In due time I left the hospital, and with Mrs. Saint-Gaudens was driven to the Fitchburg station to take the train for Windsor. We occupied a stateroom, I lying on a couch and she sitting opposite me. The day and the scenery were beautiful, and as we traveled I looked forward with pleasant anticipation to seeing Cornish again after a three-years' absence. Suddenly a series of repeated locomotive whistles, and the putting on of the brakes with violence, revealed something wrong. I was not mistaken. In another moment there was a tremendous crash. Great splinters of cars flew past the window. I was thrown forward on the floor, and although nobody was hurt, the children began to scream unmercifully and we were enveloped in a cloud of dust and smoke.

Presently we got out of the car and found ourselves in a beautiful winding gorge, a peaceful brook purling along, the birds singing, a delightful breeze blowing, and the white clouds flying gaily across the blue sky. As we looked forward, we could see what had been our locomotive, a confused mass of wreckage, wood, and twisted iron. On the other side from where I was, they told me that the engineer lay under the locomotive, his legs pinned down by the wheels.

After we had left Winchendon, Massachusetts, a gang of men at State Line, the next station higher up in the hills, began shunting some box cars a short distance away from the station which we were approaching. Suddenly they lost control of four of the cars which started down the steep decline up which we were traveling. Fortunately, of the four cars that escaped the two that were toward our train were empty and formed a kind of buffer to our locomotive, which tore through them before reaching the heavy cars laden with sand.

It was a singular accident, with the usual contrasts of life: the peaceful gentle country, the passengers sitting around on the green banks, the beauty of the weather, and in the midst of it all the poor man in terrible agony. He died in the night. At State Line, after the box cars had escaped from them, but before the accident happened, they had telegraphed for a wrecking train. In consequence it was but a few minutes after the collision that men came armed with the iron paraphernalia of rescue. The rest of the story of this adventure, until my arrival in Windsor the following day, is one of un-

CARICATURE ILLUSTRATIONS

The top and bottom pictures are signatures at the end of letters to Mrs. Thomas Hastings and to Miss Frances Grimes. The middle pictures, describing winter life in Cornish, were sent to Alfred Garnier

pleasant experiences with the underlings and the railroad employees, who treated us with no more consideration than they would have given a car full of horses—probably less.

Then, through the delightful New Hampshire autumn followed the pleasure of convalescence, combined with further work upon the statue of General Sherman. For while the principal bronze casting was being made in Paris, I was carrying out alterations later sent to the founders; with the wings which did not please me, with parts of the cloak of the General, with the mane of the horse and the pine branch on the base, which I placed there to typify Georgia.

Meanwhile when the bronze of the "Stevenson" arrived, which I had wished to see before it was erected in position in Edinburgh, I was dissatisfied with it, and remodeled it almost entirely. So the "Sherman" and the "Stevenson," both at their beginnings and at their completion, hung together.

The winter was well on by this time and I soon learned that this season in the North Country, instead of being one of gloom and slush so dreaded by the inhabitants of large cities, was one of cheerfulness and lightness of spirit. Cornish is not perfect any more than Mount Olympus, and the Cornish imperfection comes with a vengeance in the spring. Then there is the mischief to pay. The river breaks up and floods the roads, the snow melts, and mud is everywhere. So, notwithstanding an occasional divine day, the desire at this time to escape, and to escape South, develops into

an obsession. But for my first winter in Cornish I was deeply impressed and delighted by its exhilaration and brilliancy, its unexpected joyousness, the sleigh-riding, the skating, and what not. I was as happy as a child. I threw myself into the northern life and reveled in it as keenly as I did in the dancing in the moonlight in Lispenard Street when I was a boy; especially when, skating once more after thirty-five years and playing hockey like a boy, I was knocked down twice, receiving a magnificent black eye the first time and a swelled and cut forehead the second. In these I took great pride.

But without my work, assistants and congenial neighbors I could not have borne a winter in the cold country. To me, after all, Nature, no matter how superb, when it lacks the human element lacks the vital thing.

The oldest among Saint-Gaudens' Cornish friends were Kenyon Cox, Herbert Adams, and Charles A. Platt. Mr. Dewing had "trekked north" early in the period, as he had long threatened to do, that he might escape the constantly increasing sophistication of the region, the blot of the picture-hat upon the landscape. But there had arrived other congenial spirits such as Norman Hapgood, my aunt, Mrs. Nichols' family, Mr. Stephen Parrish, Mr. and Mrs. Maxfield Parrish, and Mr. and Mrs. Louis Evan Shipman.

Besides these "city-folks" there were also certain of the country people for whom my father come to care genuinely, though their ways had been strange to him in the beginning. First among them was Mr. John Freeman, "Uncle John Freeman," as he is called, a man of the older New England type and stock, gentle in manner, philosophical, frugal, generous

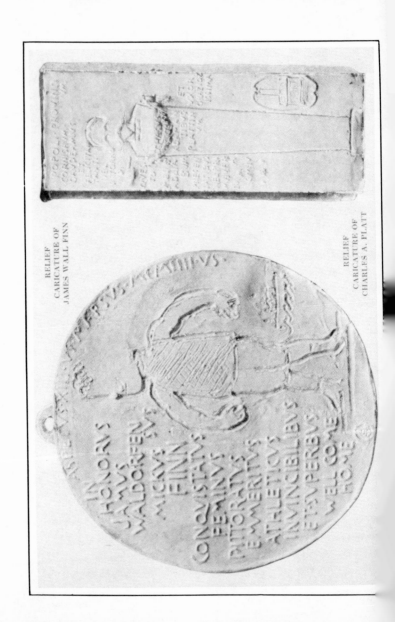

RELIEF
CARICATURE OF
JAMES WALL FINN

RELIEF
CARICATURE OF
CHARLES A. PLATT

in thought. Each time he came with a couple of trout for my father's luncheon, or dropped in for a chat, his appearance was welcomed and remembered. Great was the rejoicing when once, in "The Snuff Box," the tiny house then occupied by Mr. Percy MacKaye, they induced "Uncle John" to join in a birthday party which they gave him.

Yet perhaps even more vital to my father's happiness than these friends about him, aside from the members of his own family, were his studio assistants. Mr. James Earle Fraser, Mr. Henry Hering, Miss Elsie Ward, Miss Frances Grimes, all shared in his play as well as in his work, golfed with him, tobogganed with him, tipped over in sleighs with him, laughed at his desperate efforts at manipulating the flute, or at Fraser's equally futile attempts at correct spelling, made caricatures of each other in the evenings, or slaved for the love of it upon such of his elaborately concocted jokes as his cartoon sent to Mr. James Wall Finn at the time of Mr. Finn's wedding.

"Play, play!" my father would say to them. "I wish I'd played more when I was young. I took things too seriously."

Whereupon, if some one asked him if he was not satisfied with the result of taking things seriously, he would say half in fun:

"No. Look at these awful bronzes all over the country. The thing to do is to play more and to flirt more!"

My father had always been in close touch with assistants such as these. Of course in one way he had employed them as refined tools with which to develop his schemes, appreciating the qualities in each personality, were it a poetic grasp, a power of virile creation, or an ability to model surfaces. Aside from that, however, he felt the most sincere interest in their futures, in the work they might obtain both in and out of the studio. So, now, while his sickness increased, instead of the customary egotism of the invalid growing with it, quite the opposite took place. As he hoped more for his own com-

fort he seemed more anxious for the happiness of others, and consequently there developed in him a deeper and deeper desire to forward their opportunities. Gratefully he recognized not only in them, but in all those others about the studio—such as Mr. Gaetan Ardisson, molder, who had worked for him for twenty years—an untiring skill, self-effacement, and loyalty to his desires in the days when his failing strength made more and more difficult his task and theirs.

As usual, probably the most vivid picture of his life in the country is conveyed by his letters written at the time, a number of which I will give. The topics in them jump back and forth from the serious to the frivolous. This, however, has been seen by now to be characteristic of my father's mind.

A letter to Mr. Low and three translations of letters to Garnier show how America appeared to him upon his return. In the letter to M. Garnier it is interesting to realize what pains my father took to accommodate his description of life in this land to the European point of view. The attempt is extremely characteristic, for my father, even when talking with a man for but five minutes, would do his best to look at things from his listener's standpoint.

To Low he writes:

WINDSOR, VERMONT, January 19, 1901.

Dear old Feller:

I commenced a letter to you a year ago, one six months later, and one a month ago, all of which were to tell you that I had the Stevenson letters from you; while the two last in especial were to add that my silence did not show lack of appreciation or affection. I appreciate the gift deeply, believe me, as well for what it is as for the associations it recalls. Through you came

one of the most delightful experiences of my life, and to have a genius like Stevenson say what he did of me proves that my friend Low must have said more good things to him.

I did not finish the first two letters because of my terrible mental condition, no doubt the prelude to the deeper depths of Hell I have been in since. I will not dwell on that which, thank God, is now a horrible dream of the past. The third letter I did not continue, as on the little Christmas card you sent me from Paris, with a negligence which went to my heart, you omitted your address. Of course I could have sent it to some one's care, but that (through a negligence that must go to your heart) did not occur to me. *Enfin, me voici!*

I will not attempt a bully long letter such as yours, or you will not get this either. I'll simply tell you that it was a delight to read yours *"comme tout-jour."* Your description of the drip, drip of the Paris winter recalled the misery of the winters in that delightful city. But you will have a gorgeous and smiling spring. Like a beautiful bride it will appear and will make you forget at once the old hag who has driven you wild with her slush and mud and gloom. Paris is wonderful in the spring. Tell that to dear Mrs. Low, although I'm afraid I'm at odds with her as to the delight of the winter months there. I would never have believed it nor do I suppose you will believe me now, but I am enjoying the rigorous young winter up here keenly, snow all over, sun brilliant and supreme, sleighs,

sleighbells galore, and a cheerfulness that brings back visions of the halcyon winter days of my boyhood. Last night the thermometer was fourteen degrees below zero and I slept with my windows open, and now at noon it has grown colder. But withal one suffers infinitely less from cold than in hellish, torn-up but dear old New York, or in slush-ridden Paris—Forgive me, Mme. Low. . . .

To Garnier he sent the following:

16 Nov., 1903.

My dear Old Man:

I have the photographs of that dear country of France for which I have a love, despite my education and my experience, too hereditary and too firmly fixed to be effaced by the cosmopolitanism which goes on here. Your reminder sends an appeal directly to my heart, an appeal of which those who have not visited the United States have not the least idea. There is nothing with flavor in it here, with age. Everything is new, brilliant, or thin. One feels that everywhere. There is no past. There is no association. And when a man has got beyond the fiftieth year, he has drawn away from the desire for novelty he had at the age when we marched through the Jura mountains with our knapsacks on our backs. Nevertheless, I regret nothing. I believe that as we advance in life there are joys more keen (in any case for my nature) than when we were young. That proves that I am like a monkey jumping from tree to tree, always thinking there is happiness in the branches of the other tree.

12th of December.

It is a month since I wrote you what you have just read. Since then I have made two visits to New York, and I have not had the time to write leisurely. We have been having regular winter for three weeks. We skate and I play games upon the ice as I played them thirty-seven years ago, a little more stiffly, but that does not make any difference since I am still feeling young. Now, above all, the clear and joyous weather gives a gaiety of a singular fashion, a fashion of which those who have not experienced the cold dryness of the North can have no idea. It is far from the terrible, black, sad days of the winters of London, and Paris, and even New York, where rain and clouds are dominant. Although it is very cold here, I invariably suffer a great deal more from cold on my journeys to New York.

Louis lives about half an hour's walk away, virtually five hundred feet above me. He has a house that was formerly a species of Protestant church, belonging to a sect, the Shakers, whose religion was no love and no children. Louis' wife bought this from two old survivors twenty-five miles away from here. It is of wood, so they took it to pieces, put it on the railroad, transported it and reconstructed it here. It is a house a hundred years old. Mine also is one hundred years old, only it is in brick. It formerly used to be a house with a very bad reputation. You can see the droll things in life.

THE REMINISCENCES OF

ASPET, WINDSOR, VERMONT, 1st August, 1905.

Dear Old Man:

. . . I hope that everything is going well with you and your wife. I see by the newspapers that it has been very hot with you. Here it has been an adorable summer, except this unfortunate condition which keeps me from standing for long and in consequence from working regularly. However, all is for the best in this best of worlds. It is the only manner of looking at things. We amused ourselves very much on our trip to Southern France and Italy and we shall enjoy life together again. The older I get the more I see of things to take pleasure in, and the more youth seems good to contemplate. However, I don't regret the march of years. There's philosophy for you, in any case enough for six o'clock in the morning, the hour at which I am writing you. I have acquired this habit and there is one joy more in the day, the ineffable, I do not know what, in the air of daybreak. Stevenson, the poet, often said to me, "The person who does not appreciate the dawn does not understand life."

Homer has been married two months to a blonde, blonde, blonde. He is dark, naturally he must have some one who is the color of wheat. They have taken up housekeeping in New York. I suppose I shall become a grandfather. Eh? That's funny, isn't it, when one thinks of the Rue Jacob!

Next follow three letters which dwell upon the outdoor pleasures already alluded to and show the healthy way my father's mind turned to them. The first is to Low:

236

AUGUSTUS SAINT-GAUDENS

My dear old Feller:

. . . Your letter of July twenty-sixth is on the desk before me and it is unnecessary to tell you how pleasant it is "to read you," as they say in French commercial parlance. The race of charming letter-writers will not be extinct so long as you tread on top of this curious planet. As I look out of the window on the hills opposite, I wish I had your power of description, for the whole burst of autumn glory is at its full now, only more beautiful than ever, for some reason or other. There is more harmony in it all than usual. It's perfectly glorious, and the weather is too, and I wish you were here that we might have a long chat over the past, present and future. As you know I have had an awful time. We all seem to have it in one form or other sooner or later. But I'm out of it, thanks I suppose in a great measure to the change in my manner of existence, which from my point of view now has always been that of a damn fool. I stop work at one o'clock and I devote the rest of the day to out-of-door things, golf, walking, driving, cutting trees, and all that makes one see there is something else in life besides the four walls of an ill-ventilated studio—not that I renounce for a moment my love of the charm of that life too—I speak of this because I see so many of the *"confrérie"* living the life I led for thirty years, and I wish to drag them by the hair to where they would find other *"jouissances"* that would not undermine their health.— *Health*—is the thing! That's my conclusion.

Following this are two letters to me written while I was in college:

. . . Billy almost stands up alone on his hind-legs and the "Admiral" I have dubbed "flubdub." Finn has been and gone, but either he or Fraser returns in a few days. I had a pretty tumble off "Admiral" the other day, and I speculated while I was in the air as to whether I was going to be killed by having my skull smashed or my ribs caved in. I have also been very sick but I am all right again. I thought I was up the spout for a few hours. . . .

A collar-button was discovered in the stomach of a cow. The question is how did the cow get under the bureau???

Again:

. . . You have by this time received your third check and are happy.

The toboggan will soon be forthcoming, I hope. The slide is erected about ten feet higher than the other, and has an alarming look. I think it would be well to buy a couple of small toboggans also and send them along. Apropos of sport, I had a surprise the other day while playing hockey, with G. F. on the opposite side. I was skating in front of him without touching him in order to prevent his getting at the puck when he deliberately bucked me and knocked me down, which created mixed feelings of anger and pleasure, pleasure at being considered youthful enough to be handled in that way, and anger at the absence of proper respect

shown for maturer years! He said he had a right to do that when a person interfered. Fraser and Jaegers say he does n't know that what I was doing was all right, but that he would have been put out of a regular game for such a proceeding. Rather a complimentary shock on the whole. I was sorry you were n't around to have given him a little shock too. The day before he had tried that game on Fraser, and the result was that on striking Fraser he shot straight into the air about ten feet and landed all over the ice. . . .

The first of the next two letters refers to the construction of the "Small Studio" here which Mr. Babb designed. The completion of this studio became the jest of the family as its ramifications and complications were endless, though indeed we might have become used to such a state of affairs, as there was hardly a week in all the time my father spent on this place during twenty-two years that he did not have something rebuilt or regraded, to his intense enjoyment. Among the developments of the studio, however, it became especially interesting to watch the manner in which he applied his sense of color. For during at least four years he made endless experiments on combinations of paint upon the interior wall of the pergola and on the columns and the trellis which supports the vines, while the portion of the Parthenon frieze along the upper edge of the wall was three times laboriously and delicately tinted before he obtained the result he desired. He writes:

ASPET, WINDSOR, VERMONT. Tuesday.

Dear Babb:

I think if you could come up here for twenty-four hours it would be a great help in the settling of things. Now that the studio is gone, the field has taken such a

grand look that I regret I did not see it before they started work on the foundation. I should certainly have changed the whole scheme and moved the studio to the east. However, the mound of earth dug out of the cellar of the studio is as high as the hedge on the east side of the wooden seat, about a thousand times the amount necessary to smooth, level and heighten the ground where you suggested.

It is not possible to see the vista through the woods which reveals the extreme N. W. corner of the place as you thought from where you proposed putting a seat something like this. (Sketch.)

Could n't you come right up for a day? Take the 9 A. M. train. You get here at four, and you can take the noon or three P. M. train back the next day if you wish.

Please do.

Again:

Dear Babb:

Angel!

Gussie wants the bay windows on the house and wants you to do 'em. That's no reason why you should though, if it is to cause you nervous prostitution or sea-sickness, or give you "insomania" which a servant girl once told Louis she was troubled with! So hesitate not to say *nay* if you are disinclined. She wants the bay windows on the south side of the house both in the dining-room and the parlor, and would like them to run up both stories.

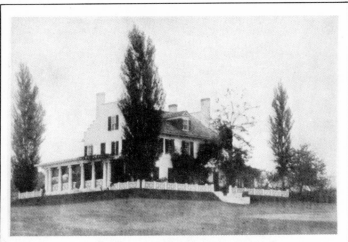

THE HOUSE IN CORNISH AS IT STANDS

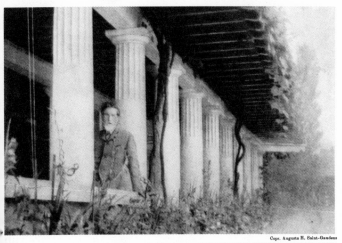

AUGUSTUS SAINT-GAUDENS IN THE PERGOLA OUTSIDE HIS STUDIO IN CORNISH

This photograph, made in August, 1906, is probably the last taken of him

Will you give us some drawings for that? In five minutes! Say ten or even fifteen minutes!!

Now besides what *she* wishes, *I* want to replace the roof and have three dormer windows and the east and west ends treated as on this sketch, and I want a *red* roof.

I won't pester you any more, but I should like to have you do this. Nevertheless, notwithstanding, furthermore, I can perfectly understand how you may send me to Ballyhack, having troubles enough of your own.

To give a glimpse of the humorous fashion in which my father regarded the turmoil which all this activity developed around him, let me conclude this group of letters with one written to Mr. Charles O. Brewster. Mr. Brewster had become my father's intimate friend first through their common love of music at the studio concerts. This friendship had been made more firm on my father's part as the years went by through his appreciation of Mr. Brewster's unfailing generosity of spirit. Therefore his appearance at any time was an event to be welcomed. My father writes:

You hold forth a prospect of your coming up here. It goes without saying that both Gussie and I would be delighted to see you. So come along when opportunity offers. You will receive a warm welcome, and I think I can have the tank filled in time so that you can have your usual plunge. It is a new tank, by the way, and a new studio since you have been here. You will see much change anyway, the place has spread to be such an establishment that it requires a general,

aides-de-camp, commissariat, wagon-trains, and what not to run the affair. I am beginning to appreciate why it is that when men are disciplined in the army they are shot for not obeying.

As a natural accompaniment of this love of the country, there developed in my father's nature two new pleasures, an interest in the development and prolongation of healthy life and an appreciation of youth in the freedom of its spirit. For the first he became absorbed in the work of specialists like Metchnikof and Fletcher, the latter of whom came to visit him in Cornish. For the second he dwelt again and again upon his own younger and athletic days and attempted to repeat them. As he has hinted, in the winter he kept a patch of ice cleared of snow, no easy task in this latitude, and was indefatigable in organizing "hockey" parties. He also erected perilous toboggan chutes and through a glorious accident, one of our family wearing its scars to this day, he established thereon an eminent reputation for recklessness. In the summer he employed all manner of labor both to furnish himself with his own golf-course and to rebuild his swimming-pool; since, though he might no longer swim himself, he could obtain endless delight in watching youth at the sport.

And of that same youth Saint-Gaudens constantly reminisced. For example, one evening at the The Players Club, as my friend Witter Bynner and I were going from the entrance down to the billiard-room, we met my father coming up the steps bravely supporting himself on the plush rope.

"Hello, Bynner!" he exclaimed. "Where are you heading?"

"To see Lillian Russell, the friend of my youth," answered Bynner.

"The friend of all our youths," my father smiled back at us.

Such was my father's rejuvenation of spirit. Many of his friends noticed and commented upon it, and one of these con

ments, at least, I would include here. It comes from Mr. William A. Coffin, who not long ago wrote me:

"Physical strength and action elicited Saint-Gaudens' admiration. We were members of a jury of three one year, John Alexander being the third, for the award of the Winchester Scholarship at the Yale School of Fine Arts, and went to New Haven. It was in June, 1902. After we had judged the competition, Prof. Niemeyer, who was acting director of the School in the absence of Prof. Weir in Europe, had a carriage ready and told us he wanted to take us out to see the Yale-Princeton baseball game. When we reached the gates, the fakirs surrounded us offering Yale and Princeton buttons, badges, flags, etc. Niemeyer and I put on Yale buttons. Alexander was for Princeton and put on the orange and black. Saint-Gaudens, conscientious as usual, first accepted the blue, but then reflected and decided that as he had received an honorary degree from Princeton as well, he would have an orange and black button, too. As soon as we were inside and seated he began to notice the movement and action of the players. He was too much absorbed in his own work to have made himself well acquainted with the rules of the game and only knew in a general way what it was all about. A Yale batter sent a grounder to the Princeton short-stop which he picked up as it bounded. Saint-Gaudens exclaimed in a low tone, 'What was that, out on the bound?' quickly followed by 'Look at that! Look at that chap!' as the first basemen jumped in the air to catch the ball which the short-stop had thrown to him too high. Then he spoke again and again of the pitchers whose 'movements' offered continual changes of pose and action in all of which he noted strength or grace, as the case might be."

It was lucky indeed that my father did develop this love of the out-of-doors and of the pursuits of youth. Had it not been for that he surely never would have accomplished what

he did, nor could he otherwise have stored sufficient energy to keep his mind active through the last days. Because it must be remembered that during the final seven years of his life he bore suffering from various troubles which would have kept most men in a condition of perpetual break-down. Upon his return to America in 1900 he went to the Massachusetts General Hospital where he remained for July and August. Then in the fall he returned to Boston to spend five weeks in St. Margaret's Hospital on Louisberg Square. Subsequent to this, he enjoyed a few comparatively painless years, though at times even then he suffered acutely and was experimenting with one physician after another, taking often an electrical treatment which seemed for awhile to relieve him; to the occasional visitors to his studio the bulky static appliances were a strange sight. Late in 1905 his condition was such that he had a trained nurse always by him, and in February, 1906, he went to the Corey Hill Hospital in Brookline, Massachusetts. The following summer a special physician came to Windsor, but by August my father was so ill that he was unable to leave his room for weeks at a time. During the winter of 1906-7 we feared he could not live. In the spring of 1907, however, he was much better. He could sit sketching directions for his assistants on a pad and was carried from place to place in an improvised sedan-chair, even coming occasionally to meals at my house, nearly a quarter of a mile from his. By July, however, he was back in his room once more, never to leave it. Knowing that he was not the man to dwell on sickness or misery, I tell of this side of his life as briefly as possible, and only that it may be understood what he had to fight against during those last days.

IX

FINAL OUTSIDE INTERESTS

The Studio Fire—The Death of White—Outside Interests—The
Roman Academy—The Artistic Development of Washington—
Impressions of Washington—Honors.

HERE in Cornish my father spent the last seven years
of his life. For the most part they were as happy
as his health would allow, though with them came
two shocks which affected him deeply. The first was brought
by the fire that burned his largest studio in October, 1904, the
second by the murder of Stanford White in June, 1906.

At the time of the fire I was with my father witnessing a
performance of "Letty" at the Hudson Theater in New York
City. We learned of the loss of the studio on returning to
the hotel. Though my father took the news with a self-
possession that showed that, despite his ill-health, the years
had brought him a share of mental peace, neverthe-
less I am sure it caused him great distress. The destruc-
tion was almost total, probably because the one man who
would have understood how to save what was valuable, Mr.
Henry Hering, was also enjoying a well-earned vacation; and
on that evening, curiously enough, unknown to us, was sitting
in another part of the Hudson Theater.

The fire started in a stable adjoining the studio about nine
o'clock at night, when, as it happened, there was not a man
on the place. The two maid-servants noticed it only after it
had got well under way; so that before they could summon
aid the flames were pouring straight upward into the still
night air. Then, though our neighbors gave their best as-

sistance, little could be done because of their natural ignorance of the value of various bits of work, or of how to handle sculpture. For instance, the Parnell statue was held to the floor by a few hasps, which might easily have been torn up with any bit of iron but which made it impossible to move the work by pressure against its side, so that the best of unskilled efforts to save it were in vain. While, again, many precious moments were spent dragging out an iron stove, despite the fact that a quantity of important casts lay loose at hand. As a result almost all of four years' work perished, a number of bas-reliefs, the Parnell, the nearly finished seated Lincoln, and a statue of Marcus Daly which sank into the embers with flakes of plastoline bursting from it as if from some tortured body.

But not only did my father's sculpture receive a severe setback, he lost as well what he regarded as even more valuable, the stored furniture of his New York house, most of his treasured papers and letters, such as those from Robert Louis Stevenson, all of his portfolios containing records of twenty years, many photographs of commissions then on hand which he was unable to reproduce, his own drawing of his mother, the portrait of him by Kenyon Cox, the sketch of him by Bastien-Lepage, the Sargent sketch of him and a water color of a Capri girl, paintings by Winslow Homer, William M. Chase, and William Gedney Bunce, and many other pictures and objects reminiscent of his life. The one bit of good fortune in the whole affair lay in my father's owning a second studio; so that this, with other buildings and adaptable barns in the vicinity, allowed the work to progress again immediately while he comforted himself with the thought that the monuments would improve because of the imposed recreation.

The second shock, that caused by the death of Stanford White, would not, at first glance, appear to have affected the sculptor so closely, since for some years he had scarcely seen

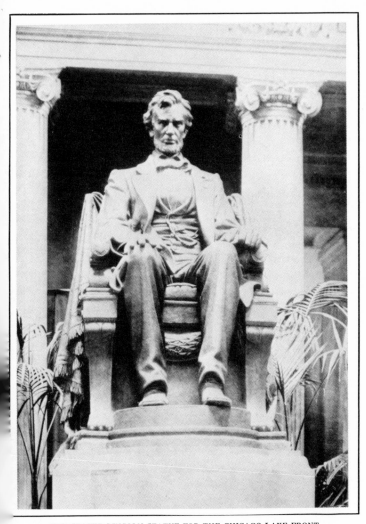

THE SEATED LINCOLN STATUE FOR THE CHICAGO LAKE FRONT

Ever since the standing Lincoln was erected in Lincoln Park, Chicago, some twenty-three years ago, Saint-Gaudens had desired to create a seated Lincoln. The one here shown is from the clay model, before being cast in plaster. Slight alterations were made later. The commission came from the Creerar Fund

the architect. However, my father had a big heart for old friendships. Wherefore, understanding that the details of personal tastes frequently lead men into widely different paths of life though their fundamental ties remain firm, he still counted White not only a master in his art, but one of the few men of his younger days on whom he could depend for intimate sympathy and advice. The next two letters which I include show how their friendship held true to the end. My father writes:

May 7, 1906.

Dear Stan:

. . . As to your visit here, I have been trying to get you up here for twenty years and no signs of you and Charles. Yet now when we are having the worst spring that ever occurred (the roads are in awful condition) you want to come up in five minutes. You hold off a little while and I will let you know, perhaps in a couple of weeks from now.

To which White replied:

May 11, 1906.

Beloved! ! !

Why do you explode so at the idea of Charlie and myself coming up to Windsor! If you think our desire came from any wish to see a fine spring or fine roads, you are not only mistaken but one of the most modest and unassuming men with so 'beetly' a brow, and so large a nose 'wot is.' We are coming up to bow down before the sage and seer we admire and venerate so. Weather be damned; and roads, too! Of course when it comes to a question of Charlie and myself doing anything, large grains of salt have got to be shaken all over the "puddin'." I am a pretty hard bird to snare, and, as for Charlie, he varies ten thousand times more than a compass does from the magnetic pole, so all this may end in smoke.

Such, then, were the relations of the two men at the time of White's murder. Therefore it is to be imagined how deeply the news of his death shocked my father. For a time the catastrophe left little for my father to say or do. But at last, when the public clamor had died out in some measure, and certain of White's friends had asked him to write a word in praise of the architect, he gladly began making attempts. At first his ill-health seemed to render the task impossible. Finally, however, an article upon White by Richard Harding Davis which appeared in *Collier's Weekly* gave him the needed strength to produce the following letter which the magazine printed:

August 6, 1906.

The Editor of Collier's Weekly,

420 West Thirteenth St., New York City.

Dear Sirs: I thank you for the remarkable article by Richard Harding Davis about Stanford White in your issue of August 4th. It is, to those who knew him, the living portrait of the man, his character and his life. As the weeks pass the horror of the miserable taking-away of this big friend looms up more and more. It is unbelievable that we shall never see him again going about among us with his astonishing vitality, enthusiasm and force. In the thirty years that the friendship between him and me endured, his almost feminine tenderness to his friends in suffering and his generosity to those in trouble or want, stand out most prominently. That such a man should be taken away in such a manner in the full flush of his extraordinary power is pitiable beyond measure.

Sincerely yours,

Augustus Saint-Gaudens.

AUGUSTUS SAINT-GAUDENS

To return again from such sad happenings to my father's mode of living, it must not be thought that he spent his whole time in Cornish. On the contrary, both his work and his outside interests frequently took him elsewhere.

These outside interests were many and scattered, and he fled to them as a relief from his own troubles. He had to do, for instance, with the regulation of American Sculpture Competitions, the founding of an American School of Fine Arts in Rome, and the beautifying of the National Capitol in Washington. The first of these I have already mentioned. The other two I shall take up with some detail after I have given a few scattered letters showing how generous he was of time and energy in lesser ways towards the development of the art of his country, such impulses and activities dating, it will be remembered, from the days of the Thirty-sixth Street studio.

First I give a draft of two letters dealing with the Roosevelt Inaugural Medal wherein he once, at least, succeeded in bringing such an object out of the commonplace rut. He writes to Mr. Roosevelt:

Jan. 20, 1905.

Dear Mr. President:

If the inauguration medal is to be ready for March the first, there is not a moment to lose. I cannot do it, but I have arranged with the man best fitted to execute it in this country (Mr. Adolph Weinman). He has a most artistic nature, extremely diffident. He would do an admirable thing. He is also supple and takes suggestion intelligently. He has made one of the great Indian groups at St. Louis that would have interested you if brought to your attention. He is so interested that he begged me to fix a price. I named two hundred and fifty dollars. . . .

And again:

Dear Mr. President:

General Wilson showed me the inauguration medal, which is so deadly that I had Weinman go down to Philadelphia. The man there who has charge of the bulk of the ordinary medals already contracted for cannot possibly do an artistic work. He is a commercial medallist with neither the means nor the power to rise above such an average. Mr. Weinman writes to General Wilson to-night that our reliefs must be put into other hands and this is to beg you to insist that the work be entrusted to Messrs. Tiffany or Gorham. Otherwise I would not answer for its not being botched. . . . I made studies on the train on my way up from Washington and I have struck a composition which I hope will come out well. Mr. Weinman is enthusiastic about it and I am certain would execute it admirably. You know that the disposition of the design on the medal is nine-tenths of the battle.

In other matters my composition calls for the simplest form of inscription and here also I wish your support, of course provided you think well of the idea. On the side of your portrait I propose placing nothing more than the words,

"Theodore Roosevelt, President of the United States,"

and on the reverse, under the emblematic design, the words,

"Washington, D. C., March 4, 1905."

The simplicity of inscription greatly aids the dignity

AUGUSTUS SAINT-GAUDENS IN THE TOWN OF ASPET, FRANCE

Enlarged from kodak

of the arrangement; but if you believe that more is needed, I will add it with pleasure.

A second example of my father's gratuitous efforts to aid in such ways appeared in his desire to help Mr. Daniel H. Burnham obtain fitting sculpture for the Pennsylvania Railroad Station in Washington, D. C. In the course of the correspondence over the question he wrote:

ASPET, WINDSOR, VERMONT, August 29, 1905.

Dear Dan:

. . . Louis, who bears a letter from me to you, has just been in on his way to the station and has told me of Mr. Cassatt's letter. I heartily agree with Mr. Cassatt. Nothing could be more appropriate than that the statues of Fulton, Stephenson and the others should be given great prominence in the station. But, aside from the fact that it would represent a row of men in knee breeches, which would be unfortunate, I fear they would not "tell" at that distance as they ought to, for of course one of the merits of such statues should be their characteristics as portraits.

I think figures of an abstract nature would certainly be more in place, and representations of the North, South, East and West flanked by "The Thinker," and "The Laborer" or "Commerce" and "Transportation" would be far preferable should the "Discoverers" with their romantic and vigorous characteristics be discarded. Mr. Cassatt's idea is so good, however, that I do not think it should be abandoned. Could you not introduce them in the station? It seems to me that panels

in relief on the walls representing the men he proposes might be made most effective, and although neither my brother nor I could do them, I should be most happy to advise and direct in the execution.

Finally in wandering even farther afield I must touch on one other characteristic line of service. My father was frequently being asked as to the genuineness of antiques and never failed to give his best efforts to unearth the fraud that so often surrounds these objects. I will take one instance in which I was directly concerned, the so-called Praxiteles Aphrodite exhibited in The National Arts Club of New York in the early winter of 1905. The genuineness of this marble was attested in most emphatic terms by its sponsor, Mr. Charles DeKay, and as emphatically denied by others, until Miss Gilder of the *Critic Magazine* asked me to see if I could not reach the bottom of the matter in a short article. In the course of my efforts I applied to my father who gave me any amount of valuable time, traveling back and forth from the chocolate-colored lady at the National Arts Club to a cast of the Medici Venus in the Metropolitan Museum. This is the letter on the question he sent to me for publication, and I quote it as being characteristic of his attitude. He writes:

Unless some scientific examination, microscopic or otherwise, would reveal how long ago the surface was cut, no one can tell whether or not the Venus is a modern copy. It is so perfect, I mean has so few abrasions, that I feel almost certain it is a modern copy of the one at the gallery in Florence, with both its beauties and its defects. For in the two cases the arms are badly drawn and the lower legs and feet rather ungainly, though the rest of the figure possesses unusual

charm, particularly the profiles. In both cases, too, the head is by no means as beautiful as many of the Greek heads. The Medicean Venus, in fact, is not one of the great ten or twenty antiques; perhaps it would be nearer to say not one of the first thirty or forty. It is wonderfully placed and lighted in the gallery of Florence and of a color that adds to the fullness of its beauty. This, coupled with the reputation given it by the poets and literati, has exalted it beyond its real merits from a sculptor's point of view. If the statue under discussion is an original it is, of course, of great value; if not, it has the worth of an admirable copy, comparatively easy to make. This question all the experts in the world cannot decide unless positive evidence of its finding is given. I could copy this Venus with the aid of a machine, have the replica buried with the original, and when they were dug up, some years later, not be able to tell them apart myself. It all resolves itself into this being as beautiful a work as the Venus de Medici, but some do not consider that statue the highest Greek art, and we do not know whether this Venus is ancient or modern.

Let me turn now to the American Academy at Rome, in which, as I have said, my father took a major interest. Its object is to provide for American students of the Fine Arts who already have laid at home a firm foundation for their work, much the same advanced instruction as the French Government offers in the Villa Medici. That this school might be firmly established with an endowment of one million dollars, my father lent his strongest aid, since he had never forgotten

the poignant charm and deep inspiration of his life and work in the Eternal City. His first efforts began in company with a number of other artists who were working in the Chicago World's Fair, where, in short order, through their enthusiasm, the movement was set on foot. For some time their endeavors had poor success, despite the fact that, lacking an endowment, the friends of the undertaking used their own resources, and devoted art scholarships such as the Rinehart and Lazarus funds to support the pupils. At last, however, an exhibition of the work in the School, held in 1904, proved so satisfactory that Mr. Charles F. McKim and Saint-Gaudens set about taking advantage of the interest aroused, by soliciting subscriptions. They were soon generously aided by Mr. Henry Walters of Baltimore, who, besides purchasing the Villa Mirafiori as a home for the Academy, presented them with one hundred thousand dollars to start an endowment fund. This lead was quickly followed by Mr. J. P. Morgan, Mr. William K. Vanderbilt, Harvard University through Mr. Henry L. Higginson, and Mr. James Stillman, each of whom, by giving one hundred thousand dollars, brought the sum up to the five hundred thousand dollar point from which the rest of the endowment was obtained with comparative ease.

As one earnest of his enthusiasm, indeed, my father, in the course of this work, delivered two speeches. The task was ever fraught with much agony to his modest nature. But here he felt the cause too high and his own opinions too vital to hesitate on grounds of personal comfort. Therefore, early in its progress, he said in Washington:

I have been asked to express my ideas concerning the Roman Academy. What I have to say can be said in few words and I take pleasure in so doing, not only from a feeling of sentiment arising from my early associations with the École des Beaux Arts and its organi-

zation, but more because I am of the firm conviction that an institution, such as that, is an admirable one.

My reason for thinking it admirable, is my belief that the strenuous competition required to gain access to the Villa Medici, as well as the four years of study in that wonderful spot, tend to a more earnest and thorough training than could elsewhere be gained under the present conditions of life in our times.

I am not one of those who believe that only the few who possess marked talent should attempt to be artists, although I do think that there are but a small number in the world who are gifted and who possess that indefinable quality, that elusive something, which makes the great artist. In art, as in everything else, only the fittest survive. But in our civilization a certain portion of the population will go into the fine arts "willy nilly," sooner or later to drop out to what the law of the survival of the fittest brings. However, this great band of the unfit have their work to perform; their love of the beautiful contributes to happiness and tends to a wider enjoyment of life in the revealing of beauty where otherwise it would have been ignored.

I know it is a question whether such a knowledge increases the general happiness and morality of a community. I firmly believe it does, as I believe that any effort to do a thing as well as it can be done, regardless of mercenary motives, tends to the elevation of the human mind.

The result, however, of the serious education required by the system of the École des Beaux Arts and the

School of Rome is that those who do not attain to high achievement will, at any rate, be better workmen in the various vocations they finally enter. In our period of hurry and of gaining ends no matter how superficial in the quickest possible way, no one will dispute that this is a healthful fight to make.

In the repeated attacks that are made on the Roman Academy and on the École des Beaux Arts and in the incessant cry for greater freedom in the development of the artistic mind, there is a certain amount of truth. But in such reaction the pendulum swings too far and the real question is lost sight of. There is a middle ground on which to stand. It seems to be rarely realized that the very men who are shown as examples against the schools were, if not actually brought up in the School of Rome, all men of thorough academic training. Only after such training does the mind become sufficiently mature and the individual personality so developed as to be able to indulge in unqualified freedom and liberty of expression.

Rodin, one of the leaders of the movement against Academic education, had a thorough and arduous training during the early years of his career and I am of the opinion that that training instead of dwarfing or minimizing his extreme power of expression, has been of enormous assistance to it. Leaving out of the question the exhaustive early study of the great masters of the past, Michelangelo and others, and coming to our own times, to the brilliant men of the French school,

we find that all have had the same early experience. Paul Dubois, one of the masters of French Art—although not a member of the Villa Medici—had a training fully equal to that which could be gained there, and is one of its strongest supporters. Houdon, Rude, Falguière, men whose work lives and breathes with divine fire, were trained there. Puvis de Chavannes and Baudry, to enter another domain, I may add to my list. It is needless to say that none of these were injured by it.

Sculpture is no more exempt from the necessity of thorough preparation than is music, architecture or any of the arts and sciences. Only constant diligence and earnest application in early years, harnessed with a natural talent, gives us master-workmen.

The disastrous results to those who ape the mannerisms of such masters as Rodin and Monet and follow in their wake, are pathetic in their futility and weakness when they are not comic, and their failure leaves them not only bad artists but, and here I come to what I consider the main point of my contention, weak and crude workmen in whatever else they do. I am inclined to think that if it were not for this class and this condition of things, I should not be so strong a partizan. But the betterment of this class and at the same time the help that is given to the young master makes it worth while. . . .

It cannot be asserted that the four years of undistracted attention, devoid of pecuniary worries and sur-

rounded by a sympathetic environment where the whole thought is directed to the highest artistic achievement possible in the formative years of a young man's life, can be anything but an enormous assistance and of vital importance to the few who have the divine gift. If it were but one in a century who was helped in this way, the institution would be worth while.

Later he said in the same vein:

My deep interest in the project comes of a vision which presents itself to me of the immense possibilities of the United States in that which makes for beauty *and all that it implies.* There is no question but that the mixture of the impulsive, imaginative races of the South, with the power, reserve and sense of measure of the races of the North *under proper opportunities* for development *must* result in exalted achievement. It is in the laying of foundations for such opportunities that this Institution is accomplishing its great work, a work which must tend mightily to counterbalance our besetting evils, of looseness, amateurishness, and shift-lessness in the training for the struggle of life. . . .

However, and here I will repeat what I have said on another occasion, if but one commanding figure in a century shall result from this foundation; one man inspired by the breath of genius, all the money that will be spent in founding and maintaining it will have been worth while.

We are nearing the goal of our ambitions and it is because of the conviction that it is the West with its

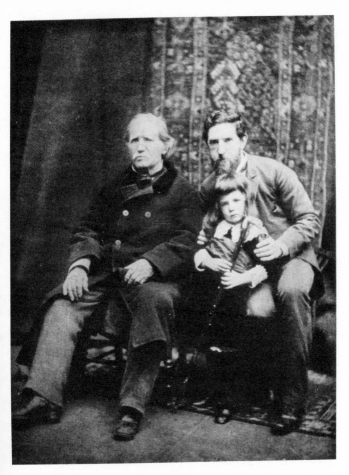

THREE GENERATIONS
Bernard, Augustus, and Homer Saint-Gaudens

open-mindedness and breadth of vision that will lay the final stones in our structure that we have to come here as pleaders.

When this is accomplished there is nothing I shall be more proud to have my children's children associate me with than the achievement of this work.

To these speeches I append an extract from a letter to my mother which amplifies my father's attitude, and moreover shows his modesty regarding his efforts, and the manner in which he used to turn to her for advice in such matters.

Dear Gussie:

Will you criticize, modify and improve, to the best of your ability, this reply to Mowbray's request. You can change the whole damn thing if you wish. I have no vanity about my writing any more after reading all the stuff I 've sent to various committees for years. Write it out nicely and send it to me to sign. Here is my draft of it:

To the Executive Committee of the American School at Rome.

DEAR SIRS: I believe the foundation of our institution in Rome, in a general way similar to that of the French Government at the Villa Medici in that city, would be not only a work of value, but one of necessity as far as the art interests of the United States are concerned. The conditions of life with us make the long and serious preparation necessary for the thorough training of an artist almost an impossibility. The temptations to plunge into an artistic career with minor preparation are constant and inevitable. To take the

best of the young men and protect them from these temptations as well as to give them the other undoubted advantage of surroundings and general atmosphere is one of the principal benefits of such an institution.

I believe no Academy can make a genius, but it can greatly facilitate his development. Such an Institution moreover inevitably forms a nucleus of thoroughly equipped men who on their return home would gradually and powerfully contribute to the heightening of the general level of artistic development.

In such a foundation, I believe we should profit by the experience of the French and establish our Academy on lines of greater liberality than obtain there in the selection of the scholarship and the rules of residence.

On the whole I am firmly convinced that great advantage would result to the interests of art with us from such an institution and I will do everything in my power to favor its development.

Yet my father did vastly more than make occasional speeches. He donated an infinite amount of time and energy to seeing that his dream became practical and financially assured. Here, for example, is one of the "begging letters" which he was constantly sending out to those he thought might be of aid. The letter is to Mr. H. C. Frick, and it is pleasant to record it as a successful one. He writes:

Dear Mr. Frick:

. . . You remember our conversation three years ago regarding the American Academy of Fine Arts in Rome. Since that time matters have progressed. In

January last a dinner of four hundred guests was given in Washington, to celebrate the passage of the bill in Congress incorporating the Academy. The President signed the bill and was the principal guest and speaker at the dinner, which was probably the most notable ever given in the United States. The presidents of the great Universities were there, and most of your distinguished friends and acquaintances, including Secretaries Hay, Root and Taft; Messrs. Cassatt, J. Pierpont Morgan, James Stillman, Henry Walters of Baltimore, Cardinal Gibbons, Speaker Cannon and many senators and representatives and Supreme Court justices. Mrs. Roosevelt and ladies of her acquaintance occupied the gallery.

This representative dinner lacked your presence to the regret of everybody, for every one felt that the national incorporation of this Academy was the most important step ever taken in America for art.

The Academy will occupy the royal Villa Mirafiori in Rome, bought for it by Mr. Walters for that purpose. Each year one man will be accepted as a scholar in architecture, painting, sculpture, and music, and one man in each art will graduate. The course is four years long, so that there will always be sixteen men at the Villa and they are to be selected by competition from the entire country, thus assuring the very brightest men we have. In the course of a few years we shall have in the fine arts, many brilliant men trained as well as, or better than, those from the Villa Medici, the French Academy in Rome.

France has had her school of Rome at the Villa Medici for two hundred years, and it is due to this that the French nation has been supreme in the fine arts. From this time we propose to stand on the same or a still higher plane.

The endowment fund is fixed at one million dollars. It is the wish of the board that ten men, families, or institutions of learning shall be the ten founders. Those who have already taken part are:

W. K. Vanderbilt..............	$100,000.00
James Stillman........................	100,000.00
J. Pierpont Morgan	100,000.00
*Henry Walters (outside of his purchase of the Villa Mirafiori)	100,000.00
Harvard University.....................	100,000.00
Columbia University..................	100,000.00
Chicago University....................	100,000.00
Yale University.......................	100,000.00
Already subscribed..................	$800,000.00

The names of the founders of this great national school will be recorded in the Villa at Rome, and there can be no higher distinction for a family than the association of its head with this source of inspiration. In Florence the Medici name is as fresh to-day as it was four hundred years ago, and in Genoa the Doria name

* Mr. Walters not only gave $100,000, but purchased the Villa Mirafiori to be held by him until the school was financially able to take charge of it.

is the same, and it is largely because the heads of these two families were patrons of the fine arts.

While our million dollars may be said to be in sight, it seems to me that this should be funded for the income, and that we should have two hundred thousand for library and equipment. Would it interest you to connect your name with that of Princeton University, or to become a founder yourself? It is an ideal cause and one in which a man will gain just distinction of a very high order. Your connection with the Academy also would give you a delightful status in the most select art and governmental circles in Rome, Paris, London and the United States. I only wish my fortune were sufficient to enable me to take the place I suggest for you.

So much for my father's efforts. I have, however, one letter more to include before I close the subject. It is from Mr. H. Siddons Mowbray to me, giving an estimate of what my father's colleagues thought of his efforts in this direction.

WASHINGTON, CONN., November 16, 1908.

My Dear Mr. Saint-Gaudens:

There have been several periods in my career as an artist that have been turning points—these I have invariably traced back to your father. But whilst he—on his part—was so often forming opportunities for me, and I, on mine, had such a profound admiration for him, we saw really very little of each other and exchanged very few letters. . . .

However, permit me to suggest one subject which I do not think should be lost sight of: the great factor your father was in the founding of the American Academy of Rome. I have not seen this subject touched on as yet, as it concerned

Saint-Gaudens, but he had it deeply at heart. I am sure he would wish to have his name associated with this work, for he labored hard both in organizing the movement and raising the Endowment Fund. At some future day, when the aims of the school are appreciated and begin to show a result in higher standards of taste and execution, your father's name will loom out large as one who led the way.

From this matter of the Roman Academy I turn to my father's interest in the artistic development of the National Capitol at Washington, where under the auspices of the Park Commission together with Charles F. McKim, D. H. Burnham and Frederick L. Olmstead, he spent much time and gave the best of his assistance in criticism and advice toward establishing on a firm basis the beauty of that city. In illustration of his endeavor I present a few extracts of what he wrote on the subject:

The first is to President Roosevelt:

ASPET, WINDSOR, VERMONT, August 15, 1903.

My dear Mr. President:

. . . I have been very apprehensive with regard to the disposition of the new Public Buildings proposed in Washington. It would be deplorable in the extreme if they were not placed according to some comprehensive plan, binding all the Public Buildings with some idea of unity and harmony. Even if the scheme suggested by the commission of which I was a member, was discarded, I cannot express too strongly the hope that nothing will be done without first consulting professional men, not directly interested in any one building. . . .

I don't know how to thank you for your more than

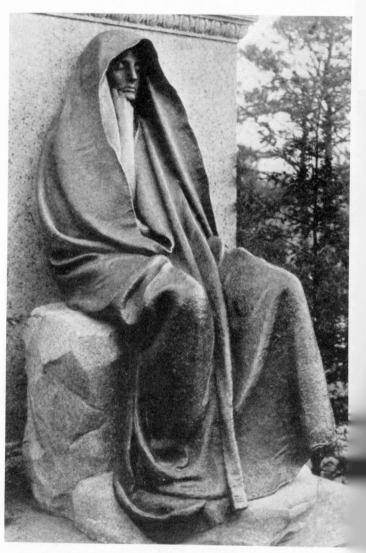

THE ADAMS MONUMENT IN THE ROCK CREEK CEMETERY, WASHINGTON

kind words about the "Sherman" and my other work. When I realize that you have taken the time to say this to me amid the multitude of other things on your mind, it is a fact that touches me deeply and your letter will be set aside and treasured for those who come after me.

Here also is the draft of a paper which my father wrote while on the commission, showing one of the many directions in which he employed the privilege of his membership, this time for the preservation of the beauty of Arlington, the home of General Lee, on the south bank of the Potomac, opposite Washington. He writes:

CEMETERIES

There is nothing that needs proper supervision and planning more than the modern cemetery, for there is certainly nothing that suffers more from vulgarity, ignorance and pretentiousness on the one side, and grasping unscrupulousness on the other; and instead of being a place to which one should go with a sentiment of respect and peace, as into a church or sacred place, the eye and the feelings are constantly shocked by the monstrosities which dominate in all modern cemeteries.

There is no doubt that the feeling which pervades the majority of people who erect monuments to their dead is one of the tenderest—a sincere desire to do nothing, even in the simplest form, which is not fitting and in entire harmony with the feeling which prompts the erection of the memorials. This feeling, if properly protected and guarded, would lead to the harmonious and sober treatment so necessary for such places.

A great example of the effectiveness of such restraint and guidance is the extraordinary dignity, impressiveness and nobility of the Soldiers' Cemetery at the Soldiers' Home, Washington; also that part of the Arlington cemetery set apart for the private and unknown dead. This is not attained by any large monuments, but by the very simplicity and uniformity of the whole.

The trouble is that the majority of monuments now in the cemeteries are produced by firms who make it merely a business affair, the greater portion of them having not the slightest idea of what is good or bad, and possessing not even an elementary knowledge of architecture or even good taste.

To remedy this it is absolutely necessary that the designs for all the monuments in all the cemeteries from the most modest to the most costly, should be made by, or subject to, the approval of a commission composed of two or three architects, and a landscape architect of the highest professional standing. They should lay out and design new cemeteries and establish rules for their proper supervision, and should control the designs for future monuments in those already existing.

A flagrant example of the abominable treatment in such matters is what is being done at the Arlington Cemetery immediately surrounding the Lee mansion. If our information is correct, it is proposed to extend the graves on the noble slope which descends from the mansion to the river. This is one of the most beauti

ful spots in the vicinity of Washington. That it should not be defaced or touched in any way, and that a law or rule should at once be passed forbidding the placing of any monument on this hill, is the unanimous opinion of this Commission. It would be desecration to allow it to be changed in the slightest degree.

Again as I closed my account of my father's efforts for the Roman Academy with a letter typical of the regard shown his work by his contemporaries, let me repeat the process in this case with the following letter which Mr. Burnham has written me:

"I was with your father when he was a member of a jury appointed in Washington to premiate a design in the architectural competition for the Agricultural Building. A large number of schemes were presented on paper, and hung up where they could all be easily examined. Your father walked around the room by himself and looked at each of the designs. He then went near a window and sat down to read a newspaper while the other members of the jury were spending most of the afternoon in studying the schemes, one of which was finally selected by unanimous vote of the jurors, including your father. After the decision was made, he said to me: 'I am glad we all agreed on the same design, which, to me, was evidently the best within ten minutes after I came into the room.'"

My father's outside interests, as I have suggested, were valuable to him in varying the Cornish routine, and to this end many trifles accomplished as much as larger efforts. For example, various little happenings of this Washington life diverted him thoroughly; the imposing Justices of the Supreme Court whom he watched file into their court room during the spring he was modeling the relief of Justice Gray; the cozy

dinners at Mr. Henry Adams' house, where witty talkers were always gathered; the foreign ambassadors' regard for ecclesiastical precedence at a dinner which Dr. David Jayne Hill, then acting as Secretary of State, gave for Cardinal Gibbons. On the latter occasion Dr. Hill led the way into the dining-room with the Countess Santo Thyrso. Count Cassini, the Russian Ambassador, was to follow with my mother, and other diplomats in their turn, Mrs. Hill and the Cardinal coming last. But by the time Dr. Hill and the lady at his side reached their seats, they were alone. The others were still bowing and making way for the dignified old man in his scarlet robe.

And even when the piquancies of his surroundings did not altogether please my father as these had done, they managed to furnish him with a variety of amusement. Invariably he would bring home a story or two. I remember distinctly how he enjoyed telling about a couple of dinners, one at which pink silk napkins, impossible for a beard, were provided, the other at which a tank of gold-fish was set in the table center, with the result that during all the speeches the guests were intent not on the wit of the man upon his feet but upon the death of a fish in the water. Here are two interesting Washington letters to Miss Nichols:

THE SHOREHAM, WASHINGTON,
April 16, 1901.

I think it is the 16th of April. At any rate it is a beautiful day, Rose, and I have been reveling in the languorous atmosphere here. The winter in the strenuous air of Cornish made me forget the charm of gentleness that exists in the South. I am already full of the languor myself and doing things in the easy soft-going manner of the natives and negroes. This is a great change from the infernal strenuousness of my

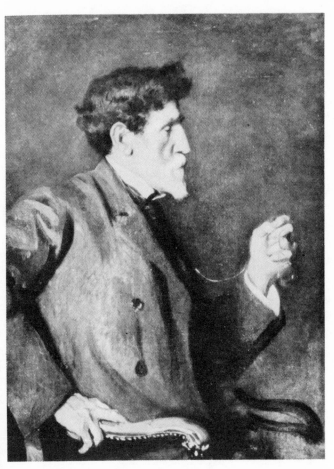

AUGUSTUS SAINT-GAUDENS
Painted in 1904 by Ellen Emmet

previous life. I can imagine you meanwhile in London moving about among the shadowy human beings that appear and disappear in the fog like ships at sea. Do you know Washington? It is a remarkably attractive place, unlike any other place I know of in the feeling of elbow room and the gentle easy-going social customs. In a few days I am to sit next the French Ambassador at dinner and then, *and then,* I wear the little red button * for the first time. I shall commence work here to-morrow on the bust of Assistant-Secretary Hill.

Again:

<div align="right">January 12, 1905.</div>

I am here "faisant antechambre" to the Office of Secretary of War Taft, where I have come to talk about the Von Steuben monument. It's unpleasant, the waiting when you have no ax to grind, but all the more so when you are trying to do the decent thing by others. . . . At 1:30 this morning LaFarge and his Jap valet Awoki (or some name like that), Henry James and I got into a cab made for two, on our return from the big dinner. It was a great success from the Presiding Toast-Master down to the speech I made, which was the best because it was the briefest. Every one was there and as Justice Harlan said, it was impossible to decline an invitation to dinner which was honored by the President of the United States, The Ambassador from France, the Cardinal Gibbons of the Church of Rome, the high Protestant dignitary of the District of Washington, the Secretary of State Hay, the great

* My father was an Officer of the French Legion of Honor.

Ex-Secretary of War Root, the Speaker of the House of Representatives, the Attorney General of the United States, and last, but not least, *Saint-Gaudens*. Well, I read my speech after evidently one of the biggest storms of applause on rising. It was followed by still another when I sat down. Cassatt, President of the Pennsylvania Railroad, and Pierpont Morgan were there, the latter having given one hundred thousand dollars to the Academy in Rome, following the gift of a like amount the day before by Mr. Walters of Baltimore. It's all an enormous triumph for McKim. . . . I enclose a copy of my speech which if memorized and delivered with the proper intonations of voice and proper vanity of smile, and quality of visage, would have been the sum of all that I said.

Here is the speech:

"Charles the Charmer," in other words Charles F. McKim, has assured me that it is essential that I should speak to-night. This is as flattering as it is fallacious, for although I have doubts about many things in life, on one subject I have absolutely none, and that is the hopeless and helpless limitations of my oratory. It is much more calculated to reduce listeners to tears than to contribute to their enlightenment or entertainment. You will therefore understand why I refrain from expressing anything more than my great pleasure at being included in a company assembled to honor that which makes for the nobility and elevation of life, the love of Beauty, Character, and Dignity in our surroundings as much in the halls of Government and Law as

in our homes and wherever we live, move and have our being.

The honors that this letter hints at which were pouring in upon Saint-Gaudens, such as his election to the Royal Academy and the degree of LL.D. conferred upon him by Yale University, were a great source of pleasure to him. For while he was always modest about his work and about his rank among other men, such praise as he was now receiving could not but deeply please his Celtic nature; and, far from taking it for granted, he invariably regarded it with the wonder and delight of a child before a new and unexpected toy. In such a vein, for example, not long after his election to the Royal Academy, he wrote to Mr. Edwin A. Abbey:

February 8, 1906.

You dear old thing:

Your letter is at hand. It is a swell honor that the Royal Academy has done me and one that I appreciate a very great deal, all the more for the surprise of it. But one of the nicest things about it was getting such a letter as you have taken the trouble to write me. I appreciate *that,* too, old boy! At the same time, I feel almost ashamed when I think that I step into Dubois' shoes and that I follow in the procession with such a lot of other swells. I don't know how these things make you feel, but they overpower me with a sense of humility and I feel like a fraud.

Yes, as you say, the alphabets and crosses, etc., that are plastered on a feller's chest are not what count so much. But when the feller who knows, thinks well of your performance, that is good for the soul and cheery.

Well, here's to you and the other chaps who have

given me this lift. I am crazy to get over there, although I do not see that I can before next autumn. I shall make a desperate effort to be at the Royal Academy dinner, but no speeches. The things you saw that I shot off at the Architects' dinner were squeezed out of me by Blarney Charles who goes around prodding us all in that direction, and for the general good, we thus make fools of ourselves. The only revenge is that he has to make speeches too, and to see him perspire makes us willing to bear with him. He has been doing a lot of work you know. We have got seven hundred thousand dollars for the Roman School, this entirely through his rodent-like determination. A gently obstinate is he. But what with his efforts there, his work on the enormous Pennsylvania Railroad station in New York and the struggle to complete a beautiful library for Pierpont Morgan in two years which should take ten, he gave out and has had to stop for three months. We were nervous about him, but are now glad to see that he is in harness again.

Again, June 3, 1906, he wrote once more:

. . . I have ordered sent you fifty dollars and whenever you have time, send one of your slaves out to bring you those Jefferson clothes you speak about and send them over here by express. I will double the amount if necessary. They have been at me for a long time to do this Jefferson Monument and I have not yet decided to undertake it. It is a big affair, very important and very conspicuous, and I don't want to do it unless

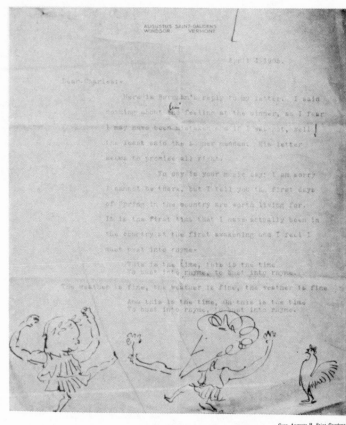

**FACSIMILE OF PART OF A LETTER OF AUGUSTUS
SAINT-GAUDENS TO CHARLES F. McKIM**

The letter, dated April 4, 1905, refers to the success of the American Academy
in Rome, and the caricatures typify the joy of the two friends

it can be done in the right way and that costs time and money and I am beginning to look at things carefully in that direction now. It's bully in you to offer to get these things for me and I appreciate the offer *much*. . . .

It was impossible for me to exhibit with you this year. I have been in pain for a long while, but I hope I shall be over it some time or other and as soon as it goes I will send something over. I should like to exhibit the Sherman group, but it is costly business, although I don't mind that so much. The trouble is that I would need to have some one who understands it thoroughly sent over from here to set it up properly. It is a very complicated machine. And then don't you think it kind of pretentious? I know it looks like a pose of modesty, but my things make me so damned sick. I assure you that is the case. The action of the Royal Academy in electing me makes me wonder whether the world has gone mad or whether I am more of a fool than I think I am. Really as I look at my things they make me pretty tired. However, I am evidently not entirely right, so if it does not seem too pretentious and does not cost me one hundred million dollars, I will send it next year.

The big English sheep dog, "Doodles," the one with no tail, whose body is so covered with hair that he looks like a busted mattress, has just jumped up on the couch beside me and lies on the Navajo blanket in the flickering sunlight.

Good-by.

AUGUSTUS SAINT-GAUDENS

While in a like half-jesting tone my father replied as follows to Mr. F. Peter Dunne's congratulations a year before on the bestowal of the degree by Harvard University:

July 6, 1905.

You dear Old Paddy:

Thank you for your letter. I feel like a fraud though, and as if something's wrong. When they give me parchments and silk hoods and things and call me Doctor of Laws I want to crawl under the table, gown and all. However, that's the way of things in this dizzy world and when I am in New York next, we'll have a drink to the honor of it all.

X

CORNISH SCULPTURE

1900-1907

The "Sherman"—Equestrian Statues—The Library Groups—The
St. Giles "Stevenson"—Lesser Work—The "Seated Lincoln"—
The "Daly"—The "Parnell"—The "Brooks."

THE first serious occupation toward which Saint-Gaudens directed his efforts after he left the hospital in 1900 was the completion of the Sherman monument, the reconstruction of the large Stevenson relief for Edinburgh, and the modeling of the statue of Governor Roswell P. Flower for Watertown, New York.

At this time one cast of the "Sherman" stood in the Paris Exposition, while a plaster duplicate had gone to the French foundry. My father, however, still dissatisfied with the result, decided to set up a third replica here in Cornish in order to send further changes to Paris where they might be inserted in the bronze. This tendency almost endlessly to alter and re-alter details lasted to the close of his life, he himself being the first to recognize his crotchet and to laugh at it. He used to say that he would have been absorbed beyond measure in watching Phidias, the sculptor of fame, experimenting with the tiny holes he bored in the eyelids of his statues in order to insert gold eyelashes. Hence, to carry forward his efforts successfully in the case of the "Sherman," my father placed a shed around the statue wherein, seated at the monument's foot, wrapped up like an Esquimau, he spent many happy days directing not only those modifications of which he has spoken, but such others as the "Germanic" hair at the back of the

289

Victory's neck, or upon the tail of the horse or the tiny angles and stiff marks of age on the animal which he felt increased its nervous snap.

During the variations of these details he explained many old and fixed ideas, some of which I have already given. As with the "Shaw," he showed his dislike of objects wholly analyzed, since he believed that the unreserved is the uninteresting. Accordingly, he experimented with Sherman's lowered right hand and hat until he had drawn across it a bit of the coat; and in the same way he satisfied himself by lapping the Victory's wing over Sherman's left leg. Again, he demonstrated how, after he had built up a careful nude of the Victory, he could cut remorselessly into her body to give a natural appearance to her drapery. Once, for instance, while he was sitting at the far end of the camera-shaped studio, he called up to an assistant who stood upon the scaffolding by the Victory's head, "Make that line longer and deeper."

The assistant gouged into the clay.

"Deeper yet!"

The assistant gave another slash.

"No, no, deep!" My father climbed the ladder. "Is that it?" he asked, pointing to a comparatively slight tool-mark.

"No, here you are," answered the assistant, indicating a tremendous hole.

My father retired, apologizing with, "That all goes to explain that you must get far away from your work to see it properly."

The line was none too deep. Moreover, it was typical of his difficult struggle with the head of the Victory. First, the initial study failed to content him, for therein he had copied certain beautiful features until he felt that he had filled it with overmuch "personality." Then the second attempt, although intrinsically of greater worth, appeared even more out of keeping with the monument. So finally he was forced to return to

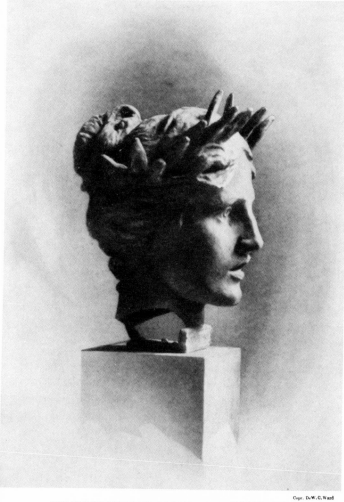

THE SECOND STUDY FOR THE HEAD OF THE "VICTORY"
OF THE SHERMAN STATUE

Although Saint-Gaudens had a preference for this, it did not accord so well with the statue as the first
study. The latter was used for that purpose, and the profile of this second study was later
reproduced in relief as the model for the new cent and the ten-dollar coin

his earlier model, and to labor over it indefatigably until he had developed it to his liking.

On the other hand, the bust of General Sherman, which he had modeled from life, evolved smoothly. As it stood, of course, it was not meant for use upon a monument. Consequently after he had determined the proportional size of Sherman's body to the horse, he had his misgivings as he caused the portrait to be enlarged to a point where it would appear in proper relation to its new shoulders. Soon, however, he felt well satisfied, remarking when the head had gone into place: "If you have modeled your best sculpture in the small, you should have accomplished your best results for your work when it is made big. Your subject should contain both the detail required upon close inspection, and the breadth that makes it tell at a distance."

This need for carrying power he constantly dwelt upon in his modeling. I remember that one day as he watched four or five assistants engaged on various portions of the Sherman, he broke the silence with: "I am going to invent a machine to make you all good sculptors."

The stillness promptly became uneasy.

"It will have hooks for the back of your necks, and strong springs."

The stillness grew even more uneasy.

"Every thirty seconds it will jerk you fifty feet away from your work, and hold you there for five minutes' contemplation."

But his troubles with that statue were not over even after these alterations. He felt too deep an interest in this new combination of the real and the ideal to let the monument escape him. So he set up the bronze itself in the field back of his house, to the delight of the farmers, that he might experiment with the pedestal and supervise the application of the patine. He had always spent much time over the color of his productions, struggling to obtain the proper "mat" upon

their surfaces either by paint or acids or gold-leaf; and in the case of the "Sherman" he explained, "I am sick of seeing statues look like stove pipes." Hence he longed for the unusual combination of a gilded bronze on a cream-colored base. The plan was not wholly feasible, as he failed to obtain the stone he desired for his pedestal. But at least he covered the "Sherman" with two layers of gold-leaf; and if the "Marcus Aurelius" on the Capitoline Hill in Rome is a test, that gold-leaf will remain on the "Sherman" for some centuries.

Unfortunately, after all his struggles, the surroundings of the "Sherman" were never to my father's liking. For a long time he fought to gain a location on Riverside Drive in front of Grant's tomb; but the protests of some of the Sherman family, he believed, settled the question against his desires and placed the site at the southeast corner of Central Park. Consequently accepting the inevitable, he wrote the following to Mr. Daniel Chester French, then on the Art Commission of the City of New York:

WINDSOR, VERMONT, March 19, 1902.

Dear French:

In view of the fact that the "Sherman" site question is now to be passed upon by the Art Committee it occurs to me that you might like to know my views with regard to the Fifty-ninth Street site, which I have just learned has been settled on by Mr. Wilcox. I consider it a most honorable and beautiful location, although not comparable with either the "Grant" or "Mall" sites, and it is regrettable that considerations which will have no weight in the future should annul so remarkable an opportunity for giving a monument to General Sherman a noble position.

At Fifty-ninth Street it will be very much hidden by

the trees and unless the circle is increased fifteen or twenty feet in diameter the work cannot be seen to advantage without stepping off the curb into the driveway (twenty-seven or thirty steps). About sixty-five feet from the pedestal is the proper distance for viewing the work. There would be only fifty-five feet from the side of the pedestal to the edge of the circle. Nearer than forty feet from the pedestal it is impossible to see the statue to any advantage. Therefore, if your committee reports favorably, might I respectfully suggest that you call the attention of the Park Commissioners to these disadvantages.

It is absolutely essential that the Circle be extended and the grass plots eliminated in order that the spectator may be free to move at will around the monument. It will also be necessary to make some redisposition of the trees, but I cannot say how without further study.

Had even this request been granted Saint-Gaudens would have had no further complaint. But when such comparatively simple schemes as this were denied, his temper got the better of him until he found himself involved in a controversy with Park Commissioner W. R. Wilcox, which reached its climax in a letter from the latter which said in part:

"In the first place, I do not agree with you that people are prevented from viewing the statue because of the grass-plots; but it might be well to consider whether the parks were made for statues or statues for parks. I am unwilling for a moment to admit that the whole park system must revolve around a single statue, or that trees and grass, or other park features, must give way to any hobby, no matter by whom it is ridden.

"It is possible that there is no one here with sufficient intelligence to pass upon a question of this kind, and if that is so the city will be obliged to stand the serious consequences—at least for another month."

The defeat was my father's, but I cannot resist adding this last letter which gives him, in spite of all, the final word.

ASPET, WINDSOR, VERMONT, May 21, 1903.

Dear French:

I have given up the fight. After promising Mr. McKim that the two trees in front would come down, I suppose Wilcox became frightened, and did nothing. Then seeing the way the green came down over the front of the statue (notwithstanding surreptitious cutting of the branches under his hand by Ardisson while erecting the scaffold), he became bold again and sent a boss with two men to trim off the concealing limbs. Ardisson plied them with whiskey and they became enthusiastic in their cutting (alas, not enthusiastic enough), and now I suppose Wilcox will become scared again.

But soon a kindlier feeling outweighed my father's chagrin at the position of the monument, for it was welcomed by the public with an admiration which gave the sculptor untold happiness. Here is a letter which he wrote to his good friend Henry James concerning it:

February 8, 1906.

Dear James:

It does not seem possible that anything I have done is worth what you have written with such exceeding kindness in the *North American Review.* Nevertheless, I take off my hat to the honor you have done me

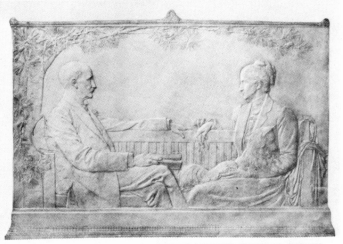

MEDALLION OF EX-ATTORNEY-GENERAL AND MRS. WAYNE MACVEAGH

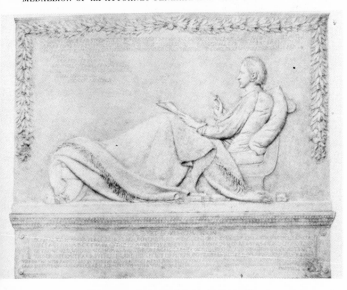

THE ROBERT LOUIS STEVENSON PANEL

The above variation of the Stevenson relief was modeled by Saint-Gaudens in 1897–99 for St. Giles'
Church, Edinburgh. The original relief, a round one, represented Stevenson in bed with a cigarette
in his hand. The alterations to couch and pen were made as being more suitable to the new setting.

and I cherish your appreciation very, very highly. I take my hat off also to what you say of the figure of Victory, Liberty, Peace (and what not besides I meant therein). It is because I feel so strongly the damnation of the whole business of war, that I made it, the very reason for which you want it otherwise! And there we are. Your reasons I am sure are better than mine, but, to paraphase what Stevenson wrote in a book he gave me,

> "Each of us must have our way
> You with ink and I with clay."

It is interesting to refer, in connection with the "Sherman," to Saint-Gaudens' regard for the needs of such a statue and to his opinion upon equestrian monuments in general. In the first case, a portion of a letter sent me by Mr. William A. Coffin well explains my father's personal attitude. Mr. Coffin writes of the erecting of the Sherman monument at the Buffalo Exposition.

"To make a long story short, I got both the 'Sherman' and the 'Shaw' and other important works by Saint-Gaudens, including the 'Stevenson.' As an assistant in placing and setting up the sculpture, the actual work, I had the capable services of Mr. Henry Hering. My letters to Saint-Gaudens through it all were many and long. I felt I could not give myself too much trouble. I determined to have the 'Sherman' set up in fine emplacement in front of the Fine Arts Building and to have it face the building. The place for the pedestal was some distance out from the building. As I remember it now, if placed facing the building, the way I was sure it would look best, the light or the place of the sun would be for the greater part of the day behind it. If placed with its back to the building, the way Saint-Gaudens preferred to set his statues

—face to the south—it would look out over the lake. The emplacement was on a high bank of the lake—an open space, macadamized, and we had got the Buffalo Park Department to take away a fountain that stood there in order to put the pedestal on the same spot. A pedestal was built and Hering and his men with many days of labor set up the 'Sherman.' I wrote Saint-Gaudens again and he came to Buffalo. He looked at the 'Sherman' in the morning, at noon and in the afternoon. He walked around it again and again by himself, and he walked around it with Hering. He was greatly pleased altogether. No mistake had been made, the effect was grand —that is the word that is best to use—and he was content. I told him Bartlett had been there and admired it, saying at the same time that he for his part preferred a placing for his works with the front to the north because of the better shadows, showing masses better than if placed facing south. Saint-Gaudens pointed out to me that in his (Saint-Gaudens') work he 'made a great deal of' detail and surface as well as mass, wherein he differed from Bartlett, but that he was convinced by seeing it that the 'Sherman' could not look better than it did just as it was, and he was happy and pleased. He thought the pedestal was too much of 'a block' in its design so a new form of pedestal was drawn by William Bosworth, Carrere and Hastings' representative on the Exposition grounds, a pedestal somewhat resembling the fine permanent pedestal in the Plaza, but not quite so high. Then the old one was hacked away while the 'Sherman' was shored up and the new one replaced it.

"What Saint-Gaudens said about surface and detail counting for much in his work apropos of what I had told him Bartlett had said to me, reminds me of one of his characteristic expressions. I had more than once discreetly hinted, when we were together looking at some work or another of his, something about the importance in my mind of weight and mass

as the essentials of sculpture and whenever Saint-Gaudens seemed to think I was hinting in his direction he would say the same thing, about in these words: 'Well, Coffin, you see I have always a great fear lest my work should look Teutonic.' I knew he meant 'heaviness' and I knew I did n't, but I always made the same reply, about in these words, 'Good Lord! avoid anything that might look Teutonic.' And there the matter always rested."

My father's regard for other equestrian statues both ancient and modern I can fairly well illustrate in the next few letters. First let me explain that to his eyes came before all others the "Gattamalata" by Donatello in Padua, then the "Colleoni" by Verrocchio in Venice, and then the "Jeanne d'Arc" by Paul Dubois in Rheims, about which I have already quoted what my father has put down. Of contemporary American equestrian monuments he has written at length in two letters to Mr. V. A. Blacque:

July 27, 1905.

My dear Blacque:

There are equestrian statues galore, most of them atrocious. Three admirable ones, however, come to my mind. The first is that of General Grant in Philadelphia by French. It is very fine, dignified, strong, and full of character. Then there's the statue of General Scott in Washington by H. K. Brown. The figure is unusually excellent and so is the horse. It is really a swell thing. But it is too bad that the General is too big for the animal. If it were not for that there could be no adverse criticisms. Finally there is that of General Thomas, also in Washington, by Ward. It is spirited, and from some points of view, admirable. The horse is unusually good.

If you want to know of the rotten ones I will try and think them up. There are two other good ones, although I do not care so much for them, the Hooker and Washington by French; the former near the State House in Boston, the latter in Paris, given by the women of America to France. Then of course there is H. K. Brown's Washington in Union Square. That is a noble work. The figure is particularly fine, the horse rather modern.

August 7, 1905.

Dear Blacque:

Your letter of August first is at hand. Another good statue I had forgotten is that of Washington by Ball in Boston; rather cocky and un-Washingtonian, but good work. A bad one of General Grant by Rebisco is in Chicago. These, and another in the latter category by Partridge of Brooklyn are all that I know of, although there are legions I have no doubt in some form or other at Gettysburg. As I write, three others come to me, one equestrian Washington in Washington, I do not know by whom, that contributes to the gaiety of nations, the historically joyous old Jackson in front of the White House and one of the revolutionary General Greene also in Washington, poor, although the horse is good. The Secretary of the Committee of the Library of Congress can inform you of these and of others in the United States, I have no doubt. And still they come to my mind; two jokes in front of the City Hall, Philadelphia, Meade and McClellan. When you are depressed, go and see them.

A PAINTED REPRODUCTION OF THE BOSTON PUBLIC LIBRARY FIGURES, SET UP BY
ARTIST TO DETERMINE THE SIZE

Other terrors are the Hancock and MacPherson also in Washington, and there you are. If others come to my mind, I shall tell you of them.

There is one of General Slocum recently erected in Brooklyn by MacMonnies. I have not seen it.

Besides the "Sherman" my father brought back with him from Paris two carefully studied groups for the Boston Public Library. The length of time that he had been ruminating over this commission may be shown by this letter sent to Mr. S. A. B. Abbott in 1894:

May 21st, 1894.

Dear Abbott:

I am working on the library work on the following rough lines: on one pedestal Labor, represented by a man seated between two female figures—Science on one side and Art on the other—; on the other pedestal, a male figure of Law in the middle, with female figures of Religion on one side and Force, or Power, on the other. Sail into me all you wish about it, please. The idea was to get two leading male figures, Law and Labor, supported by the others as you see. It is an extremely difficult thing to manage, and I have been thinking of it more than anything else in my life. Blarney * and you might say that "that is not saying much." But such is the case.

These great elementary figures may be made to embrace the principal sub-divisions by shields which they may hold, or they may be indicated in the pedestals,

* Charles I. McKim.

bearing the classifications. For instance, under **Art**, we should put music, architecture, painting, sculpture, poetry, and drama; and so on with the others. I am feeling rather happy at this arrangement, as it seems to have some kind of harmony, making Law and Labor the units, on which the others depend. Although I am happy about it I shall be happy as I said before if you abuse me, now that there is something to abuse. I shall be in Boston within a week or ten days surely.

The outcome of this idea was a final arrangement in which one pedestal bore four figures, Law, flanked on one side by Executive Power, and on the other by two more personifying Love. The other pedestal had three figures typifying Science, Labor and Art, the latter as expressed in Music. These names convey little significance of the ideas he intended, nor would a detailed description of the poses explain the quality of his conceptions. For his own purpose he had created complete studies and had he lived, he would have finished them rapidly. But he considered the problem exceptionally serious with an opportunity so unrestricted, and yet so difficult of treatment, the figures to be placed in a position that would force the results violently upon the visitor. He often used to say that he would give much for the fertile imagination of Vedder, who was just the man to conceive such compositions. Also his anxiety about them was increased by the fact that they were to go to Boston, a city which he regarded as filled with ingrown hyper-criticism. Hence, though he had frequently turned to the studies, he felt unwilling to finish them until he could allot them whole-hearted devotion, with the result that he never completed the work upon which he had looked long and fondly. The third, and only other important production which my father carried on in Europe to perfect here, was

the large variation of his Robert Louis Stevenson medallion for the church of St. Giles, Edinburgh, Scotland. True, he had the work sent to a French bronze foundry before he sailed for home. But at that time he was suffering from the illness that caused his return. Therefore, when he saw the relief with fresh eyes in Cornish and discovered that the foundry, after two or three failures to cast this huge surface, had sent him an unsatisfactory result, he discarded that bronze and altered the changes he had already made.

So much, in a general way, for the more vital work completed between Saint-Gaudens' return to Cornish and the spring of 1902.

The larger productions of the years which followed began with a second Lincoln for Chicago, Illinois, wherein my father realized his long-cherished hope of returning to one of his earlier commissions and of developing it again according to his later ideas. It is interesting to record that he nearly lost this opportunity, however, through that very absorption in his work which had placed him where he stood. As in the case of the first Lincoln monument, so with the second, the Committee asked him to enter a competition, which, of course, he refused to do, and then came again with a direct offer. Near the time of this second visit, about noon of a Sunday morning, my mother went to the studio where my father was working alone. On a large board was written: "Lincoln Committee, Century Club, ten o'clock."

"Have you seen them?" asked my mother.

"Great Scott! No!" cried my father, staring at the board. He had forgotten his appointment, engrossed in his task.

At once my mother hurried to the Century Club to inquire about what had happened. Alas! Here she found only a note from Mr. Norman Williams saying they had waited an hour in vain. From the Club, therefore, she followed Mr. Williams to his hotel where she met him in company with an-

other member of the Committee who intimated that any man so oblivious to punctuality should not be intrusted with the monument. Nevertheless, she succeeded in setting matters straight. Possibly Mr. Williams felt that a sculptor who could become engrossed in his work to the exclusion of everything else would be just the man to do that work well.

At the time when Saint-Gaudens considered his original Lincoln, as I have explained, he thought seriously of making a seated figure; and though the idea was then given up, it had always caused him a twinge of regret. So now, he gladly began upon the project. He set his mind this time upon Lincoln the head of the state, rather than Lincoln the man, as in his earlier monument; but he wished a gaunt Lincoln in a gaunt yet official chair, as he had placed a gaunt Sherman on a gaunt horse. Accordingly, to reach his solution of combining the personal with the national, he shifted the three four-foot models of the statue back and forth over seats of countless shapes and sizes; he added thereto the flag of the United States; while for the larger composition, he first considered placing figures of Justice and Charity on each side of the Lincoln, but later modified this scheme to an architectural one of two columns.

The work on this Lincoln well illustrated my father's care for the proper dimensions of the monument as seen in the large. Because, in order to determine this, before the small model was half finished, he had full-sized solar enlargements made of it and the result set up in a field behind the house, together with a representation of the architecture. While the statue progressed, also, Saint-Gaudens' answers to a number of questions which arose concerning it clearly revealed how he never hesitated to tread on the toes of Nature if forced thereto in the process of gaining the effects of Nature. As in the standing Lincoln he had lengthened the body a trifle at the waist, so here he slightly elongated Lincoln's

MODEL FOR THE PARNELL MONUMENT FOR DUBLIN, IRELAND

This full size model was erected by Saint-Gaudens at his home at Cornish, New Hampshire, against a background
of trees so that the sculptor might judge of the effect. The monument stands in a Dublin square

MODEL OF THE SQUARE IN DUBLIN IN WHICH THE PARNELL WAS PLACED,
MADE BY AUGUSTUS SAINT-GAUDENS

legs from the knee down, to guard against the foreshortening by the low point of view of the visitor. The head he "shrunk" since he had a horror of making a man "look like a tadpole." The hair he modeled in a manner quite different from the hair seen in photographs of Lincoln, though the result seemed to give the onlooker that proper sense of Lincoln's hair which my father desired to convey. On the other hand, with his usual care, he spared no pains to obtain correct materials for costume and figure. He even asked Mr. John Bixby, who posed for the statue, to wander among the farmers dressed in black broadcloth of the cut of Lincoln's time, that he might wear the proper wrinkles in the suit.

The other two statues in the round that my father planned soon after the Lincoln were those of Marcus Daly for Butte, Montana, and of Charles Stewart Parnell for Dublin, Ireland.

The Parnell in especial my father attacked with zest, because he declared that he felt in his element with anything Irish; though on second thought he added that Parnell was only as Irish as himself, which was just one-half.

At the outset in this commission he found trouble both in lack of portrait material and in a scheme for an original treatment of modern clothes. The portrait presented unusual difficulties because Parnell had sat for few photographs, all of which proved of exceptionally little use. But before long the sculptor was lucky enough to think of a series of caricatures in *Punch* and such papers published during Parnell's trial by Sidney P. Hall, John Tenniel, Harry Furniss, and others; through which curious means he made this monument in Parnell's honor.

For the composition as a whole Saint-Gaudens placed a table with a draped flag close by the figure, forming the requisite mass at the foot of such a shaft as he had long been anxious to erect. Moreover, here again he displayed his customary anxiety over the final harmony of his work with its sur-

roundings and took care to reinforce his powers of visualization by experiments with tangible objects. First he procured a map of the square in Dublin where the monument was to stand, together with detailed photographs and measurements of the blocks that surround the square. Next he caused a small model of the place to be erected from this data, that photographs might be taken of this with the miniature shaft in the midst of it. Lastly he had the cast of the nearly finished statue set up in a field before a wooden pillar over seventy feet high, marked to resemble stone, with the result that when he asked the committee to inspect the result one of them said: "Wonderful! Wonderful! It looks just like a marble statue!"

In one other respect, too, the monument is of peculiar interest. Except for the face, the figure represents not so much the man in accurate detail, as his spirit in the broad sense. For although Parnell was known to speak poorly, my father portrayed him in the midst of oratory, with his thin right arm stretched rigidly from his shoulder. Here is Saint-Gaudens' idea of this question, expressed in a letter to Mr. Thomas Baker of the Parnell Committee:

WINDSOR, VERMONT, September 12, 1904.

Dear Mr. Baker:

. . . It would be very regrettable if I were called upon to lower the outstretched arm, for, aside from the fact that the people who knew Parnell have told me that the gesture was one that they saw him use, and it is referred to in one of his "Lives," it is one which treated rightly can give the commanding spirit of Parnell and the nobility and calmness of his bearing impossible to show in any other way. Besides, from an architectural

and monumental point of view it is very much finer. The work is to endure for generations, when idiosyncrasies will have been forgotten and the monument will count as a whole regardless of any personal peculiarities.

The studio fire of 1904, as I have said, made a definite break in the progress of my father's work. In the reorganization which followed he found opportunity to take up other commissions long-delayed. Chief among these was the monument to Phillips Brooks for which he had already created over twenty sketches, and on the small model of which he had already progressed. How many years earlier he began to think about this monument is shown in this letter sent in 1893 to Dr. Winchester Donald. The general scheme of sculpture and architecture mentioned therein was never altered. He writes:

148 WEST THIRTY-SIXTH STREET, Dec. 26, 1893.
Martin Brimmer, Esq.,
Rev. Winchester Donald,
Dear Sirs:

Since our correspondence in relation to the monument to Phillips Brooks, I have visited Boston and examined the vicinity of Trinity Church and fully considered the matter. As far as my conception now goes, I should wish to make the monument a covered one on the principle of the Scagliere Monument at Verona, and compose the Bishop with an accessory figure, the character of which to be determined by fuller study. The figures would be about ten or eleven feet in height and the entire work about thirty feet; the monument to

be so designed that it would be placed in the triangle on the north side of the church to compose with the church as it now stands, or to be either in the center or at the entrance of an enclosure or cloister, should that be determined on in the remodeling of the building. . . .

Before dealing with the sculpture directly, however, I will emphasize for a moment this question of the architecture mentioned in the letter I have just given. Because this architecture, more elaborate than usual, my father studied most earnestly with Stanford White. It is strange that these two men who first worked together in Trinity Church, Boston, should have designed their last composition to go under the shadow of that building. I give three letters between them:

January 17, 1906.

Dear Stan:

I return you the drawings you made for the Brooks years ago. I think I like the plan of Number Four the best and the style of Number Three, but I leave this entirely to you. I will say, however, that I should greatly like to have it in the character of your Parkhurst church, which I think great and just in the line I had wished for this. I think you must provide for a bulge out in front as in Number Three and for the cross to run up as in Number Three also.

The statue of Brooks is to be eight feet and four inches in height, or thereabouts, and the rest of the group very much as shown in the drawings.

Gus.

To which White replied:

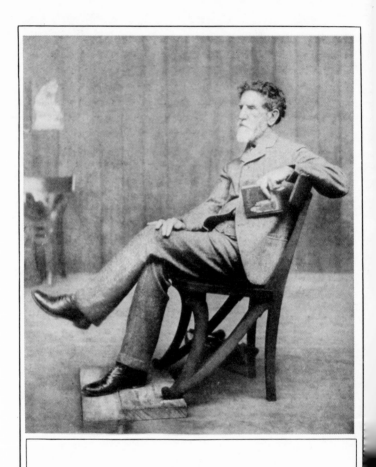

AUGUSTUS SAINT-GAUDENS ABOUT TWO YEARS BEFORE HIS DEATH

AUGUSTUS SAINT-GAUDENS

New York, March 17, 1906.

Dear Gus:

I send you with this a careful drawing for the Phillips Brooks monument. In your letter to me you ask that I should send drawings for both the square and the circular one, but I am so positive that square form is infinitely the best, every one agreeing with me (Mc-Kim, Kendall and Phil Richardson), that I beg you to give up the idea of the round one and go ahead with the square one. The round one might look well from the front, but all the other views would be complicated and ugly. . . .

Affy,

Stanford.

To which my father answered:

March 30, 1906.

Dear Stan:

. . . When the model is made I will communicate with you. My objection to the square form and the reason I preferred the circular was that the circular covered the group more. You remember some one objected to the Cooper monument, that it was a "protection that did not protect."

That my father clung to this determination to the end is shown by a letter which he wrote on July 1st, 1907, directly before his death, to Mr. Kendall of the firm of McKim, Mead, and White, insisting on the semicircular canopy but leaving the rest to the architects.

Saint-Gaudens' delay of ten years in starting the commission seems inexcusable on the face of it. Yet there were three

very definite reasons that held him back, love of his subject, a dread of Boston such as also influenced his delay upon the Library figures, and ill-health. This love of his subject came to him through an especial quality of Brooks' nature which Brooks defined when he said:

"Do not pray for easy lives. Pray to be stronger men; not for tasks equal to your powers, but for powers equal to your tasks. Then the doing of your work shall be no miracle, but you shall be a miracle."

As for Saint-Gaudens' dread of Boston, here is what he wrote to John La Farge about this undertaking:

I suppose I am getting well, as I am able to work seriously for the first time in a year on the "Brooks." Physically, he is terribly difficult to represent, considering what he is in the minds of his admirers; and when beyond this there is the introduction of the Holy figure, it makes me feel abominably audacious. . . .

While that other third cause of his delay, ill-health, is rather gruesomely stated in this letter to Dr. Winchester Donald:

ASPET, WINDSOR, VERMONT, October 10, 1903.
Dear Donald:

I have your bully letter and if you were not such a bully fellow I should have much trouble in answering you. But you understand things.

For six years there has not been a day in my life when a horrible vision of death has not been constantly hanging over me. . . . About three months ago, as the result of diet or something, a total change in mentality came; the vision of death vanished and an entire

new grip on life and health took possession of me. It was so extraordinary that I seized on it as a drowning man seizes on a rock. In order to maintain this grip, I have not done a stroke of work for three months. The "Brooks" is now where it was at that time. This is the first time in my life, when sound in body and mind, I have refrained from work. I am entirely a new man and am crazy to get at it again. But I will hold off as long as the fine weather lasts and then will "sail into" the monument. This is a good deal of talk about me and I only mention it to explain why there has been no progress for these months.

As finished, Phillips Brooks stands well forward in the architectural canopy; his left hand grasps a Bible that rests upon a lectern; the right hand is raised in a gesture of concluding emphasis; the gown swings with energetic motion; and the face looks down at his listeners, earnestly, soberly. Behind, and above the figure, and beside a cross that rises through the shadow of the canopy, Christ, veiled, peaceful, half-remote, touches the man softly on the shoulder with His right hand.

To my father's understanding, Brooks, in preaching, threw back his shoulders and poured out thoughts and feelings as if the effort of speech could not hinder the ideas he had to deliver. So for some time he did his best to discover how to express this and yet avoid a bug-bear of which he wrote:

I got at the "Brooks" again yesterday. I am making him more alive. I fear from the general things I hear that I must not do anything that resembles in he remotest degree academical oratory.

But, at last, sharply realizing that he had no means of portraying freedom of vocal expression except by freedom

of gesture, he acted, in a measure, after the fashion of his work upon the Parnell. He chose a gesture he was told Brooks occasionally took and he emphasized that, believing, as in the other case, that since the statue was to last for all time it was best to take a slight liberty with the personal idiosyncrasies of the preacher, which would only go against the grain of a few of his friends now surviving, in order to present to generations to come a symbol of the spirit of the real man.

Indeed there were few objects in his later years that my father "caressed" as long as he did this figure. He selected and cast aside. He shifted folds of the gown back and forth. He juggled with the wrinkles of the trousers, which invariably obstructed the development far more than their final interest justified. He moved the fingers and the tilt of the right hand into a variety of gestures. He raised and lowered the chin of this long-studied portrait until finally he left it lowered, since he considered the angle of the head a question of art and not of fact, and since he felt that he expressed more definitely the magnetism of the preacher by having him appear to talk directly at the visitor. He shifted the left hand first from the chest to a position where it held an open Bible, and last to the lectern; because, although the lectern has aroused argument as not being the point from which Brooks spoke, it was vitally necessary for the composition.

The process certainly brought my father pleasure. As long as he could stand and model for himself, he resumed his former habit of singing airs from old Italian operas and of whistling as he worked, after the fashion of the days in Rome and later in the New York Thirty-sixth Street studio. "Maid of Athens," "In the Gloaming," snatches from "Faust" and the Offenbach Operas were mingled day by day with negro songs such as "As I walk that Levee down," and ditties of the type of "Johnnie Jones and his sister Sue."

When he first turned seriously to the character of the figure

behind Brooks, he designed sketches of fully thirty angels. But after coming to work in Cornish he received the suggestion that he substitute a Christ for the angel he had planned. The conception appealed to him more because of what he might develop in the composition and because of the fitness of the subject than from any desire on his part to portray an idea of the character of Christ. However, as was his custom, he sought a "biography," and on being handed Renan's "Life of Christ," read it eagerly. Next he procured Tissot's "Life of Christ." After that, the story has it, he went to his friend, Mr. Henry Adams, explained what he had been doing and asked for another book on the subject. Whereat Mr. Adams promptly suggested one called the Bible.

Then while he ruminated upon his task, a sincere change in his attitude towards his subject came over him. Hitherto, though educated a Catholic, he had never found appeal in the historical self-chastising doctrines of Christianity. Only the joy of religion had drawn from him any response. He always remembered his aversion to his schoolmates, who, according to their instructions, beat their chests and named themselves "miserable sinners;" "Craw-thumpers," he and his brothers used to call them. But now, as he gave the subject more and more individual thought, Christ no longer stood to him as the head of a cult that announced bewildering self-contradictions and endless punishment of sin, but became the man of men, a teacher of peace and happiness.

From that time Saint-Gaudens began to express a genuine faith in his conception of the physical image of Christ as a man, tender yet firm, suffering yet strong. It scarcely coincided with other representations in the past, though, of course, a few of them proved the exception to the rule, the "Bon Dieu" at the cathedral of Amiens, Dagnan-Bouveret's "Christ," and Rembrandt's Christ in the "Supper at Emmaus." Rather the greater share of influence from pictorial work

came, as I have said, from Tissot's "Life of Christ," so well illustrated by the author.

Here is a portion of a letter my father wrote to Tissot on the subject:

I am making a statue of Christ and turn to you as the highest authority in anything pertaining to Him. I would be most grateful if you could give me some information with regard to the shape and size of the garments He wore; details of arrangement I cannot get by simply studying the illustrations in your extraordinary work, which I have the good fortune to possess.

Will you excuse me if I take this opportunity to express the profound admiration I have felt for your art for a long time, beginning with the etchings of "The Prodigal Son" which I saw years ago at Knoedler's in New York. Your sincerity and devotion have been a great incentive and inspiration to me.

Thereafter the development of the figure was inevitable. For as soon as Saint-Gaudens knew exactly what he desired, he worked not only with his usual energy but behind closed doors in the fear that the committee would get wind of his scheme and would judge adversely before he was prepared.

At first he designed two reliefs of Christ, the first low, the second almost in the round, as in the case of the Shaw Memorial. He considered them failures, for one thing because he insisted that the hand of the Christ should rest upon Brooks. Of course as in the bas-relief of Dr. James McCosh he had already modeled a complete hand extending from a medallion. Yet he could not nerve himself to grasp the problem again, so finally he constructed the whole Christ as a statue, and therea his troubles multiplied. He desired the figure back amon

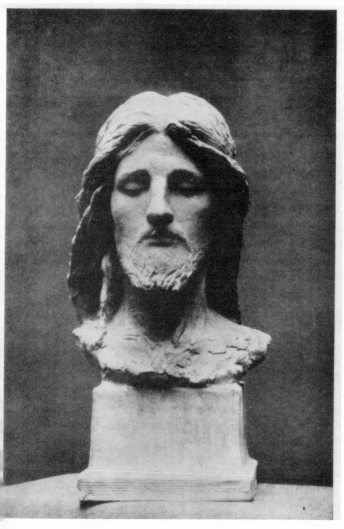

STUDY FOR THE HEAD OF CHRIST MADE FOR THE
PHILLIPS BROOKS MONUMENT

'his and the medallion of Mrs. Augustus Saint-Gaudens were the last pieces of sculpture worked upon by Saint-
Gaudens with his own hands. In the monument the Christ head was somewhat veiled and altered

the columns, and sought in the head an air of mystery which should be intensified by drapery and shadow, a sense so long ago sought in the "Silence" and later in the "Adams Monument." But for a while the folds of Christ's garments would not compose as he wished. When they crossed the shoulder in a humble manner they did not accord with the lines of Brooks' figure, and when they harmonized with the preacher, they failed properly to characterize the Christ. Eventually, however, my father evolved a scheme which satisfied him.

The head of the Christ was one of the last two pieces of sculpture that he actually touched with his hands, and as it stood alone he felt most happy over the result. However, when the bust had been placed upon the figure he believed it too abstract and too remote, especially about the eyes, which he desired to look directly toward Brooks. Moreover, for reasons that have been explained in other cases, he wished the head draped and in shadow. Accordingly, he set upon the problem an assistant, Miss Frances Grimes, who, under his direction, modified the features until at last he undoubtedly gained what he sought because, toward the end of the commission, and of his life, he said more than once: "There, it's all right now; all right now!"

XI

FINAL WORK

1904-1907

The "Hanna"—The "Magee"—The "Whistler"—The Coins—The
Puritan—The Hay Bust—Hay Letters—The Mitchell Relief—
The "Masque"—The "Sage"—The "MacVeagh"—Mrs. Saint-
Gaudens—The "Booth"—The Baker "Christ"—The Albright
Caryatids—Philosophy.

BESIDES the "Brooks," after the erection of the new
studio on the spot where the old one had burned, my
father turned not only to the reconstruction of the
statues which he had lost, but before long to a monument to
Marcus A. Hanna, memorials to Christopher Lyman Magee and
James MacNeill Whistler, the United States coins, the Cary
atids for the Albright Art Gallery, and other commissions.

The Hanna developed with unusual speed. To begin with
the nature of the subject allowed my father to refer back to
photographs he had taken of his numberless sketches for the
Peter Cooper monument and so made possible his choosing a
pose without much difficulty. He secured, also, through ex
ceptional fortune, a series of satisfactory, unretouched photo
graphs of Mr. Hanna, though, as usual, without a profile
among them. As for the problem of the chair, which often
annoyed him, an assistant settled this early in the day by sug
gesting a method of treating the seat with an upholstery fringe
which, before that time, my father invariably had disliked.

The Magee Memorial, now standing in front of the Carnegie
Institute in Pittsburgh, provided for the sculptor an inter
esting opportunity to deal not only with the Greek stele,

form he had always admired, but also with alto-relief. So fond was he of this type of modeling that in his class-rooms he had occasionally advocated creating it in the hope that it would attain even greater success than the full round. Accordingly, for the "Magee" he designed in such high relief a figure of Abundance, a woman, large and somewhat removed from his ideal type, with a cornucopia and cloak, standing beneath an oak tree. This he planned to cut directly in the monolith, until consideration of Pittsburgh smoke caused him to decide on bronze.

The Whistler Memorial at West Point, which belongs to the same period, developed into another stele. Saint-Gaudens would have enjoyed modeling a figure of Painting upon it and, indeed, submitted a sketch to the Copley Society who controlled the commission. But as they desired no sculpture in that sense of the word, seeking rather the simple stone, he confined himself to an architectural composition and arrangement.

The scheme for the United States coins—the cent, the eagle, and the double eagle—also originated about this time at a dinner with President Roosevelt in the winter of 1905. There they both grew enthusiastic over the old high-relief Greek coins, until the President declared that he would have the mint stamp a modern version of such coins in spite of itself if my father would design them, adding with his customary vehemence, "You know, Saint-Gaudens, this is my pet crime."

The following letter from my father to the President shows conclusively what must have been their attitude toward their subject:

November 11, 1905.

Dear Mr. President:

You have hit the nail on the head with regard to the coinage. Of course the great coins (and you might al-

most say the only coins) are the Greek ones you speak of, just as the great medals are those of the fifteenth century by Pisanello and Sperandio. Nothing would please me more than to make the attempt in the direction of the heads of Alexander, but the authorities on modern monetary requirements would, I fear, "throw fits," to speak emphatically, if the thing was done now. It would be great if it could be accomplished and I do not see what the objection would be if the edges were high enough to prevent the rubbing. Perhaps an inquiry from you would not receive the antagonistic reply that would certainly be made to me from those who have the "say" in such matters.*

Up to the present I have done no work on the actual models for the coins, but have made sketches, and the matter is constantly in my mind. I have about determined on the composition of one side, which would contain an eagle very much like the one I placed on your medal, with an advantageous modification. On the other side would be some kind of a (possibly winged) figure of Liberty striding energetically forward as if on a mountain top, holding aloft on one arm a shield bearing the stars and stripes with the word "Liberty" marked across the field, in the other hand perhaps a flaming torch; the drapery would be flowing in the breeze. My idea is to make it a living thing and typical of progress. . . .

To enlarge upon what my father indicated in this letter,

* See pages 67 ff. (Reference to Columbian Medal.)

he first purposed to model the cent with a flying eagle, the formal lettering treated in a new fashion, and to execute for the gold coins a full-length figure of Liberty mounting a rock, with a shield in her left hand and a lighted torch in her right, backed by a semi-conventional eagle, with wings half-closed. For one reason and another, however, the scheme proved impracticable. So, after months of confusion, he settled that the one cent should exhibit a profile head and the lettering; that the ten-dollar gold piece should carry the same head, with the inscriptions shifted, and the standing eagle; and that the twenty-dollar gold piece should exhibit the full-length figure of Liberty, without wings or shield, and the flying eagle.

To accomplish this result, my father altered and realtered the coins for a year and a half. The suggestion for the flying eagle he developed from the bird on the 1857 "White Cent." The conception of the standing eagle he drew from a design he had often used on such work as the Shaw Memorial, the medal struck to commemorate the inauguration of President Roosevelt, and the shield of the monument to President Garfield in Fairmount Park, Philadelphia. In all, he created seventy models of this bird, and often stood twenty-five of them in a row for visitors to number according to preference.

The profile head he modeled in relief from the favorite, but superseded bust of the Sherman "Victory," * adding the feathers only upon the President's emphatic suggestion. Many persons regarded it with disfavor at the time because it was thought to have been posed for by an Irish maid, Mary Cunningham, when none but a "pure American" should have served for a model for our national coin. As a matter of fact, the features of the Irish girl appear only at the size of a pin-head upon the full-length Liberty, the body of

* See page 135.

which was posed for by a Swede, while the profile head, to which exception was taken, was modeled from a woman supposed to have negro blood in her veins. Who, other than an Indian, may be a "pure American" is undetermined. In reality here, as in all examples of my father's ideal sculpture, little or no resemblance can be traced to any model; since he was always quick to reject the least taint of what he called "personality" in such instances.

Finally he attacked the difficult problem of the inscriptions by placing upon the previously milled edge of the coin, in one case, the forty-six stars and, in the other, the thirteen stars with the "E Pluribus Unum." The motto "In God We Trust," as an inartistic intrusion not required by law, he wholly discarded and thereby drew down upon himself the lightning of public comment. It is interesting to discover in regard to this that Secretary Salmon P. Chase received quite as severe a censure for placing the words upon this coin as was aroused by their removal.

Upon the striking of the coins it seemed impossible to reach a satisfactory understanding with the mint authorities, who, shortly after my father's death, began issuing the Eagles with extremely poor results. In vain his assistant, Mr. Henry Hering, who had personally carried on the alterations protested to the authorities. They replied that they were forced to lessen further the proportional depths of the relief, and that in the process details were lost. Mr. Hering promptly exhibited three grades of relief reduced abroad to the same extent from the same original by the same machine that the mint employed. The details stood out quite as vividly in the low relief as in the high. At last, however, Mr. Frank A. Leach, the new Director of the Mint, took a hand in the turmoil and brought the matter before the President, with the consequence that the designs remained for a time somewhat as my father planned them, though what with the

lowered relief and most careless reproduction, especially of the profile head, the results appeared far from those he would have allowed had he been alive.

Turning to his other final commissions he remade in the round the original Springfield "Puritan" for the Pilgrim Society of Philadelphia, and he completed the bust of the Hon. John Hay; in relief he created a variant of the "Amor Caritas" for Dr. S. Weir Mitchell, a plaque commemorating a "Masque" at Cornish, and portraits of Mr. William Oxnard Mosely, of the Hon. Wayne MacVeagh and his wife, of Justice and Mrs. Stanley Matthews, of Governor Roger Wolcott, of Jacob Crowningshield Rogers, of Mrs. John C. Gray, of Justice Horace Gray, of Mr. Henry W. Maxwell, of Mr. Dean Sage, of Mr. Frederick Ferris Thompson, and of my mother.

Among these commissions the creation of the Hay bust proved of especial pleasure to him in that the two men were warm personal friends. Secretary Hay's letter asking to be modeled is characteristic of their mutual cordiality.

"I wonder if you could make anything of so philistine and insignificant a head as mine. You succeed with all sorts and conditions of folks, but, to tell the truth, I do not recall any proposition you have ever tackled so unpromising as mine. I lack profile, size, and every other requisite of sculpture, but I have been an unusual length of time in office and I fear that after I am dead, if not before, some blacksmith will try to bust me. Turn it over a little in your mind."

Even further in connection with this commission, also, I am fortunate in being able to quote a few of the letters which passed between this statesman and the sculptor, letters which showed not only the delight the two men took in one another and in Mr. Henry Adams, with whom they made a most congenial trio, but as well my father's continued power of maintaining his spirits. The Adams caricature to which they refer is in the form of a small round bas-relief, representing a head

of Adams flying by means of wings feathered with porcupine quills. Adams' outward gruffness and inward gentleness had earned him from Hay and my father the title of "Porcupine Poeticus."

My father writes:

ASPET, WINDSOR, VERMONT, July 12, 1904.

My dear Hay:

. . . Now that we are neighbors, perhaps on some day of leisure you may run up here. I would not mind glancing at you again for a moment or so before sending the work to the bronze founder. Then you could see my new studio which I hardly dare enter for two reasons: first, it is too perfect for my imperfect self to dwell in; second, the danger of being sucked up the fireplace chimney by the wonderful draft.

ASPET, WINDSOR, VERMONT, August 19, 1904.

Dear Hay:

A package has been sent you containing another which holds the bronze caricature of Adams. You said you would send it to him with diplomatic seals, etc., etc. Presently you will receive another for yourself. . . .

ASPET, WINDSOR, VERMONT, August 30, 1904.

Dear Hay:

You are "a scholar and a gentleman" in the matter of your offer to make the final payment on the bust, to say nothing of your standing in other directions, and I really do not know how to thank you in full appreciation, but

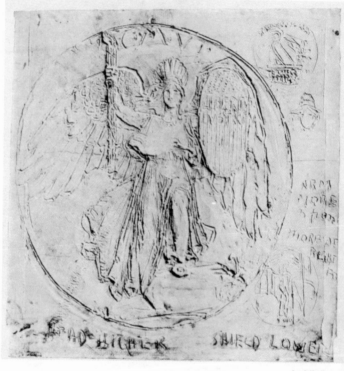

PRELIMINARY SKETCH FOR THE DOUBLE EAGLE,
OR TWENTY-DOLLAR GOLD PIECE

The wings, shield, and head dress were omitted as not suiting a composition within a circle. This design was intended for all of the gold coins, but the authorities had a head substituted on the eagle, or ten-dollar piece

Whereas: The bust is finished in every respect so far as I am concerned and all that I can do is done; and

Whereas: There are four copies of the work in different places, so that it is protected from loss unless the world blows up, in which event nobody would care except Henry Adams who would shriek and yell in delight and derision as he sailed into the air, and

Whereas: The non-payment of a similar amount due me for more than a month and the absence of all signs of its appearance upon the horizon has thrown my exchequer in still more glorious and inextricable confusion than usual, *qui n'est pas peu dire;* and

Whereas: The protection from loss to you puts what shreds of conscience still remain in me at ease in your direction; and

Whereas: Henry Adams has counseled me always to seize any money I can possibly lay hands on! I shall be more than grateful, I assure you, to receive the check, if you still have it so that you can dispose of it.

With regard to your inquiry as to the cost of a replica, I will tell you that I propose unloading *two* busts on you, one in marble, the other in bronze—for town and country, or for any other disposition you may decide on—these to be included in the piratical charge I have made for the work. . . .

To the letter Hay replied:

NEWBURY, NEW HAMPSHIRE, September 1, 1904.

My dear Saint-Gaudens:

I inclose my cheque. . . . I am glad to get it out of my hands and into yours. Every little while some lunatic sues

me for a million or two for not taking care of his interests "outre mer." But I would rather he would do that than dynamite me.

I note your generous offer about the replicas. I shall want one or the other, for myself. As to Uncle Sam, he is a "vrai grippe-sou" and gives for a portrait about as much as would serve for a pourboire to the artist's concierge. I am not speaking of Congress. They usually give twenty thousand dollars, with always the proviso that it must be a hopeless daub by a deserving, self-made artist, who has spent at least a year in lobbying for it.

All this month has been delightful, with a premature tang of Autumn in it. I have missed the full enjoyment of it from a grudging sense that it is too rapidly passing away, and from the necessity of wasting from two to four hours a day on the Washington mail. . . .

At about the same time, in connection with the aforementioned caricature, Mr. Adams sent the following:

23 AVENUE DU BOIS DE BOULOGNE, 3 September, 1904.
My dear St. Gaudens:

Your winged and pennated child arrived yesterday by the grace of God and his vicar the Secretary of State, or his satellites Adee and Vignaud. As this is the only way in which the Secretary will ever fulfil his promise of making me Cardinal and Pope I can see why he thinks to satisfy me by giving me medallic rank through you. Docile as I always am to suggestion, I agree that the medal is probably worth more than the hat. . . .

Work! And make a lot of new porcupuses. I'm sorry you can't give Hay wings too, he needs them more than I who live in holes. Adieu!

Ever Yours,

HENRY ADAMS.

In answer to this and to another letter, my father wrote:

AUGUSTUS SAINT-GAUDENS

Dear Adams: ASPET, September 15, 1904.

. . . It was good to hear of your automobile, and the Salon, Rodin, Besnard and the Sixteenth Century glass. I recall some pretty fine stuff of that period in Brussels and in one or two of the "villes mortes" of Holland, Monnickendam and Marken. Run up there in your automobile, you will find it worth while. But what's the use of telling you anything. Is there anything you haven't seen or don't know about?

I hope the medal makes you a little miserable. It was made for that purpose. And if I could believe it did, it would compensate for the diabolique neurosis or sciatica which keeps me prisoner here. If it had not been for that I should have, I hope, accompanied you on some of your automobile rushes this spring. And if it were not for that also I would write this letter straighter. But it's hard to have an eye for the proper "aplomb" when you are writing half-reclining. I succeeded in getting Hay here for a day and a half and his bust is finished and I'm going to inflict *two* upon him. One he can give to you. Some day I hope to achieve a caricature of him, but I fear to approach it. Sometimes they are shameful. I never know how they may tempt me. . . .

Some months later Mr. Hay wrote:

EDEN HOTEL, NERVI, PRÈS DE GÈNES, April 12, 1905.

My dear Saint-Gaudens:

It has just occurred to me that I left God's country without taking leave of you and without saying anything of those mineral treasures of mine in your charge. Whenever you like

to be rid of them, please send them at my cost and risk to the Department of State, where they will be taken care of.

As the American newspapers have set forth at quite unnecessary length my miseries before sailing, I need say nothing more about them. We had a delightful voyage, summer seas, and a ship as steady as a church. My doctor here says there is nothing the matter with me except old age, the Senate, and two or three other mortal maladies, and so I am going to Nauheim to be cured of all of them. This involves parting with the Porcupinus Angelicus—and I would almost rather keep the diseases. He has been kindness itself—the Porcupine has "passed in music out of sight" and the Angel has been perfected in him. As Sir Walter sings,

> "Oh! Adams, in our hours of ease
> Rather inclined to growl and tease,
> When pain and anguish wring the brow
> A ministering angel thou."

In my father's answer which follows he speaks of the Academy. This is the American Academy of Arts and Letters, of which he was a member.

UNIVERSITY CLUB, FIFTH AVENUE AND FIFTY-FOURTH
Dear Hay: STREET, April 23, 1905.

I was delighted "de vous lire" (as the French commerçants write me) ten minutes ago. I found your letter in the box here where it had been forwarded from Windsor, and it was good to hear you were better, although I knew from Harry White that the newspapers had been making their usual copy.

I came here for the Academy meeting yesterday, the list you and Adams sent was what several of us based our votes on. Sargent and Gilder and Jefferson were

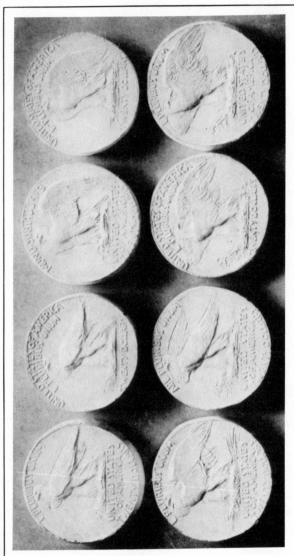

RELIEF SKETCHES FOR GOLD COIN, SHOWING EVOLUTION OF DESIGN

elected, but for the life of me I cannot recall the two others. Bigelow and Furness, I think. You will know in a day or two from the indefatigable Johnson.

Howells, Lounsbury, and Stedman were there, fresh, young and blooming, much more so than the younger ducks. La Farge arrived when we were through. McKim, Stedman, and MacDowell were the others.

Lounsbury told me about Chittenden's work at Yale, of the remarkable results in the food investigations he has been pursuing; and there is no doubt that the trouble with you (if you have any trouble), and me, and all of us is our blessed stomachs. Of course you have the senile senate, and no wonder you ran away. . . .

I called at your house the day you ran away and I can assure you you were well guarded. I had two weird conversations at the little side door, the first with a Gaul who told me some strange lie, the second on my return in the afternoon (at the suggestion of the Gaul) with a Puritan who had a front like the Palisades and who told me a reverse lie. But she did it so much better than the treacherous Gaul that I was filled with delight. . . .

Mr. Henry Adams had meantime printed privately for his friends his remarkable book, "Mont Saint Michel and Chartres." My father writes, thanking him for a copy:

ASPET, WINDSOR, VERMONT, April 6, 1905.

You dear old Porcupinus Poeticus:
You old Poeticus under a Bushelibus:

I thought I liked you fairly well, but I like you more for the book you sent me the other day. Whether

I like you more because you have revealed to me the wonder of the Twelfth Century in a way that never entered my head, or whether it is because of the general guts and enthusiasm of the work, puzzles what courtesy calls my brains. You know I never read, but last night I got as far in your work as the Virgin, Eve and the Bees, and I cannot wait to acknowledge it till I am through.

Thank you, dear Old Stick in the Mud.

Your brother in idiocy.

A year later he writes again:

April 24, 1906.

Dear old Porcupine:

. . . You have heard no doubt of my having been nailed in the hospital and all that. I am out of it, convalescing, and they say I am getting fat, very pretty, and all that. They have been telling me that for the last five years, and if I had been growing at the rate they say I would be as big as a balloon by this time. Perhaps the thing I regret the most in this captivity is my not having been able to get to Washington and sit by you for a little while and listen to you pegging away at somebody or other.

Well, everything is for the best, as our friend Voltaire said. I am reading "The Bee" in the intervals when I am thinking why I did not do a lot of things while I was younger than I am now—when I was as young as you are for instance.

Please excuse this typewritten letter, but this is the

only way in which I can communicate with my friends now. I am not writing you, I am cylindering to you, i.e., I am talking into a talking machine and the secretary reproduces it on the typewriter. It is a singular sensation and to hear my voice makes me more tired of myself than I am usually. If you want to be more lowered than usual in your own estimation, listen to your voice in one of these affairs. It is awful and shows to what depths the human mind can descend. . . .

To turn again to my father's last works, the commission for Dr. S. Weir Mitchell held for him the same fascination of improving an earlier work which he had felt with the "Puritan" for Philadelphia. Here is a portion of a letter to me on this subject from Dr. Mitchell.

. . . When I wrote to your father asking him to make a monument commemorative of my daughter, my wife's only child, he said it was simply impossible, that he had work on hand for two lifetimes. Then Mrs. Mitchell wrote to him. What she said I do not know but he replied by saying, "I shall throw aside all other work until I have done this thing for you." He then created a modified replica of his "Angel of Purity," or so he called it, which is, I think, in the Luxembourg in Paris. There is some resemblance, but much difference. This exquisite monument satisfied Mrs. Mitchell, and nothing could exceed the kindness and care and effort he gave to the whole business and the friendly relation of the most affectionate nature which he created with my household. I think a sweeter gentleman I never knew, nor one so magnanimous about his fellow-artists, nor any so capable of putting the high poetry of his imagination into marble. I have often regretted that I have not seen more of him.

And here is part of one of the letters which my father wrote to Dr. Mitchell:

October 9, 1901.

Dear Dr. Mitchell:

I enclose a photograph and two sketches. The photograph is of the relief bought by the French Government and now in the Luxembourg. It is a modification of a monument in Newport and is one of the things I care for most that I have done. As time goes by I can think of nothing that would be better for the purpose we have now in mind. Of course there will again be changes in this that will prevent it from being a replica of these other works. The Greeks did this, and I do not believe we can do better, in this memorial at least, than follow in their footsteps. I am having a large solar print made which will be sent directly to you, and if you agree to my proposition, I shall have the work begun at once. It seems that the character of this suits the beautiful and youthful character you have described. Of course a principal feature in the memorial will be the inscription which will surround the figure, and I believe the result will be a happy one. I have been for years hoping for an opportunity to make such an arrangement and modification of this figure, and it is of great interest to me. . . .

The remaining ideal relief is the plaque for the " Masque," the reason for its existence having developed in a charming manner from a remark my father let fall to three of his friends during the winter of 1905, when he said that, as the following summer would number his twentieth in Cornish, he

intended celebrating it by an outdoor party. The subsequent spring the Cornish neighbors removed that scheme from his hands. I can do no better than to include a portion of what Mr. Percy MacKaye wrote of the pageant in his article in *Scribner's Magazine:*

"In 1905, to celebrate the twentieth anniversary of the founding of the Cornish Colony by Augustus Saint-Gaudens, an outdoor masque was performed by his neighbors in a pine grove at Aspet, his estate.

"The masque, written by Mr. Louis Evan Shipman, the dramatist, with a prologue by myself, was produced under the direction of Mr. John Blair, the actor. More than seventy persons took part, among whom were some forty artists and writers of craftsmanly repute, who had spent many weeks in careful preparation.

"About twilight, on the longest day of the year, the sculptor, with his family and some hundreds of guests, were seated in front of a green-gray curtain, suspended between two pines, on which hung great gilded masks (executed by Mr. Maxfield Parrish). Close by, secreted artfully behind evergreens, members of the Boston Symphony Orchestra awaited the baton signal of Mr. Arthur Whiting, conductor and composer of the music.

"First, then, in the softened light there emerged from between the curtains the tall, maidenly figure of Iris, in many-hued, diaphanous veils, holding in one hand a staff of living fleur-de-lis.

> "Fresh from the courts of dewy-colored eve,
>
> Jove summons me before you."

"With these words, she began the prologue—a brief tribute in verse to Saint-Gaudens, as artist and neighbor—at the close of which commenced the first strains of the hidden wind-instruments, and the curtains parted. Visionary as some Keatsian glade, the natural stage disclosed at its farther end

a sculptured altar, beneath a little temple of Ionic columns, from whose capitals suspended laurel ropes and flowers stretched to a nearer column on either hand. Still nearer, on both sides, stood classic benches. Behind the temple, from a precipitate ravine among the pines, rose faintly the murmurous roar of a stream.

"Enter, then, with staff and crown and snaky caduceus, Juno, Jupiter and Mercury. The motive of the masque, composed in a spirit of chaffing comedy and local allusions, was to compass—with pictorial effectiveness and practical groupings—the presentation to Saint-Gaudens of a golden bowl of ancient Greek design—a token from the Cornish Colony. To this end, Jupiter, declaring that he has an important communication to make, despatches Mercury to summon all greater and lesser divinities to hear it. . . ."

From the only contemporay record of this fête, written by Mr. Kenyon Cox in *The Nation*, for July 1, 1905, I quote the following:

"First came somber Pluto and his court, in black and gold and purple; then Neptune and Amphitrite, with their attendant Nereids in sea-green and blue; Venus and her body-guard in varying shades of tender rose; Diana and her nymphs, in white and silver and pale blue; the Wood-gods, in green and dun and yellow; Apollo and the Muses, all in white and gold, grouping themselves about the altar; Ceres, all in yellow, crowned with corn; Pan, gilded all over and exactly imitating an archaic Greek statue; Mars, a gigantic figure, in blood-red draperies and armor; last, Chiron, the Centaur—the one frankly comic figure in the masque—at the head of a rout of children.

"All being assembled, they are informed by Jupiter that he has decided to abdicate; Pluto and Neptune dispute the succession; Minerva, calling upon Fame to decide, makes invocation, and strikes the altar with her spear. Immediately smoke

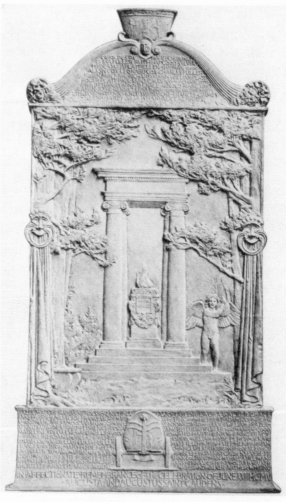

PLAQUE MADE BY SAINT-GAUDENS AS A GIFT TO EACH OF THE
PARTICIPANTS IN THE MASQUE WHICH HAD BEEN GIVEN IN
HIS HONOR AT CORNISH, NEW HAMPSHIRE, JUNE 23, 1905

The original was modeled about two feet high. Reductions three inches high were
made for the participants, their names appearing on the plaque, which shows
the Greek altar in front of which the masque was performed

and varicolored fire transfigure the temple and the irradiated pines, and out of the altar rises a Sibyl of burning gold, maidenly, Olympian, holding aloft in both hands the golden bowl. This Minerva takes and draws from it the name of— Saint-Gaudens.

"The cry is taken up by all voices, the bowl is delivered to the master-artist, and group by group the divinities are presented before him. Then, as these form in procession, a chariot, embellished with a medallion of the sculptor, is dragged from its covert by fauns, nymphs, and satyrs, Saint-Gaudens and his wife enter it, and are dragged across the long, golf-turfed slope to the pergola of the studio, where a banquet is spread under twinkling Japanese lamps.

"As Mercury, it was my prerogative to head the procession just behind the chariot, in which the sculptor stood looking back with emotion upon the astonishing beauty of the scene. In the afterglow of sunset, that edged with gold the blue volcanoesque summit of Ascutney, the pied procession of those ephemeral gods swayed and then broke into glorified groups of frolic over the vivid sward: Apollo skipped flower-ropes for the laughing Muses. Swart Pluto gamboled among the sea-nymphs. Semi-nude children twitched the hind legs of the Centaur. Graces locked arms with dun-hued Fates. Cupid, with little wings, danced with the statued Pan. And still while a lump rose in the throat of each, and revelry spread glamour over all, there echoed, rhythmical, from the New Hampshire hillside, the long, spontaneous shout of 'Saint-Gaudens!'"

It was a scene of beauty which became fixed in my father's memory. But more than that, the charm of the tribute deeply stirred his Gallic nature. Later he wrote of the occasion:

Much of pleasure in life has happened here in the past twenty years, but nothing so delightful and in

every sense remarkable as the "Fête Champêtre," which was given on my place to commemorate the twentieth anniversary of the founding of the Colony. The real founder was Mr. C. C. Beaman; there is no doubt of this, for he subsequently brought friends here directly, and it was through him and the foresight of Mrs. Saint-Gaudens that I came. However, my friends choose to think it is through my coming that the place has taken the artistic and literary development which characterizes it, and therefore did me the great honor of executing a "Masque," as it was called, within a few days of the twentieth anniversary of our entering the house, and in commemoration of the event.

It was certainly extraordinary and it is beyond my powers of narration to do it the slightest justice here. I wish I could quote what my friend Kenyon Cox wrote of it at the time.

As the play ended and the performers followed the chariot up to the house in their classic dresses, all bathed in a wonderful sunset, it was a spectacle and a recall of Greece of which I have dreamed, but have never thought actually to see in Nature. It closed with a ball which marked the opening of the new studio built to replace the one destroyed by fire, and if anything can console me for the destruction that happened then, it was the beauty of the day and occurrence, and the great-hearted friendliness of the neighbors.

Not long afterwards, therefore, Saint-Gaudens composed his relief representing the temple of the Masque, with a young god, lyre in hand, standing upon the steps in an attitude rem-

iniscent of the sketches of the winged Liberty for the coins, and the following summer he distributed reductions of it among those who had shared in the performance.

Of the remaining portrait reliefs, only two need mention, the first of the Hon. Wayne MacVeagh and his wife, the second of my mother. In one way the MacVeagh interested my father more than the others because, like the Lee and Howells reliefs, it was modeled to be shown in two lights.

On the medallion of my mother, my father worked last with his own hands at a time when he could no longer stand, nor, indeed, labor for many consecutive minutes. In the composition he suggested the columns of the porch outside the studio, the golden bowl of the "Masque," and the tangle-coated sheepdog already referred to in a letter to Edwin Abbey, and associated with my mother by the phrase, "go 'way, Doodles!" Unfortunately, when the dog received an anonymous hair-cut, my father was forced to call a premature halt on the lower part of the relief.

Let me pause here for a moment, before making a conclusion of this account of his final tasks, to speak of a monument, the erection of which was close to his heart though he never came even to sign the contract. The members of the Players Club, of New York, desired him to erect before their building in Gramercy Park a memorial to the first player of them all, Edwin Booth. So at Mr. Francis Wilson's request I wrote to my father on the subject and drew the following reply:

April 21, 1906.

Dear Wilson:

. . . It goes without saying that for many reasons, artistic as well as sentimental, nothing would give me greater pleasure than to undertake such a work. Something should be done to show our feeling toward Booth and I should be only too glad to help in any possible

way to further an adequate memorial, no matter what form it should take and whether I am directly concerned with it or not. I shall, of course, be very glad to hear from you and go into any details that you may wish to know about. . . .

After my father's death, this monument was given to Mac-Monnies.

At the time of which I speak, however, two large commissions were still at hand, and both of these deeply attracted Saint-Gaudens; the figure of a seated Christ with a background of two angels in relief for Mr. George F. Baker, and the Caryatids for the portico of the Albright Art Gallery in Buffalo.

When Mr. Baker had come to him asking for a seated figure that should carry with it something of the same feeling as that brought by the one at Rock Creek, my father had accepted the commission with alacrity. For after his reading in preparation for the figure in the Brooks monument, it was natural that he should feel impelled to express still further his new sense of the beauty of Christ. As far as the main figure was concerned, the monument developed smoothly enough to completion, except for the sculptor's usual difficulty in getting the legs sufficiently long, and for some trouble with the drapery which fell over the rock on Christ's left side. Of the angels that were to go behind the figure, Saint-Gaudens left only the roughest sketch. Mr. Baker, however, kindly allowed the modeling of this relief to be entrusted by my mother to one of my father's most gifted assistants, who, under his direction, had finished much of his sculpture and who had worked for him upon the Christ, Miss Elsie Ward, now Mrs. Henry Hering. She, with infinite care and patience, developed this composition from details suggested by the Morgan Tomb figure, the "Amor Caritas," and the like, until, at

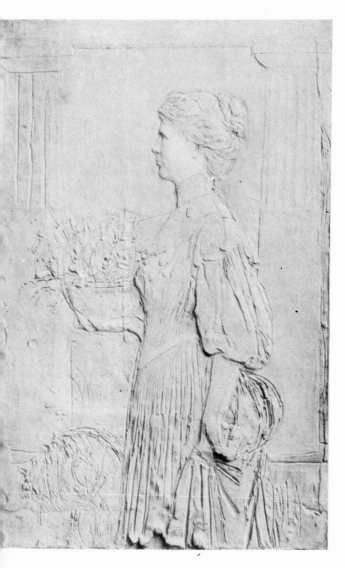

SKETCH FOR RELIEF OF MRS. SAINT-GAUDENS

last, she produced an astonishingly beautiful and poetic result, filled with the spirit of his work.

Last of all, the Albright Caryatids strongly held my father's attention since he appreciated the rich worth of the architecture he was adorning. For such a building, bearing to him a strong note of Greece, he wished to create his caryatids as large, reposeful women, in no way personal and to some extent archaic. Short portions of letters which he wrote to Mr. Albright on the subject show his feelings toward them as well as the manner in which, from his first commission to his last, he ruminated over his tasks before ever he touched his hands to clay. He writes:

The scheme is a most alluring one, admitting of infinite possibilities as regards treatment. I have thought of making twelve different figures, but this would be a formidable undertaking; besides, it seems to me now that it would not be necessary. I think that the system adopted at the Erectheum would be the best here, and to have two, three, or four different models of which the other figures would be replicas, modifications being made in each of the other eight, nine, or ten figures, in the folds of the drapery, some detail or accessory.

Again:

This doing something to recall the Erectheum is what perhaps frightens me more than anything I have done in my life. It seems so presumptuous. However, we shall see.

And again, much later:

They have made good progress, I suppose on account of the years of thought, and the year of preliminary

studies devoted to them before the actual large size figures were begun a year or so ago. It's not the finger but the brain-work that takes the time; and I knew what I wanted to do and have done it, in fact more than I proposed, as I have made three different heads instead of two.

First my father decided to have wings upon the figures: then he purposed that they should carry garlands in their hands. Later he developed a plan for the four central figures to hold lettered tablets, and those on the corners, palms. Again he conceived a more elaborate scheme of representing at the corners Attributes, and between them Arts. He feared, however, that such an idea might confuse. So at last he decided that he would place palms in the hands of the end caryatids, while by the middle ones he should denote Architecture, Sculpture, Painting and Music.

At the outset he studied the figure of Painting with detailed care, as all the others were to be variations upon it. For example he had cast a heavy plaster cap, under which the living model could pose for only a moment, though during that moment he could see her head at an angle which banished the hated "stuck out chin." His general scheme of drapery he drew from the decorative figures on a terra cotta Etruscan altar; but he developed these compositions mostly through deliberate and original thought, partially through accident: one morning, for instance, showing pleasure when he found that the garments had happened to be cut off in a way that cast a straight, dark line across the feet.

With that commission my father's work came to its end, closed while he was making almost superhuman efforts to keep active despite the progress of his illness. In that commission he gave his strongest indication of what his future work would have been, work notably of a monumental character he had never

before attained. His sickness brought only feebleness of hand, none of mind. To the last his vision grew even fuller and deeper.

A few days before his death which came on August third, 1907, he lay watching a sunset behind Mount Ascutney, from "Aspet," the spot which years before had seemed to him restful and far away. He spoke out of a long silence, "It's very beautiful," he said, "but I want to go farther away."

THE END

CHRONOLOGY OF THE WORK OF AUGUSTUS SAINT-GAUDENS

1867 Bust of his father Bernard P. E. Saint-Gaudens. 15 in.
 high. Signed and date.

1869 Model of Nude Male Figure.

1870 Miss Belle Gibbs. Marble bust.

1870 Miss Florence Gibbs. Marble bust.

1871 Hiawatha. Marble. Seated Figure.

1871 Fisher Boy. Statue.

1872 Edward W. Stoughton. Marble bust.

1873 Edwards Pierpont. Marble bust.

1873 Mrs. Pierpont. Marble bust.

1874 Silence. Marble Statue. Heroic size.

1874 William Maxwell Evarts. Marble bust.

1875 – 1879 Theodore Dwight Woolsey. Marble half statue.

1876 Benjamin Greene Arnold. Marble bust.

1876 Fresco Painting, Trinity Church, Boston.

1876 Henry E. Montgomery, D.D. Bronze medallion.

1877 George W. Maynard. Bronze medallion.

1877 David Maitland Armstrong. Bronze medallion.

1877 William L. Picknell, Bronze medallion.

1877 William Gedney Bunce. Bronze medallion.

1878 Angels adoring the Cross. Saint Thomas' Church. New
 York.

1878 Miss Helen Maitland Armstrong. Bronze medallion.

1878 Charles F. McKim. Bronze medallion.

1878 Caricature Augustus Saint-Gaudens, Charles F. McKim and
 Stanford White. Bronze medallion.

1879 Richard Watson Gilder, Wife and Son. Bronze medallion.

1879 Rodman Gilder. Bronze medallion.

1879 LeRoy King Monument. Newport, R. I.

CHRONOLOGY OF THE WORK OF

1879 Mrs. Emilia Ward Chapin. Bronze medallion.

1879 Dr. William E. Johnston. Bronze medallion.

1879 Frank D. Millet. Bronze medallion.

1879 Dr. Walter Cary. Bronze medallion.

1879 Miss Maria M. Love. Bronze medallion.

1880 Dr. Henry Shiff. Bronze medallion.

1880 John S. Sargent, R.A. Bronze medal.

1880 Tomb of Ex-Governor Morgan.

1880 William Oxenard Moseley. Medallion and bust.

1881 Children of Prescott Hall Butler. Bronze relief.

1881 Admiral David Glasgow Farragut Statue unveiled in Madison Square.

1881 M. McCormick. Medallion.

1881 Leonie Marguerite Lenoble. Medallion.

1881 Mrs. Charles Carroll Lee and Miss Lee. Bronze medallion.

1881 Miss Sarah Redwood Lee. Bronze medallion.

1881 Dr. Josiah Gilbert Holland. Bronze medallion.

1881 Samuel Gray Ward. Bronze medallion.

1881 Two Caryatids for marble mantel in house of Cornelius Vanderbilt.

1882 Sculpture decoration in Villard House.

1882 Homer Saint-Gaudens. Bronze medallion.

1882 Ex-President Chester Allen Arthur. Bust.

1882 Commodore Vanderbilt. Bronze medallion.

1882 Two sons of Cornelius Vanderbilt. Bronze medallion.

1882 Miss Gertrude Vanderbilt. Bronze medallion.

1883 Dr. Alexander Hamilton Vinton. Bronze relief, heroic size.

1884 Robert Richard Randall. Bronze statue.

1884 Mrs. Stanford White. Marble relief.

1884 Prof. Asa Gray. Bronze medallion.

1884 Dr. Holland monument. Springfield, Mass.

1884 Dr. S. Weir Mitchell. Bronze medallion.

1884 Portrait of a Lady. Bronze medallion.

1884 Charles Timothy Brooks. Memorial Tablet.

1885 Two seated Angels, Stewart Tomb.

1885 Bust of Homer Saint-Gaudens.

1885 Dr. Henry Bellows. Bronze Memorial Tablet.

1885 William Evarts Beaman. Bronze medallion.

1885 Chief Justice Waite. Bust.

1886 Son of Joseph H. Choate. Marble bust.

1886. Henry P. Haven. Bronze medallion.

1886 Smith Tomb. Angel.

1886 Fountain in Lincoln Park, Chicago.

1887 Abraham Lincoln. Bronze statue. Heroic size.

1887 Amor Caritas. Bronze tablet.

1887 The Puritan. Bronze statue.

1887 Chester W. Chapin. Bust.

1887 Robert Louis Stevenson. Bronze relief in rectangular form.

1887 Robert Louis Stevenson. Bronze circular medallion.

1887 – 1902 Robert Louis Stevenson. Rectangular bronze tablet St. Giles.

1887 Mrs. Grover Cleveland. Bronze medallion.

1888 William M. Chase. Bronze medallion.

1888 Children of Jacob H. Schiff. Bronze relief.

1888 William M. Evarts. Bronze medallion.

1888 Bust of General William T. Sherman.

1888 Dr. Edwin Hubbell Chapin. Bronze memorial tablet.

1888 Mrs. Schuyler Van Rensselaer. Bronze medallion.

1888 Oakes Ames. Large medallion.

1888 Judge Tracy. Medallion.

1889 Kenyon Cox. Bronze medallion.

1889 Washington Medal. Bronze medal.

1889 Dr. McCosh. Bronze Memorial Tablet.

1889 Jules Bastian Lepage. Bronze medallion.

1889 Hollingsworth Memorial. Bronze.

1890 Miss Violet Sargent. Bronze relief.

1891 Adams Monument. Bronze statue.

1891 Seal for the Boston Public Library. Stone relief.

1891 Study for the Head of Diana.

1891 Peter Cooper. Tablet in Cooper Union.

1892 Mrs. Hamilton Fish monument. Two figures adoring cross.

1892 Diana. Bronze figure.

1892 – 1893 Columbian Medal.

1894 Charles Cotesworth Beaman. Bronze relief.

1895 President Garfield Monument.

1895 Tomb for Mr. Henry Nevins.

1895 Miss Annie Page. Bronze Head.

1896 William Astor Chanler. Bronze bust.

1896 Martin Brimmer. Marble bust and medallion.

1897 Memorial to Col. Robert Gould Shaw, unveiled.

1897 General John A. Logan. Equestrian Statue.

1897 Peter Cooper. Bronze statue.

1898 William Dean Howells and Miss Howells. Bronze medallion.

1898 Miss Howells. Bronze medallion.

1898 Charles A. Dana. Bronze medallion.

1899 Mrs. Charles Russell Lowell. Marble medallion.

1900 Mrs. Charles C. Beaman. Bronze relief.

1901 Hon. David Jayne Hill. Marble bust.

1901 Jacob Crowninshield Rogers. Medallion.

1901 Justice Horace Gray. Bronze relief.

1901-1902 Governor Roger Wolcott. Marble relief.

1901 Robert Charles Billings. Relief.

1902 Maxwell Memorial Tablet.

1902 Mrs. John Chipman Gray. Bronze relief.

1902 Senator Macmillan. Bust.

1902 Hon. and Mrs. Wayne MacVeagh. Bronze relief.

1903 Governor Roswell P. Flower. Bronze statue.

1903 Equestrian Sherman Statue.

1904 Mr. and Mrs. Stanley Matthews. Relief.

1904 Mrs. Charles W. Gould. Marble bust and relief.

1904 Hon. John Hay. Marble Bust.

1904 Dean Sage. Bronze relief.

1904 Caricatures of Henry Adams, Charles A. Platt and James Wall Finn. Bronze medallion.

1905 Marcus Daly. Bronze statue.

1905 Commemorative Medallion of the Fête at Cornish.

1905 Head of the Victory. Bronze.

1905 Victory head medallion.

AUGUSTUS SAINT-GAUDENS

1905 The Pilgrim. Bronze statue.

1906 Charles Stewart Parnell. Bronze statue.

1906 Frederick Ferris Thompson. Marble relief.

1907 Designs for the U. S. Coins. Eagle, Double Eagle and
 One Cent.

1907 William C. Whitney. Bronze bust.

1907 Marcus A. Hanna. Bronze statue.

1907 Sketch of Figure of Painting.

1907 Whistler Memorial at West Point.

1907 Abraham Lincoln. Seated Statue, Bronze, heroic size.

1907 Boston Public Library Groups. Unfinished.

1907 Caryatids for Albright Art Gallery.

1907 Magee Memorial.

1907 Phillips Brooks Memorial.

1907 The Baker Monument.

1907 Mrs. Augustus Saint-Gaudens. Bronze relief.

1907 Study for the head of Christ. Marble.

INDEX

INDEX

369

INDEX

INDEX

Cathedrals, Saint-Gaudens' feeling about, ii. 161-164

Champ-de-Mars, Saint-Gaudens' exhibit at, in 1898, his success, ii. 185-188

Chanler, William A., bust of, ii. 167

Chapin statue, Springfield, Mass., i. 353, ii. 14

Chase, Alexander, ii. 221

Chase, William M., i. 275, 276; bas-relief of, i. 272

Choate, Joseph H., i. 268

Christ figure, Phillips Brooks memorial, ii. 323-327; George F. Baker monument, ii. 354

Cisco, John J., i. 162, 167, 181

Clemens, Samuel, i. 248, 262

Cleveland, Mrs., Saint-Gaudens modeling bas-relief of, i. 300.

Coffin, William A., his letters concerning Saint-Gaudens, ii. 50, 93, 137, 245, 299

Coins, United States, Saint-Gaudens' designs for, ii. 329-332, 336, 341

Cole, Thomas, i. 59

Coleman, Samuel, i. 59

Columbian Exposition, 1892, Saint-Gaudens a general adviser regarding the entire sculptural scheme, ii. 73; his enthusiasm, ii. 66; his medals, their rejection and his relations with the Washington authorities, ii. 45, 66-72; his tribute to MacMonnies, ii. 73, 74

Colvin, Sidney, ii. 126

Comet, Donati's, i. 18

Competitions among sculptors, and Saint-Gaudens' work for the regulation of, i. 174, ii. 35-37, 253

Concerts on Sunday afternoon in Saint-Gaudens' Thirty-sixth Street studio, i. 281, 306, 309, 311

Cook, Clarence, his articles on the National Academy of Design, i. 187, 250, 257

Cooper, Peter, statue, ii. 74, 75, 108, 109, 111

Cooper Institute, Saint-Gaudens in the drawing school, i. 45

Cornish, N. H., Saint-Gaudens' first summer in, 1885, i. 311-315; purchase of property, i. 316, 320; barn studio, i. 317, 320; friends near, i. 317-323, ii. 228; trip to Europe in 1897, return in 1900, ii. 206, 222; his delight in the country, ii. 227, 228, 232-244; picture of the house, ii. 241; studio destroyed by fire in 1904, ii. 247, 248; studio work, 1900-1907, ii. 289-358; twentieth anniversary celebration of the Cornish Colony, ii. 347-352; Saint-Gaudens' gift to participants in the masque, ii. 350, 352; failing health and last days, ii. 246, 359

Cottier, his work for La Farge, i. 257

Cox, George C., ii. 113

Cox, Kenyon, i. 250, 288, ii. 43, 94, 216

Crawford, Thomas, i. 33, 56

Cummings, T. S., one of the organizers of the New York Drawing Association, i. 34

Dammouse, Albert, i. 73, 81, 88-92, 192

Dana, Charles A., medallion of, ii. 124

Degrees conferred on Saint-Gaudens by Princeton, Harvard and Yale universities, ii. 94-96, 283, 288

Dewing, Thomas W., i. 276, 278, 282, 317, 323, ii. 43, 217

Diana, tower of Madison Square Garden, i. 393, ii. 99

Dix, Governor, i. 168

Donald, Winchester, ii. 97, 98, 313, 318

Drama, Saint-Gaudens' interest in, ii. 59

INDEX

INDEX

German Savings Bank Building, Saint-Gaudens' studio in, i. 154-159

Gérôme, Saint-Gaudens' admiration for, ii. 50

Gibbs, Montgomery, his assistance to Saint-Gaudens in Rome, i. 112, 113, 117, 120-123

Gibson, Charles Dana, his experience in Saint-Gaudens' studio, ii. 10, 11

Gilbert, Cass, ii. 59

Gilder, Helena de Kay, i. 186

Gilder, Richard Watson, his comradeship with Saint-Gaudens, i. 257, 283, 284; his opinion of the Farragut monument, i. 265; Saint-Gaudens' bas-relief portraits of the family, i. 216; Saint-Gaudens' letters to, concerning death of mother, i. 129; concerning the Society of American Artists, i. 186

Gortelmeyer, his friendship with Saint-Gaudens, i. 46, 60, 130, 131

Greeley, Horace, and Bernard Saint-Gaudens, i. 17

Greenough, Horatio, i. 33, 56

Grimes, Frances, Saint-Gaudens' assistant, ii. 231; Saint-Gaudens' caricature signature on letter to, ii. 225

Haddon, James, i. 27, 30

Hand of Saint-Gaudens, plaster cast of, i. 96

Handwriting of Saint-Gaudens, i. 329

Hanna, Marcus A., monument, ii. 328

Hartley, Jonathan, i. 353

Hassam, Childe, ii. 47, 221

Hastings, Thomas, ii. 59

Hastings, Mrs. Thomas, Saint-Gaudens' caricature signature on letter to, ii 225

Hay, John, bust of, and personal relations with Saint-Gaudens, ii. 333-343

Hering, Henry, Saint-Gaudens' assistant, ii. 231, 247, 332, 354; caricature of, ii. 182

Herzog, Louis, i. 60, 64, 128

Hewitt, Cooper, ii. 119

Hiawatha, modeling of, in Rome, i. 109, 112, 121, 122; picture of, i. 116; order for statue in marble from Governor Morgan, i. 116, 122, 133

Hippopotamous, family and restaurant in Rome, i. 114, 117, 132

Holt, Winifred, ii. 38

Homer, Augusta F., see Saint-Gaudens, Augusta Homer

Homer, Mrs. Thomas J., Saint-Gaudens' letters to, i. 167-170, 179-181

Homer, Winslow, i. 185, 276, ii. 47, 221

Honors at home and abroad for Saint-Gaudens, ii. 94-96, 128, 132, 201, 281, 283, 287, 288

Hooper, Edward, i. 331

Howells, William Dean, his letter concerning Saint-Gaudens ii. 61-65; Saint-Gaudens' bas-relief of, and of daughter, i. 216, ii. 61, 62, 77

Hudson River School of landscape artists, i. 59, 251

Hughes, Ball, i. 33

Hunt, Richard M., ii. 72

Hunt, William Morris, i. 185

Hutton, Lawrence, i. 27

Illustrations and the illustrators, ii. 217, 218

Inness, George, i. 275, ii. 44

Instruction by Saint-Gaudens, see Teaching by Saint-Gaudens

Italy, 'Saint-Gaudens' first stay in, 1870-72, i. 102-127; life in Rome, i. 104-110; trip to Naples and Mount Vesuvius, i. 110-112; his second stay in, 1872-75, i. 132-

INDEX

INDEX

studio, ii. 6, i. 312, 342; at Cornish, N. H., i. 320; Saint-Gaudens' letter concerning his relations with the "grown up" MacMonnies, ii. 15; Saint-Gaudens' criticism of the Nathan Hale statue, ii. 20; Saint-Gaudens' admiration for MacMonnies' work, ii. 52; the fountain at the Columbian Exposition, ii. 73, 74; in Paris with Whistler and Saint-Gaudens, ii. 179; caricature of, by Saint-Gaudens, ii. 182; the Edwin Booth monument, ii. 354; other works, i. 42, ii. 187, 210

MacNeill, H. A., ii. 211

MacVeagh, Wayne, and his wife, bas-relief of, i. 216, ii. 129, 297

Magee, Christopher Lyman, memorial, ii. 320, 328

Martin, Homer D., i. 59, 275

Martiny, Philip, Saint-Gaudens' assistant, i. 312, 342, 391, ii. 6

Masque at Cornish, on the twentieth anniversary of the founding of the colony, plaque made by Saint-Gaudens, ii. 347-352

Maynard, George W., i. 161; portrait relief, ii. 167

Mayor, Ernest, i. 134-138

Mead, Larkin G., 153

Mears, Helen, ii. 29

Medallions, *see* Bas-relief work; names of persons

Medals, the Columbian Exposition, ii. 45, 66; their rejection, and Saint-Gaudens' relations with the Washington authorities, ii. 67-72; the Roosevelt inaugural medals, ii. 253, 254

Mercié, i. 74, 77, 110, ii. 47

Metcalf, Willard L., i. 276, ii. 47, 119, 221

Millet, Francis D., i. 161, ii. 43, 44; portrait relief, ii. 167

Mills, Clark, i. 56, 57

Mitchell, Dr. S. Weir, monument to

daughter, a variation of the Amor Caritas, ii. 345, 346

Money meant to Saint-Gaudens the power to produce work, i. 274

Monvel, Boutet de, ii. 198, 201

Moore, Thomas, his testimony as to Saint-Gaudens' optimism, i. 60

Moran, Thomas, i. 59, 275.

Morgan, Governor E. D., order for the Hiawatha in marble, i. 116, 122, 133

Morgan tomb, first projects for, i. 179; work begun in Paris, i. 214; correspondence between Saint-Gaudens and Stanford White concerning, i. 220-224; views of angels, i. 228; destroyed by fire in Hartford, i. 272-274

Morse, S. F. B., one of the organizers of the New York Drawing Association, i. 34

Motto of Saint-Gaudens, i. 166, 167, 329, 344

Mowbray, H. Siddons, i. 44, ii. 58, 216, 271

Municipal Art Society, Saint-Gaudens refused the presidency of, ii. 115

Mural decoration in America, ii. 43, 216

Music, Saint-Gaudens' love of, i. 306, 307, 309, 311

Naples, Saint-Gaudens' visit at time of eruption of Vesuvius, i. 110; with Dubois and Mayor, i. 134-138; with Garnier in 1900, ii. 145

National Academy of Design, beginning of, i. 34; Saint-Gaudens as a student, i. 49; rejection of Saint-Gaudens' "Sketch in Plaster," i. 164, 188; revolt of the "reformers," i. 185-189

New Mexico, Saint-Gaudens' trip to, described in letter to his wife, i. 294-305

INDEX

INDEX

i. 259, 278; his love of sleep, i. 271; letter to, from Augustus, concerning his work, ii. 211; his home at Cornish, N. H., ii. 235

Saint-Gaudens, Mary McGuiness (mother), birthplace, i. 5; ancestry, i. 5, 9; marriage, i. 10; children, i. 6; picture of, i. 25; Saint-Gaudens' love for, i. 129; her death, i. 130

Saint-Gaudens family, legendary origin of, i. 3-5

Saint-Gaudens village, ii. 142

St. Thomas Church reliefs, commission from La Farge, i. 163; modeling of, in Paris, letters to La Farge, i. 190-200; shipment to America, i. 199; picture of, i. 197; La Farge's criticism of, i. 201; Saint-Gaudens' letters concerning, i. 203, 206, 256; public reception of, in New York, i. 209; destruction of, by fire, i. 210

Salies du Salat, France, Saint-Gaudens' at, ii. 138-141, 149

Sargent, John Singer, i. 250, 276, ii. 43, 44, 194, 216, 221

Sargent, Violet, bas-relief of, i. 348, 351

Schiff, Jacob H., children of, in bas-relief, i. 312, ii. 70, 189

Scott, David B., i. 37

Sculptor's tendency to bias his drawings in the direction of his own likeness, ii. 5, 61

Sculpture, character of a work classifies it as good or bad, i. 278

Sculpture in America, to 1848, i. 32-34; to 1867, i. 56-60; 1878 to 1890, i. 277; 1888-1897, ii. 42; to 1907, ii. 210

Shaw memorial, the execution of, by Saint-Gaudens, suggested by Richardson, i. 327, 328, 332; development of the plan, i. 332, 333, ii. 120; various sketches for, i. 329, 332, 340; adventures with

negro models, i. 333-338; difficulties in modeling, i. 341-344; fourteen years in studio, i. 344, 347; view of, ii. 82; worry over the inscriptions, ii. 88-93; unveiling of, ii. 78-84; congratulations and honors, ii. 93-96

Sherman, General, bust modeled by Saint-Gaudens, i. 378, ii. 167; his meeting with Stevenson, i. 381-383

Sherman monument, ii. 63; beginnings of, in New York, ii. 77; work in Paris studio, 1897-1900, ii. 123, 124, 133-136; completion of, at Cornish, N. H., ii. 227, 289-300; controversy concerning location of, in New York, ii. 294-296; in French exhibitions, ii. 133, 135; at Buffalo Exposition, ii. 299, 300; ten years in studio, i. 347

Sherwood studio in New York, i. 268, 272

Shiff, Dr. Henry, acquaintance and influence with Saint-Gaudens, i. 114, 124-126; bas-relief of, i. 125

Shirlaw, Walter, i. 275, ii. 43

Silence statue, ordered by L. H. Willard, i. 130; work begun in Rome, i. 133, 134, 140, 141; difficulties, i. 142, 143; picture of, i. 116; Saint-Gaudens' letter to J. Q. A. Ward concerning, i. 142

Simmons, Edward, ii. 43, 119

Smedley, William, ii. 119

Smith tomb, Newport, R. I., i. 350; comparison with the Morgan tomb, i. 354

Soares dos Reis, his friendship with Saint-Gaudens, i. 79, 109

Société des Beaux Arts, Saint-Gaudens elected a member of, ii. 128, 201

Society of American Artists, founding of, and Saint Gaudens' interest in, i. 184-189; meetings of

379

INDEX